Pop Song

Pop Song

ADVENTURES IN
ART AND INTIMACY

Larissa Pham

CATAPULT 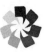 NEW YORK

This is a work of creative nonfiction. The events are portrayed
to the best of the author's memory. While all the stories in this
book are true, some names and identifying details have been
changed to protect the privacy of the people involved.

ISBN: 978-1-646220-26-7

Jacket design by Nicole Caputo
Book design by Wah-Ming Chang

Library of Congress Control Number: 2020943174

Printed in the United States of America
1 3 5 7 9 10 8 6 4 2

If you've ever sung along to a song on the radio,
this is for you.

Contents

Pop Song

On Running

October in Connecticut. I'm nineteen, tightly lacing up my running shoes. Foot propped against the wall, my face skimming close enough to my knee to kiss the dry skin there. I yank at the laces until they leave white marks on my fingers, then swipe at my phone screen to check the time: just past midnight. It's taken all evening to let the tension build, pacing around the common room I share with two roommates who have filled the place with incense and pillar candles. Shoes tied, I stretch, tapping my toes. One exhale in place, then two, the anxiety settling low in my stomach with the dinner I put away hours ago. Before long, I know, I'll feel physically sick if I don't start running, if I don't leave, if I don't go. Then I'm loping down my dorm's five flights of stairs, and then I'm out the door.

I never knew where I was going on those late night runs, only that I couldn't *not* go. It was a version of the same impulse I'd recognize in you years later, in the way you silently got out of bed one winter morning. From within the nest of your sheets I imagined your neighbors seeing your naked form in the window—your lean body in the cool light. You dressed without saying anything:

running shorts, the thermal long-sleeve I'd bought for you at Uniqlo, a black hoodie you pulled over it all. You would have left without a word if I hadn't asked if you were going for a run. Yes, you said. But I wasn't asking because I didn't know the answer; I was asking to hear you speak to me.

In New Haven, I'd start out down one of the main roads that ran through campus—Elm Street, maybe, looping around the silent, tree-lined quadrangle of Old Campus, then cutting through Cross Campus, past the library, where at night the fountain of the Women's Table still shone. I liked dragging a finger across its smooth granite surface, watching the water rip-ple in my wake. But staying close to home—close to the dorms, where people slept and dreamed all stacked up on top of one another in their rooms like terrariums—felt claustrophobic, and after doing a lap I'd head north on College Street, up the hill, my heart pounding high in my chest. Past the cemetery, with its inscription over the gate—*The dead shall rise again*. Past the science buildings, where I'd already dropped out of first chemistry, then genetics, abandoning meticulously typed-up lab reports for paintbrushes and glass palettes in the studio on Chapel. Up in the quiet on the hill I ran clenching the flat brick of my phone in one hand, a Phantogram album playing tinny through my earbuds, knotted white wires knocking against my chest.

Today I don't even remember what I was so upset about. What pining had led to the evening spent pacing around. But maybe

that's not important anymore; what I recall is the impulse, the way I reacted and what I reached for: dark pavement, empty streets, an album thudding in stereo. The lift of the music like a wind at my feet, taking me away from the ordinary, making me feel as though I were a spectator of my own life, or a protagonist in a film somewhere.

I wasn't really an athlete. I'd participated in track lackadaisically in high school, but in college I acquired a set of unruly bangs that had to be pinned back and a pair of heavy acrylic-framed glasses that slipped down my nose and were impossible for sports. My gear was cobbled together: old sneakers, nylon running shorts splattered with gesso and acrylics, T-shirts from 5Ks I'd done in Portland—all the same clothes I wore in the painting studio. It wasn't about training, or speed, or strength, the ways a better person might have tried to better themselves. Running was halfway between ritual and impulse for me, a call I felt compelled to answer no matter how unprepared I was. Alone, keeping a jagged pace up College Street, the traffic lights blurred ahead of me in bright, primary colors, as if I were seeing them through tears. Or maybe it was just because I didn't have glasses on.

None of it felt good, but after a while, it started to feel like nothing. It was this nothing I was after—the moment where the noise of my brain cut out and I crested onto that smooth, high plane of emptiness, empty of feeling, empty of thought, my body churning out its own high. It was a beautiful place to be, however briefly

the feeling lasted—ten minutes, maybe fifteen. Once I reached that mark, I kept running, until my legs burned, until something inside me told me it was time to go home.

The next day I'd be sore, my calves and thighs aching. I never seemed to run quite far enough for my body to get used to it— the beating of the pavement. But I relished the discomfort in a secret, perverse way, the way I relished the hickeys and bruises that came from hookups and one-night stands. The pain was a way of knowing something had happened, that some kind of alchemy had been performed and left me, I liked to imagine, changed. Coming home from a late night run, I'd immediately feel better—like the tangles in me had been untangled, like my whole spirit had been smoothed out. After showering, I'd sit placidly on my lofted bed, hair dripping on my comforter, and retrace my route on Google Maps to learn the night's mileage, working backward to figure out my pace, comforted to learn the distance I'd come.

Looking back, I see all those numbers were mere window dress-ing, stats for me to chew on with the personal competitiveness with which I attacked my academics. My night runs weren't about improving my pace or endurance; they weren't even about athletics. I didn't care about fitness—when I thought about the shape of my body too much, it tipped me into a self-hating spiral. When I ran, I didn't have to learn to love the soreness in my legs. I loved it already, as a sign of what I had done to myself. And I loved having the fierce pride in pushing myself. I never asked where,

or for whom. I never asked what I was running from, or what I hoped to find.

•

I suspect no runner really loves the act of running, but they all do say they love it. Nothing about running is fun—not in the way I've ever understood fun. There's the health advantage offered by most exercise, but running is predominantly punishing: it ruins your knees, wrecks your ankles, and causes shin splints. Running a marathon seems impossible to me: I can't imagine running for more than an hour, let alone three or four. But maybe that's why running has its adherents: there are those who are drawn to its simplicity, who find beauty in its pure, egalitarian punishment. Who even find joy in it.

For a while I thought that was the kind of runner I wanted to be: the happy ascetic. I've always harbored a fantasy of ditching my ordinary life and becoming a Buddhist nun. Wishing I could be as true and neat as an arrow. What if, I wondered, I could stop reacting so much to the world, striking out for miles in the dark at the slightest provocation, and instead find peace within it? Become the kind of healthy, well-adjusted person who puts away a 5K before breakfast. Become the kind of healthy, well-adjusted person who eats breakfast. The novelist Haruki Murakami might be this type of long-distance runner's most idealized form—seemingly zen about having completed multiple

marathons. "You don't have to go to any particular place to do it," he wrote in *The New Yorker*, in 2008. "As long as you have a pair of running shoes and a good road you can run to your heart's content." He's the kind of runner that runners like me aspire to be, and so chill about it, as though he's just washed up on the shores of the isle of inner peace.

If all it could take to satisfy me were a pair of shoes and a good road! Reading Murakami on running makes me feel entirely too needy—too volatile, too susceptible. In a 2005 interview, when asked about his long runs, he answered: "I try not to think about anything special while running. As a matter of fact, I usually run with my mind empty." That's the part about Murakami's relationship to running that I can connect with, that doesn't feel just aspirational. That emptiness—the running makes the nothing possible, taking one away from one's self. But I wonder which comes first: the empty head or the sole striking pavement? When I ran, I ran frenetically, panicky, as if trying to lose my mind; I wonder if Murakami runs the way he does because he's already learned how to clear his.

So, appealing as it is, something about Murakami's affable stride doesn't quite resonate. I'm not sure anything ever comes that easy. It's too neat, too pat, when I think about the way that even a good road will wear away at the cartilage in a runner's knees, how miles of pounding away at pavement inevitably causes stress fractures and shin splints. Instead, as if switching polarities, I've been pulled to tales of extremity—stories about ultramarathoners, runners who cover hundreds of miles on foot, through rain, mud,

snow, and extreme heat, with each new race seeking a challenge that tops the last. This makes more sense to me as a bodily practice: that desire to push one's physical limits well beyond their natural bounds. Morbidly, I love reading about the grime, the gore, the toenails falling off, the way these runners keep trudging forward, driven by some internal force more powerful than any I've ever known.

There's the Barkley Marathons, a grueling, hundred-mile course through saw briars, mud, an old prison tunnel, and several bombastically named hills: Rat Jaw, Little Hell, Big Hell, Bird Mountain, Coffin Springs. Runners rarely finish the entire race: the point is to have attempted even a single, marathon-length lap, let alone five. Or the Iditarod Trail Invitational, a thousand-mile race across Alaskan wilderness—the runners each pulling a heavy, supply-laden sled behind them. No one's died on that trail yet, but in 2016, the runner Pete Ripmaster nearly did, falling into freezing water, and men have lost fingers and toes to frostbite in similar races. Why, I wonder, as I pore through magazine archives to read each odyssey, settling into the details of dehydration, exhaustion, and men losing their minds, would anyone do this? But maybe I'm being presumptuous, thinking that I could understand, reading articles from *Outside* online while cozily ensconced in my apartment in a pair of sweatpants that have never seen the outdoors. Imagining that the instinct to run this way might stem from something simpler than the mess. Maybe it's about moving past feeling nothing to feeling something—perhaps so much something that it feels like nothing again.

Now that seems right: how often in my life have I wanted to crest on the edge of pure sensation, seeking out the shape of something so big it could obliterate me? In my adolescence in Portland I got into the live-music scene. An early curfew kept me from catching headliners at shows, but I didn't care what band I heard. At first, I wanted to make friends; then I learned I just wanted to be in the room with the big sound. It didn't matter where or what kind: a house show in North Portland full of squealing static; the otherworldly post-rock of Explosions in the Sky at the Crystal Ballroom; or, later, a punk show in Connecticut, my glasses tucked in the pocket of my hoodie as I slid into the mosh pit. What I craved was the swaying, oceanic feeling of being totally surrounded in music, a small part of something large, and that thing so large that my own small part didn't seem to matter at all. Yes, I understood that kind of disappearance: being slammed speechless by a wall of sound, in a packed room full of roiling bodies, everything surging into an incoherence so ecstatic the bounds of myself seemed to fade away. If I could find it in music, it made sense that it lived elsewhere in the world, hovering at the outer edges of extremity. I knew I ran just enough to feel that little bit of nothingness, but I could imagine that running farther, running harder, could push a person even closer to a sense of total surrender.

The ultra of ultras must be the Self-Transcendence 3100 Mile Race, a race conducted around one single block in Queens, New York. It's an event so poetic it seems made for metaphor. Runners have fifty-two days to finish the race's thirty-one hundred miles, which means running more than two marathons a day, every day, for several weeks. There are no rolling hills in this race,

no historic bridges to traipse across. Nor is there the inelegant obstacle of a muddy trail, or a thicket of brambles, or icy water. All there is—and what little it is—is the sidewalk upon which the runners pound, darting around pedestrians who are still going about their days. The philosophy of the race, which is organized by the Sri Chinmoy Marathon Team, founded by the spiritual leader of the same name, seems to be a meditative one. Practically speaking, by keeping the course to a single block, the runners' support teams can attend to each participant's needs, no matter how many hundreds of miles they're ahead or behind. But really, the race is a challenge for the mind of the most banal kind: faced with looping around a single block 5,649 times, in all weathers, from 6 a.m. to midnight, while all of life in Queens passes one by, or actively gets in one's way, how does an individual endure?

I like that the aim of the race is in its name: self-transcendence. Run thirty-one hundred miles and leave that same block transformed. When I first learned of it I thought no one must have ever finished it, that its lessons laid in the inevitability of failure, but as I write this at least forty runners have—maybe that level of endurance isn't so otherworldly. When I hear the word *self-transcendence*, I picture a cosmic vent in the top of my head, and my soul spiraling up and out of it. I tend to leave my body, neck-down, out of this visualization: that's the goal, isn't it, to escape it? We all have ways to get there: for some it's running; for others it's drugs, or music, or sex. I've tried so many—and I keep trying.

When I ran in college, and when I run now, I think of this hazy, escapist feeling, the feeling I think I'm always trying to reach. I've

tried to find it in so many places, and now, as I write this in the middle of a global pandemic, when the small circle of the world accessible to me feels claustrophobic and close, I wonder where I'll find it next. For that's been my perpetual problem, as it was then and as it remains: I'm always trying to get somewhere else. It doesn't matter where I'm going, only that I'm going, and that, eventually, I hope to be gone—winked out of my troubles, my responsibilities, my everyday existence.

In Connecticut I felt fatalistic about my late night runs. I'd text a friend before I set out, telling them if they didn't hear from me in an hour to call, or track me down. But nothing ever happened, and I wonder if, back then, I'd wished something did. Something that could be used to point to a change. Something that might create in me a rupture or a break.

One night, I ran up past the observatory. There, my freshman year, I'd learned how to take photographs of stars and distant galaxies. The telescope, which was in the observatory on the hill that overlooked the lights of New Haven, was connected to a camera, which captured light through separate filters: red, green, and blue. By combining three exposures of a celestial object, a false color image could be made: composite the layers to clarify the signifiers from the noise, dark from light, and a nebula appears, shrouded in its cloud of cosmic dust. On clear nights, my class met up at the observatory, and we'd take turns looking through the telescope,

centering heavenly bodies in the frame. While we waited for our turn with the big lens inside the dome, we peered through the smaller, freestanding telescopes outside, angled at the nearest visible planet. Some nights, Venus, Mercury, Mars. Once, Jupiter. Shivering in our fall layers, we counted its stripes—if I strained my eyes hard enough, I thought I could even make out the red spot of its endless storm.

The building sat on a grassy slope of its own, set back from the road, the lawn spotted with small trees. It was dark up on the hill; to see the stars, it had to be. I kept running, up through the neighborhoods on East Rock, the silent houses, their faces impassive. It was quiet, and I was the only person around—awake, I mean, as far as I knew. It was strange to be surrounded by that much silence. As I looped back down the darkened streets, heading back toward campus, I heard a rustle that frightened me. It was probably a mouse, or a raccoon, but I didn't know that, and I bolted down the hill.

I'd come up to the edge of something, then. Not in the world, but in myself. It was time to go home. I ran down Prospect, down to where it turned back into College, turned right on Elm, cutting through the dark quad, the dry grass a deep blue-green in the moonlight. It was quiet.

You told me once that when you lived in New Haven—a year after I left; two years before I'd meet you—you had run at night the same way I had. I should have asked you why you ran then. I wonder if it was for the same reasons I ran, too.

On our observation nights, in the warmth of the dome, our instructor told us that the big telescope the university owned was only so powerful, and only so sensitive. If we wanted to photograph one of the closer galaxies, which some of us did, it would read only as a blur of blank white—an excess of light, all detail blotted out. We were told that to see anything bright, and clearly, we had to look at it at indirectly, at angles, out of the corners of our eyes, and composite an image out of fragments. Otherwise, there was too much light. The photograph overexposed. You couldn't see the whole thing for its burning fire, that enduring flame.

Blue

When I was very young I was told that the blue of the sky is the hardest color to mix with paints. It made sense to me that there must be something humans are always chasing. I, earthbound, assumed it would have to be the heavens.

Some years later, in my first painting class in high school, we learned how to paint with oils and turpentine in a room with huge windows that looked out over a bell tower and a cherry tree. At the long table, mixing oily cobalt blue straight from the tube with a little titanium white, I wondered what all the fuss was about. I'd made sky blue: I held my palette knife up to the window to compare, and yes, it was sky. I could add buttery strokes of more titanium white, for clouds, and dapple on a warmer white, if I wanted to light them, and then there was a whole spectrum of pinks and peaches and oranges for sunset or sunrise. It was that easy. There is even a commercially produced shade, I discovered, called cerulean. Its name derives from the Latin word for the heavens.

Years later yet, when I realized I wasn't very good at painting, I considered that perhaps what I had first heard about blue was

more about expression than replication. That perhaps what was difficult about sky blue was trying to capture the size and depth of the sky: the distance that stretches between us and the rest of the universe. By that point, I'd studied painting long enough to know that there were many ways to make a flat surface look like something of the world—there were ways to paint oranges or glass bottles or slices of cake like Thiebaud—but that was only half the problem of art making. You could paint all sorts of things, but it was harder to convey the feelings you had about them. When I tried to paint landscapes, I couldn't capture that vast distance that *was* the sky, the blue that Rebecca Solnit describes, in *A Field Guide to Getting Lost*, as "the light that got lost":

> The world is blue at its edges and in its depths. This blue is the light that got lost. Light at the blue end of the spectrum does not travel the whole distance from the sun to us . . . This light that does not touch us, does not travel the whole distance, the light that gets lost, gives us the beauty of the world, so much of which is in the color blue.

Painting a canvas blue wasn't enough. It was like dropping a curtain. All along I knew the world went on and on beyond the surface of the thing.

It's not only the sky that is blue in this specific way. Solnit's "light that gets lost" is the light that comes to us from afar, so places very high and very far appear to us as blue, too: places like distant

cities or mountains or even the flat lip of a foggy horizon at sea. But that blue—that blue isn't stored in those distant locations. It's not like what painters call local color, the way an apple is red or an orange is orange. And that blue isn't stored close to us, either; we can't carry it around with us, even if we buy thousands of tubes of cerulean. That hazy, achy, atmospheric blue is the product of the distance between us and the places we observe, and that gives it its particular poignancy, I think: closing that distance precludes ever meeting it.

By the spring of 2017, I felt entirely burnt out. I was working at an anti-violence nonprofit, at a job that I loved but which required me, among other duties, to monitor the news for violent incidents motivated by homophobic and transphobic hate and bias. Following Trump's inauguration, the mood in the office was grim: his election had bolstered the confidence of hate groups and white supremacists, who appeared to feel that their views were being recognized as legitimate. From news reports we learned that hate crimes had already gone up in the days after the election, and that rise in violence was confirmed by an increase in concerned callers on our hotline, many of whom feared for their physical safety, or worried about being deported, or both. The mood outside the office was grim, too—if also grimly activated, with people marching through the streets and streaming into the city's airports to protest the travel ban. There was a constant presence of police barricades surrounding the reality-TV president's high-rise,

faux-luxury tower, which I flipped off, Ai Weiwei style, whenever I found myself in midtown.

Every day I sat at my desk and scrolled through Twitter and felt as though I were slowly growing insane. Everything—every news story, every inflammatory tweet, every poorly written executive order that leaked from the White House and ended up, through a circuitous route of progressive listservs, in my inbox, followed shortly after by an official press release—felt compressed, both blown up and yet infinitely atomized, as each news item and its aggregate commentary catalogued another incipient horror and human rights violation. There was the truth of the very real buffoon in office, and then the equally appalling scam of the #Resistance that arose in response, consisting of a variety of political grifters posturing in a kind of coy defiance, with no transparency as to *where* all this suddenly fundraised money was being funneled. And then, of course, there was the flailing aimlessness of people like me, who wanted to do something but felt more or less tiny in the face of a dramatic failure of electoral politics and much else besides. Everything felt close to my face, and the world felt both very large and very small. I took crisis calls on the agency's anti-violence hotline. I donated money to immigration-rights organizations and read the news and pledged to vote in the midterm elections. And then I decided to go to New Mexico.

It was irresponsible, but I wanted to be free of all of the responsibilities I had found myself entangled in, caught up in the maelstrom of D.C. politics and online political posturing and always,

always in the back of my mind the very real violence that people enacted upon one another daily, the intimate knowledge of which could be a trauma of its own. And I did know. For now, I had the privilege of getting to decide how to arrange my life, the privilege of leaving, and I wanted to go to that furthest extent—chasing that blue of a place somewhere away from here, which shone so brightly in the distance.

The only solution seemed to be to run as far as possible from my current life, which is also the only solution that ever occurs to me. Even if it was just for a couple days—how long could it take? I wasn't asking for a change in my fates, just a retreat from the noise that surrounded me. I thought I'd find the salve I'd been seeking the moment I touched down. So I bought a ticket and filled my suitcase: Renata Adler, Roland Barthes, a pair of heavy hiking boots. Then I got on a plane and a few dim hours later I was in the desert, in a city with no skyline.

The Southwest, if you haven't been, feels very wide. A turn seems to have more than 360 degrees to it, and it seems as though you will never be able to breathe all that air. Everything is parched in the high elevation—on my first morning, I woke up with a nosebleed—but there are plants: scrubby bushes, mostly sage, which you'd think would scent everything, as they do in the sand dunes of Eastern Oregon, some hundred miles from where I was raised. In New Mexico they only give off fragrance when broken and rubbed between

your hands, and it smells to me more like weed than incense. Nothing man-made rises over the horizon, just the mountains and the mesas, which are the frame of the world. The landscape is white, tan, ochre-red, and all around, I did see blue.

I landed late at the Albuquerque airport, where my aunt came to pick me up. She was staying in Taos for the month with her husband, who was training for some kind of race in the mountains—I didn't know exactly what route he was running, but it required hiking tens of miles every day, and she insisted he get a satellite phone. Earlier that spring, she'd offered an open invitation to my vast and wide-ranging extended family to come visit Taos, and now, for a little under a week, it was my turn. We spent the night in the city, and the next day we drove up to Taos, diverting west to make a stop just outside of Abiquiú, to visit Ghost Ranch, where Georgia O'Keeffe once kept a home.

On the drive up, I couldn't stop staring at the mesas, their tops flat as if sliced clean off, the sandstone craggy underneath, revealing the earth's excavated layers in ribbons of white. Orange. Red ochre. In the middle distance were the once-blue mountains, now brown as we approached, dotted with dark green trees; closer to us and the road were the shells of abandoned metal trailers, and the occasional barn, and small houses with tin roofs. I don't know what I was expecting when I took off for New Mexico— some kind of pristine, high desert wildness, the same landscape and crystalline sky that had attracted painters like O'Keeffe or Agnes Martin? And it was true that the scenery hadn't changed at all. The sky I looked upon was the same sky it had been when

O'Keeffe moved to Abiquiú in 1943. The mountains were the same mountains; the trees the same trees. What was new was *my* presence in it, my arrival as an outsider who'd come to see what so many other people had come to see.

Here I was now in the distant blue place I had been seeking, and it was no longer blue: I had arrived to meet the colors of reality. Here was the desert and here, as we drove, were also faded street signs in shades of gray, and glossy wreaths of dried red chiles, and shuttered businesses and houses with boarded-up windows. It was impossible to ignore the evidence of the opioid crisis everywhere, on billboards and flyers promising quick treatment or cheap rehab or paid studies: addiction had taken hold in this hot, dry place, and I could feel its constant presence, leaching the energy from the land. It seemed unfair that something so sad and deadly could grip a beautiful place like this. And the sight of it, the closed-down businesses and empty streets, made me wonder how many people here had voted for Trump—I knew parts of the state had gone red, like so many pockets of the America I was unfamiliar with, bigger and more expansive and more complicated than I had imagined. I wondered if he'd seemed like the only option for something new for so many people, people who were jaded by the joblessness engendered by the capitalism so deeply rooted in our country it wasn't something politics could fix. People who were frustrated by the addiction that fed on precisely that desperation and alienation. I thought of Nan Goldin's anti-Sackler protests at the Guggenheim and the Met, intended to call out how the family's patronage of the arts was abetted by their involvement with the pharmaceutical industry, and I thought of the people I

knew doing harm reduction work in the nightlife scene in New York. Earlier that year, I'd started carrying a dose of naloxone in my bag, to treat emergency narcotic overdose, the blister pack of nasal spray nestled beside my chewing gum and matchbooks and house keys.

The trouble with leaving somewhere is that it means arriving, eventually, to some other place. No matter how far or long you go, eventually you'll arrive somewhere where you need to refigure yourself. My father had done it, leaving his home in Vietnam to attend a university overseas, before war broke out again in earnest and he learned he wouldn't be able to return home for decades. My mother's family had done it, as refugees, airlifted out just after the fall of Saigon in April of 1975. Through a string of refugee camps, first in the Philippines, then Arkansas, she'd come to Portland, Oregon, where she met my father. And then they had me. A product of this political displacement, I've always been in this space of refiguring. I've never really felt I had a home, only places I've lived. I've always been aware of what my existence means, that my presence here—wherever *here* might be—is the result of an absence somewhere else.

When I arrived in New Mexico, I had to reconcile the fact of my presence once more: what it meant that I was here at all. I wasn't from here, doubly not-from-here: an outsider in a place where the impact of such displacement—a different era, a vaster scale—was still so clearly felt. Visiting the quaint, touristy areas, like old-town Albuquerque or Santa Fe, which had purposefully

avoided developing the patina of a cement-covered city that distanced you from the earth, it was impossible to ignore that the country I lived in—the only country I could imagine calling home, though maybe it wasn't home at all—was a product of ongoing colonization. It wasn't simply history, the way it could seem in New York, the Indigenous origins of the city buried in the name Manhattan. In the American Southwest, the architecture of the past had been preserved—even the Courtyard by Marriott was built in the style of the pueblos—which only seemed to demonstrate ever more clearly how the violence of Western colonialism continued to cannibalize from the cultures it had overrun.

It was visible on maps, too. The small green swaths marked as Native American reservations that only served to emphasize how much had been taken from Indigenous people. And it was visible in the ongoing forced poverty and violence against those who lived on the reservations, especially Native women. It even showed in the cynicism of the old-town Santa Fe tourism, where a platonic ideal of untouched Indigenous America was shilled, parceled out in silver jewelry and lumps of turquoise that, one seller quietly muttered to me, were frequently counterfeit, and had actually come from China. I couldn't blame the vendors for it, true or not—they were reacting to the tourism market, and what that market needed. I didn't say anything. But I felt the history of the place—of America—in a nearly archeological sense, my own political displacement scraped and layered, like the strata of the mesas, atop the displacement of the Indigenous people upon whose

land I now stood, the land of the Pueblos, the Ute, the Mescalero Apache.

It was my first time here, but I'd felt this feeling before: this cross-roads of my own displacement intersecting with the violent history of the country I'd been birthed in, my own complicity in its structures not always clear to me. What I felt wasn't guilt, not exactly, but a kind of close and fresh awareness of the history that had come to the surface and the inequity that was still present now. I knew I benefited from my own set of privileges—the privilege of movement, of visiting, of observing. I had come like O'Keeffe did—seeking open blue skies and the exposed ribs of the earth. And the space did provide. But what I encountered was even more than that—it was both the beauty of the landscape and the history bared within it. The least I could do, I thought, was to hold that knowledge, and let it complicate my experience in this place. To write about it, as I am writing now, however small these words might be against that history.

Ghost Ranch, when we finally arrived, was a sprawl of adobe buildings, with thick walls and modest windows to keep the heat out, the grounds peppered with Adirondack chairs for gazing at the mesas visible from every direction. Georgia O'Keeffe had kept a house on the property for years, but it wasn't open to the public, accessible only through a digital, video livestream. Instead, for curious visitors there were a series of museums—here a skeleton

of a dinosaur, there a remnant of a fossilized tree, both unearthed on this very site. Here, an educational exhibit, attempting to reckon again with the land's colonial history. There, two wooden Pueblo ladders, leaning against the adobe walls, symbolizing the relationship between the material and spirit worlds.

We went on a hike and I took pictures of the yellow cactus flowers in bloom against the bright blue sky. There was a library, too, in an old church, a book of O'Keeffe's paintings already open on a table, the way a dictionary might have been displayed in a different library—the spreads revealing abstract landscapes, papery-looking flowers, and cow skulls. I paged through. Outside, on a shelf, there was a stack of books, with a small box for pay-what-you-wish donations. At least, that's what I remember—there's no mention of a donation library on Ghost Ranch's website, and I can't find any pictures online. So maybe I stole it, or maybe I paid for it, but either way, I left with a copy of Roland Barthes's *Camera Lucida*, its cover a minerally, purplish blue, its pages sun-baked, and its cover stiff from exposure to the elements, the wind and the sand.

On the rest of the drive up to Taos I argued with my aunt about the new president and affirmative action and the lack of social safety nets for the Native people who lived on the reservations. I couldn't figure out a way to convey eloquently the massive, ongoing unfairness of it—that American imperialism had taken away a way of life, and centuries later offered no correctives or restorations. The answer lay in the land itself, I thought, which we were unwilling to give up—the land that was taken, that we

bled for resources and paved over with concrete. Our conversation ended unresolved, as many conversations with my family do. That night, I slept fitfully in the guest room, in a dry cool and rural darkness which I was unused to. When I woke up, there was a spider, which had lost one limb, its seven remaining legs splayed on the surface of my glass of water.

There's a fifty-mile gorge that runs through New Mexico, cut so deeply into the earth that when I first glanced over the edge, I almost wet myself. It starts near the Colorado border and stretches southwest down past Taos. The gorge is eight hundred feet deep at its deepest point, and in its switchbacks live bighorn sheep and prairie dogs and red-tailed hawks and mule deer, and the Rio Grande runs through its basin. The Rio Grande Gorge Bridge, just outside Taos, crosses over it. People keep trying to jump off the bridge, but no one really seems to know what to do about the suicide attempts—perpetually underfunded, the city doesn't have the money for barriers or other deterrents. I can understand why someone would want to jump: the bridge is long and the guardrail is low and the wind whistles in your ears. When we stopped there, even I was tempted to lean over and pitch myself into the basin of the river, which is so far below you that it feels as though it's not really of this planet, and I've never once considered suicide. On each of the viewing platforms—beneath which the earth drops the equivalent of eighty stories—there is a small machine with a button that connects you directly to a suicide hotline, and to drive the point home, graffiti above the starburst mouth of the speaker says things like *You are Loved!*

I am not sure if that would make me feel better if I were in crisis. It's possible it could. Later that day, on a hike, I saw a rabbit, small with huge and liquid eyes. It was hiding in a sage bush, and it let me come close enough to see its nose twitch. When I tried to take a photograph, it ran away.

A few months before my trip to Taos, I played hooky from work and went to the Guggenheim alone to see the Agnes Martin retrospective. I've liked Martin ever since my friend Annabel whisked me upstate to Dia:Beacon on my last day of finals, freshman year, then promptly left me alone in the galleries while she spent half an hour standing silently in front of an Agnes Martin painting called *The Beach*. I looked at the painting—a soft white ground covered in a delicate graphite grid—and I wanted not only to understand it but to feel what my friend was feeling. I couldn't imagine what could possibly reward such prolonged looking.

Born in 1912 in Canada, in the small town of Macklin in rural Saskatchewan, Martin moved to the United States in 1932 and worked as a teacher for several years, traveling through remote stretches of the Pacific Northwest, before deciding, at age thirty, to become an artist. After studying painting at Teachers College at Columbia, in New York, receiving her degree in 1942, Martin traveled frequently between New Mexico and New York City. In 1957, she moved to New York, where she worked alongside abstract expressionists and other artists in a studio on the Coenties Slip. It was

the beginning of minimalism, though Martin never considered herself a minimalist. After her good friend Ad Reinhardt's death in 1967 and the concurrent demolition of her studio's building, she stopped painting and drawing, traveled through the states, and eventually resettled back in New Mexico, on a remote mesa, once again picking up her practice in 1973, where she developed the method of the six-foot-tall, square paintings she is now best known for. She lived there until her death in 2004, iterating and reiterating the grids and gentle tones of her work.

What was there to explore; what was there to reward such pro-longed looking? From the thumbnails and the descriptions, one might think that Martin's work would feel cold or clinical, but it's the farthest from cold I can imagine. Her paintings seem simple at first: grids, stripes, and geometric shapes rendered in almost unbearably subtle colors, and by her later years, almost always painted on those square canvases just larger than an average man's wingspan. For me, it was how she answered the question of scale, how she asked a viewer to experience both near and far when viewing. From a distance, the paintings are serene. They appear thinly modified, the texture of the canvas visible through the painting; some even appear blank at first sight, as if just newly gessoed. The patterns Martin uses form an allover composition in her paintings, with no focal point—the eye roves across the surface, taking the canvas in as a whole.

Up close, though, the work takes on a different energy: you can sense her hand in every mark, in the thinly applied paint and the graphite lines that lay atop the canvas, and to me, at least, it's the

slight variations in line and surface that make the painting vibrate with feeling. It's not hard to imagine her with a brush or a pencil in hand, moving across her rectangular grid with quiet intention—indeed, that's likely why she identified not with minimalism but with abstract expressionism, relying on the gestures of the hand to tell the story of an emotion. Unlike my problem with the sky—which resisted representation—Martin dispenses with mimesis altogether. After all, why paint the sky when the sky itself is a stand-in, when you can instead paint the feeling you get when you look at the world and realize there's so much beauty in it that you haven't yet seen? Her paintings evoke subtle feelings, feelings that can seem trite—like Faraway Love and Friendship and Gratitude. But they are real; they are felt. They are even, astonishingly, earnestly, the titles of her paintings.

"When I first made a grid, I happened to be thinking of the innocence of trees, and then a grid came into my mind and I thought it represented innocence, and I still do, and so I painted it and then I was satisfied," said Agnes Martin in a 1989 interview. Martin's childhood was marked by the absence of her father, who died when she was two years old, and by a tense, emotionally abusive relationship with her mother, who wielded silence like a weapon. Biographer Nancy Princenthal suggests that Martin's idealism of innocence was influenced by her fascination with children, which could also perhaps explain, in part, why the artist spent her twenties as a teacher. Later in life, after achieving monetary success, Martin frequently donated to initiatives and charities that supported vulnerable youth and survivors of domestic abuse. Martin's mature abstract grid paintings, then, could be seen as an

ongoing representation of the childlike innocence that she didn't get to experience firsthand. Reading Martin in interviews, I was struck by her seeming serenity, which swoops from Zen Buddhism to Dadaist poetics. "Toward freedom is the direction that the artist takes," she said in a 1976 interview. "Art work comes straight through a free mind—an open mind. Absolute freedom is possible."

When I got to the museum, it was just an hour before close. The show was in its last days, too, and the Guggenheim was packed. Everyone was moving with what seemed to be a kind of hectic, fierce calm, as though demanding to be raptured. At the time of my visit, Donald Trump hadn't been inaugurated yet, but it was clear a steep and dramatic change was upon us. Approaching the ramp at the entrance to the galleries, I ran into an acquaintance I knew from going to parties downtown; when we caught sight of each other, he waved at me sheepishly. His lips were chapped. It was a Tuesday in January. "I left work early today," he explained. "I wanted to see the show before it closed." I hadn't even known he was someone who liked art. But we weren't friendly enough to walk through the show together, and I wanted to be alone for it, anyhow. We shrugged at each other, and I watched his dark coat disappear into the crowd.

Martin's work of the forties and fifties bears little resemblance to the carefully gridded paintings she's now best known for, though her palette then already held the colors she would consistently return to: grays, blacks, light washes of peach pastels, and gold. Her paintings at the time were described as biomorphic—the

shapes organic and curving, a visual vocabulary influenced by nature. Shapes float in space, their colors a warm dove gray; reddish black; brushy, thinned sienna brown. It was during her first stint in New Mexico, in 1946, that Martin grew close to Georgia O'Keeffe, twenty-five years her senior. The two shared a close friendship, with Martin looking to the elder painter as a mentor, even a personal hero; it was O'Keeffe who encouraged Martin to decisively explore her interest in abstract painting.

After returning to New York in 1957 at the behest of her dealer, Betty Parsons, with whom she would become romantically involved, Martin did delve further into abstraction. She worked alongside her close friend Ad Reinhardt, of the famous black paintings, and lesbian artists like Lenore Tawney and Chryssa, each of whom Martin also had relationships with, though Martin would never identify as a lesbian in her lifetime. At the Guggenheim, I pored over her paintings from this period, like *White Flower*, from 1960, a heavily worked, gridded piece, resembling woven fabric—perhaps inspired by Tawney's work—which foreshadowed the strict geometric abstractionist Martin would become. And I was struck by a bit of wall text that described the minute variations in her paintings: "I used to pay attention to the clouds in the sky," Martin was quoted as saying. "I paid close attention for a month to see if they ever repeated. They don't repeat. And I don't think life does either."

In early adulthood Martin was diagnosed with schizophrenia, bouts of which required hospitalization. Unlike Hilma af Klint, a spiritual foremother whose work would also be shown in the

Guggenheim, decades after her lifetime and just a few years after the end of Martin's, Agnes's voices and visions didn't inform her art-making process, but rather strictly dictated her actions—where to be, what to eat, what to own. Though useful for her career, New York wasn't good for her mental health: while living and working on the Coenties Slip, Martin was hospitalized on and off. In 1967, following a series of schizophrenic episodes, as well as the loss of her studio building, the end of her relationship with Chryssa, and Reinhardt's death, Martin left New York after a decade in the city, giving away her painting materials and disappearing into the American Southwest. Nobody knew exactly where she went. Then her story takes an unavoidably mythic turn: she resurfaced eighteen months later, in Cuba, New Mexico, pulling into a gas station and asking the manager if he knew of land for rent. As it happened, the manager did. From that point on, Martin stayed in New Mexico, where she developed her mature body of work.

It felt rhapsodic to walk through the Guggenheim in a slow, winding spiral, taking the work in as an extended series, the vocation of a lifetime. These days I love encountering a singular Martin painting in the wild, as part of a museum's curatorial hang, for example, recognizable immediately from a great distance. It feels like running into an old friend. But to see so much of her work, all in one place, felt like a kind of gift: of comprehension, a laying-out of patterns.

And Martin's drawings of the seventies, frequently thin black lines on a white ground, evoke sewing patterns or the ruled pages

of a schoolbook: the lines at regular intervals, set precisely by her hand, are carefully interspersed with geometric motifs—arcs, lozenges, triangles. There is the sense that one is standing before some kind of mystic language. Her paintings, in contrast, have a certain fluidity, a soothing quality that allows a viewer a gentler passage into the work. In each painting, the surface has been applied with a brush, lending to more gestural marks, though Martin's movements are specific and minute. She's said to have worked quickly and meticulously, throwing out canvases if a drip or stroke was improperly applied. *The Islands*, a series of paintings that she completed in 1979, demand especially close looking. Cool blue tones hover over frosty white, the two hues barely indistinguishable. At first, the paintings seem impossibly blank, with that blankness further emphasized by their arrangement in series. Then, as your eye travels across the surface, shapes form in the variation of the thickness of the paint itself, suspended between her penciled grid lines. Once observed, you can't un-observe the textures and gestures—the paintings themselves teach a way of looking.

Martin's final painting, *Untitled* (2004), feels almost baroquely gestural in comparison, with a roiling fluidity that the artist never permitted earlier in her career. I wonder if, approaching the end of her life, she loosened her hand. A five-foot-by-five-foot canvas, divided into six equal parts horizontally, two bars of white are framed by two bars of slate gray. A wider wash of gray, double the height of the other bands but the same shade, stretches in the middle between them. The paint retains her characteristic thinness, but it's been applied in broad, almost drippy strokes, which

ripple across the canvas; they have the feel of a stormy sea, or incoming rain clouds. It was the last painting in the show.

But there was one other painting of Martin's I was struck by, one that I kept returning to. I am returning to it now: *Summer*, from 1964. It's on paper, done in watercolor and gouache, and scaled about the size of a large drawing pad, maybe a little smaller. Unlike the muted hues of many of her other paintings, it is blue. Not the blue of the sky, or the hazy cyan of the mountains in New Mexico, but a rich, lapis lazuli blue, a marbled blue with a tone of violet in it. A material blue, a touchable blue. It fills the whole square and even spills over in places: her brush has strayed over the outline. But it isn't evenly painted—the watercolor collects in areas, forming wavelike, swirling shapes, and the white of the paper shines through where the paint is most thinly applied. Inside the square, also, a gift: a grid, done in black ink, and inside each square, again a gift, a white dot of gouache. The crinkling of the paper is evident under the paint, the material yielding to the way it has been marked, and the painting is alive with beauty and profundity, each moment in it slightly different from the next, and as a whole somehow larger than the sum of its parts.

In *Summer*, Martin has captured the longing I feel when I think of the blue of distances I cannot close, and in putting it somewhere where I can see it, she closes that distance. Somewhere in there, too: a little joy, tempering all that wanting. It soothes my anxieties about mimesis, about replication, about what I fear is the ultimate failure of communication. Because if across time and

space I can still feel spoken to, by a hand reaching through that distance—if I can be moved and understood, then maybe I can make something myself that conveys an understanding. For that's something I've always worried about: that I keep making things that don't mean what I want them to mean.

Two years after the retrospective closed, I'd get a tattoo of Agnes's last drawing. A small, looping sketch of a potted plant, the lines shaky, as if done in ballpoint pen—more an idea of a plant than the plant itself, its species unidentifiable. It occurs to me now that, at the end of her life, she did return to the material, the explicable, and through the movement of her hand, make it inexplicable again.

Taos is a small town. There's not much to do except ski and eat green chiles and watch commercials for pills designed to alleviate the constipation caused by opiates. The inn at the center of town, residents say, is haunted, but they say it with a sort of pride. For my part, I'd told myself I was in Taos to write. I was trying to write, trying to close that gap between the mess of my own life and its interpretation. Mostly, I sat at the desk I had set up and thought about that distance, and the distance I had put between myself and the life I was trying to escape, and it seemed to me that home, so far away, had become blue, too. I missed it terribly—I missed even the idea of home. But it seems to me that if you are someone who leaves, then you must always be leaving, because

to stop leaving is to stay, which holds its own consequences. The space between staying and leaving, I think, is called longing. I had wanted to leave the place I knew, but that meant moving toward the horizon, toward the blue sky and the blue mountains, and now that I was nestled in their foothills, their colors so earthly to me, I didn't know what was worth making.

I did love the place, the exposed sculpture of the earth, the red clay and the hot, dry atmosphere. I loved the scrubby sage and crystalline light and the sweet mountain smell of the air. Outside the reach of the city I could understand why Agnes and Georgia and so many others had come to this place—there was something special, even transcendent in feeling so close to the land. But I felt blocked, somehow, in my own creative work. I opened and closed my blank document a thousand times, scrabbling at sentiment. I kept waiting to lift up off my feet into another, more spiritual plane, but my boots stayed firmly planted on the ground, my head consumed with earthly things, the space in the world I occupied and for which I was, however reluctantly, grateful. I didn't kill any more spiders, not even on accident. I drank water and went for hikes, where rabbits were just rabbits and pebbles remained pebbles.

I thought a lot about that Solnit essay, driving down the highways, our truck swallowing great distances as we sped toward a horizon that never seemed to come any closer to my comprehension. When I was asked where I wanted to go, I always pointed at the bluest mountains. I wanted to be *inside* that heartbreaking turquoise blue, not stuck down here with the mortals among

gray-green sage bushes and dusty-red ground; I wanted to be both there in the place and able to behold its beauty at the same time. I wanted to feel the way I felt standing in front of an Agnes Martin painting, where if you stand back you see one thing and if you get close you see another, and all it takes is leaning forward to fall into the details of how it's made and what it says. Of course, you already know by now that I never got to the blue place, that the world keeps turning and the horizon keeps rolling just out of reach, no matter how many exits you miss. When I got to Taos, I wanted the land to remain fantastic and cool, but get up close to anything and the light will change.

Later that long, destabilizing year, I would meet you at a music festival upstate. I didn't know you were an artist at first, but it made sense. On the last morning, still awake from the night before, we watched the sun rise over the lake. We were sitting close to each other on a bench; next to you, afraid to make contact, my eyes lingered on the reflections of the rushes in the water. When I think of mornings like that, mornings after parties, I always imagine a high, pure tone in the air, as though there's a specific sound that accompanies a new day beginning. Or maybe it is just my ears ringing. Anyway, that was when I fell in love with you, for the first of many times I'd fall.

Later, when we knew each other better, but not much better, we went to Dia. It felt like the kind of thing people in love did, and

I wanted to think that was what we were. And I wanted to show you the paintings I loved so much, as if it would teach you something about me, too. On the train up, I chattered happily about Agnes. I asked if you'd seen the Guggenheim retrospective; you said that you hadn't. You asked me if I'd seen the documentary about her, the one called *With My Back to the World*. I told you I hadn't.

But when we arrived we found that Agnes Martin's paintings were no longer on view. After being on display for over eight years, her exhibition had closed in March of 2017—the month I had gone to New Mexico. Instead, there was a new installation we could walk through, of fluorescent tubes between transparent panels, an homage to Josef Albers. And in the small galleries where I'd last seen Agnes's work there were now Anne Truitt sculptures and paintings, in sleek, slightly dissonant pastel tones. I admired them, but it didn't remove the sting. I remember being disappointed: I had wanted to show you the sublime. I had taken you to my blue, my bluest mountain, but the blue wasn't there anymore. I tried not to show my sadness, but I think you noticed anyway. That was the kind of thing you saw, even then.

We walked around and stood inside the Serra spirals, surrounded by the soft organic red of rusted steel. Oval splatters upon its surface the same dappled pattern as light coming through leaves. I took a picture of you inside one, its walls rising behind you like a wave. In the pale fall light, in that turned-over factory upstate, you touched one of the sculptures, big as a room. I watched you run your hand slowly along the metal, the way you touched me

sometimes. I tried to imagine how it felt, then, the patina of the steel on your palm.

One evening in Taos, as the sun was setting, I watched the stars come out—pinpricks of light that filled the sky like a saltshaker overturned. I went outside and looked up, pointing out constellations to myself—the Big Dipper. Orion and the Pleiades. Cassiopeia—at least, I thought it was Cassiopeia. It was so dark, I could see the stars between the stars, and even the darkness had a richness. I thought then of my senseless runs up that hill, and the late nights in the observatory trying to take photographs of nebulae and galaxies, and I wondered at why I had ever tried to capture anything up close, when a different kind of beauty emerged at this scale, at this distance. But maybe it was true that I needed both, the near and the far, in order to comprehend what I was seeing.

At night, anyway, I don't think about the way sun scatters and makes everything blue. Everything becomes as close as I feel it.

Body of Work

The bruise in Nan Goldin's *Heart-Shaped Bruise* could be anyone's bruise. A woman reclines on floral sheets, her face out of frame, on her side like an odalisque. Her black-and-white striped dress is pulled up above the knee, sheer black tights yanked down. Framed in the middle, as if between curtains parted to reveal a stage, is the photograph's titular bruise, high on the woman's right thigh. It is defined by its outline, like the imprint left on a table by an overfull coffee cup. One edge is beginning—just barely—to purple; the bruise is at most a day old.

The photograph can't show how the bruise will diminish, as bruises do, into blacks and blues. We won't see how the burst capillaries, like lace under the skin, will sour into greenish yellow and mauve. But we know that the bruise will move through a rainbow of colors, mottled like the translucent surface of a plum, until finally—weeks later, and no longer heart-shaped—it will fade back to the pink of healthy skin. We know that the bruise has long since healed: Nan Goldin took the photograph in 1980. It is an old wound. It exists now only as a memory—a mark destined to fade, captured before it did.

Every time I have a nosebleed I absolutely must take a photograph. I wish I didn't have this terrible, maudlin impulse, but as soon as I feel the jet of warm blood I'm in the bathroom with my iPhone, a self-serious self-portraitist doing my best Francesca Woodman until the little runnel of red hits the bottom of my chin. In fact, like any diligent art student, I photograph all my wounds—skinned knees, shaving cuts, any accident that excavates bright red blood. Bruises, too, have found their way onto my camera roll, captured from the moment I first notice their purpling presence and tracked until I've grown tired of them.

In college, when I was a sophomore taking my first serious painting class, I printed out *Heart-Shaped Bruise* on a department inkjet printer and taped it to my studio wall. It hung over me for a semester, that bruise, watching me work, forever the color of strawberry jam. I was drawn to the mix of beauty and pain, like watching the way butterflies settle on a carcass to taste the blood. I loved the detail of the model's fingernails, painted a matte silver; I loved the way her arm curved along the length of her thigh, how her hand tenderly cradled the bunched-up stockings at her knee. I loved the mundane, pretty floral sheets, the way the patterned black-and-white pillow rhymed against the striped black and white of her dress; I loved how all these touches gave the photograph a lived-in domesticity, softening the harshness of the flash. And, of course, I loved the bruise, the way I loved my own bruises.

There was the huge splotch of purple that appeared on my right knee after slipping on ice—I made a painting of it, swirling a wet brush across my palette to muddy the colors. Or the archipelago of love bites on my left thigh, left by an upperclassman I'd hooked up

with for years, even though every time we saw each other he said he didn't want to date me. But one night in his room he bit me, hard, and what I liked more than the pain itself was the mark it made after. It was proof: even if in daylight we ignored each other, the pink swelling, the capillaries bursting, the bruise itself was evidence that we had been together. That I was the one who wore that proof on her body only seemed fair. I was the one who wanted evidence.

There was the bruise on my knee, again, which grew impossibly dark, like a bar of iron, and perfectly straight, from tripping on the patio of an apartment building, my first month in New York. I measured the time I'd spent in the city by the amount it healed, until it finally disappeared and I knew the subway system. And there were, always, the daisy chains of love bites on the soft skin of my neck, some of which I'd asked for and many of which I hadn't. There were so many men, and so many who made me feel insignificant, or who would in the course of time become insignificant to me. Still, I filled my camera roll.

And there were other bruises, later, that served as testaments to the way I pushed my body in pursuit of incandescent pleasure-pain. Braided rope marks down my arms. Violet streaks, very close together, from a bamboo cane. The baby-pink blushing that followed a leather paddling. Of course I took a picture. I always did.

Was it the memories that I loved, or the fact that they had left a mark? The photos were important to me, the way photos are always important: as evidence. Here I was, a wild thing; I had experienced something, and that experience had become visible. *Look at it!* (How often does this simply mean *Look at me!*) But this

kind of documentation falls victim to what Sontag calls "time's relentless melt": a photograph can only ever be proof that time is passing. By the moment the shutter clicks, it's already over.

Francesca Woodman died young, leaping out of a loft window. Her photographs and her story are her legacy to us. It's all too easy to make an icon of her—her beautiful face gazing forthrightly into the camera, her shapely body, her long and tousled hair. In some images she looks at us; in many others, she looks away, shielding her face with hair or props, or fragmenting it with a reflection in broken glass. She once photographed herself nude, with clothespins pinched all over her torso. That she remains such a tragic, saintly figure—that her story can so easily be turned into shorthand for a kind of beautiful suffering—makes her pictures all the more appealing. They are strewn all over, in low resolutions, on Pinterest, thumbtacked by young women like the young woman I've been, trying to find a home for their hurt in hers. But of all her images I'd rather linger on her long exposures, the camera's eye staring for thirty seconds, maybe more. Crouched in empty rooms, in corners, her body in these becomes blurred, fugitive even, impossible to pin down.

In her essay "Grand Unified Theory of Female Pain," Leslie Jamison writes of having an ambivalent relationship to pain—the twinned desires of wanting to dwell in the wound, to make art about it, from it, while also dreading being perceived as a woman who lingers in her own suffering. "The boons of a wound never get rid of it; they just bloom from it," Jamison writes. "It's perilous

to think of them as chosen. Perhaps a better phrase to use is *wound appeal*, which is to say: the ways a wound can seduce, how it promises what it rarely gives."

When I think about the promise of bruises, I think about Caravaggio's painting *Bacchus*, from 1595. The young god reclines against a background of thinned umber, one marble-hard shoulder uncovered, a pink nipple exposed. His right hand holds his robe together; his left extends toward the viewer, offering a glass of red wine, the goblet's bowl so exaggeratedly wide that the liquid threatens to spill over. Tempting though Caravaggio's Bacchus might be, with his one eyebrow suggestively raised, I'm less interested in his baby-faced flush than I am in the succulent bowl of fruit, placed in the painting's foreground. Though it's full of figs and quinces and pears and grapes painted that lush, mouthwateringly translucent way that grapes in still lifes are always painted, Caravaggio subverts our expectations: every piece of fruit is rotten, spoiled, or bruised. A pomegranate, gashed open, garnet-red seeds spilling out, seems a likely target for Jamison's idea of a metaphysical wound—"A wound marks the threshold between interior and exterior; it marks where a body has been penetrated," she writes.

That's one kind of wound I know. But I'm drawn to the rotted golden apple next to it, to the bruise that covers most of its surface in deep sienna tones. It looks soft, heavy, like it would yield instantly at a touch—I could reach in with my finger, poke through the waxen skin to feel its insides, mealy and deliquescent. I remember from an undergraduate art history lecture that the bruised fruit is supposed to represent the sins of excess and the hastening toward death that decadence implies. We're supposed to crave

the fruit, then, realizing its decay, be repelled by it. But I'm not repelled.

When I was sixteen, a musician I'd started talking to on Myspace told me I should join a new platform that was just starting to become popular. It was called Tumblr, he said, and I seemed cool, and I might like to start posting there. Post what—it didn't matter then. There was no one to impress; not at the beginning, anyway. It was 2009. The platform was equal parts moodboard and blog network: a casual, homey place where diary entries and selfies and terribly out-of-context quotes from books streamed down my dashboard, interspersed with digital scans of people's film photographs. I thought myself a poet then, so I put my poems there; I drew, so I put my drawings next to my poems. And there I started to keep a diary—to date, still my life's most consistent project, what would become a five-year chronicle of my days.

Online, to an audience of first hundreds and then thousands, I wrote about the things that were new to me then. First crushes, first kisses, first boyfriend, first awkward fumblings in the dark. The first time anyone ever touched me below my waist: two fingers, slipped up the leg of my shorts, finding the soft places. A revelation.

It was the era at the end of twee, approaching the age of new confessionalism, which carried with it that sweet, melancholic angst that can feel so self-indulgent to step inside. My online cohort had put down Stephen Chbosky's *The Perks of Being a Wallflower* and turned to Plath, to *Ariel*, to her handwritten drafts on pink paper, which we posted on our blogs at regular intervals, as though it was our way of showing up to church. We were sixteen, seventeen,

eighteen. We were feeling a lot of things for the first time. We were reading Murakami and listening to M83 and on the horizon was shoegaze, and Alice Glass, and the buzzy bass reverb of witch house. In the midst of all this, in the fall of 2010, I left Portland for New Haven. I stayed with my high school boyfriend, who—unnerved, perhaps, by the seventy-nine miles between our campuses and all the distractions that college implied—revealed a controlling side hitherto unknown to me, calling at eight thirty every morning, demanding to know if I was awake, if I had been out drinking, and where I had spent the night.

I didn't know how to explain to him that I was busy learning things, eager, hungry things about the world that didn't have anything to do with the version of me he knew. I had only just discovered how interesting and liberating it felt to spend the night in a place that wasn't my own bed, even if that place was someone else's couch or floor. I was learning that the night itself could be a rhapsody of possibility, a place where things happened, and I was so excited to become. But it became clear, each time we spoke, that he didn't want anything about me to change. He didn't want me to pierce my nose, or get a tattoo, or dye my hair. When I impulsively dip-dyed the ends of my long hair a deep turquoise green with a jar of Manic Panic I ordered online, I gchatted him apprehensively: *please don't be mad*, I wrote. *i promise it looks nice.* He demanded pictures, dispensed his judgment, writing: *at least it'll wash out later.* And I did think it looked nice.

I loved him so much, or thought I did. I didn't want to upset him. To avoid this, I wasn't allowed to drink or go to parties: those were the rules he had set, and which I had agreed to. I wasn't

supposed to stay out too late or have male friends. But when we video chatted, which still felt so novel then, we often fought, and it was in these instances I learned how to cry silently and without resistance, watching myself mirrored by the front-facing camera, letting the tears roll down my face. It was the first time I learned to perform my sadness. It is a skill I have retained.

One Friday night, near the start of spring semester, he called me at 11 p.m. We'd had plans to talk then, but I had gone out anyway. I was with my friend Nicki, somewhere on Old Campus. "Hello? What's that sound—are you out?" he asked me.

"Yes," I said, fiercely, like I was biting into a piece of hard licorice.

"Have you been drinking?"

"Yes," I said again.

"I can't believe this," he said, and for a moment, I was afraid, of how he would berate me, the way he had berated me before, but Nicki took my phone out of my hand and hung up the call.

"Enough of this," she said. "Give me your arm."

She wrote on my forearm in highlighter: "BREAK UP WITH YOUR BOYFRIEND." And the next afternoon, I did.

Nicki and I were in an art history lecture together, the introductory course full of hundreds of students that met in a giant lecture hall,

covering the Lascaux caves through the Renaissance. We were in the same discussion section, too. I noticed her because of her dyed red hair. We both liked the TA who was leading our section—we liked her pretty, apprehensive smile, her creative assignments and long brown hair. It was in that class that, exhausted from late nights out and my mind always elsewhere, I dozed through lectures about Greek sculpture, chiaroscuro, Caravaggio's bruised bowl of fruit.

Jenny Saville's monumentally scaled, impressionistic portraits are characterized by an awareness of the heft and fleshiness of the body—its damages, its weight. Her subjects sprawl, perch, and press their bodies together, their forms Rubenesque and smushed and, in her paintings of animal carcasses, flayed. In Saville's layered oils, each stroke seems to have a planar existence of its own. Though her work is firmly rooted in the history of figurative painting, Saville's interest is not in beauty but in the burdens of the body: she investigates the problems and movements of flesh. While still in her early twenties, Saville grew famous for her paintings, which received early comparisons to Francis Bacon and Lucian Freud. After attending the Glasgow School of Art, immediately after graduation, at age twenty-two, she was approached by Charles Saatchi, the patron of the Young British Artists movement, who offered to pay her to work full-time on a show of her paintings, to be exhibited in his gallery at the end of the year. Financially free to paint whatever she wanted, Saville dove straight into the life of an artist, where she has remained ever since.

In *Stare* (2005), an exploration of a motif she's returned to multiple times, Saville renders an androgynous young person's bloodied face, the canvas tightly cropped around the head, painted in deep reds and blues, flecked with light. The subject's bruised lips and bloody cheek—a fall? a fight? worse?—take on a flattened, luminous quality in the painting, making the portrait both viscerally upsetting and strangely unreal, as if digitized. The painting is unnervingly violent; it's also beautiful, majestically so. How did such harm occur? We meet the subject's gaze, unable to look away.

I lied earlier, when I was telling you about how my high school boyfriend and I broke up. It wasn't an intentional lie, but a misremembering, or a proxy, as Brian Blanchfield might call it.

That scene on Old Campus is how I remember it playing out—nearly a decade later, I can practically conjure the chill air outside, the decisive snap with which I said to him, "Yes." Didn't I tell him that? Didn't I tell him yes, I was out, and drinking? Wasn't that my great act of rebellion, even though I was scared, because I was sick of being scared?

But it seems that in my memory I wrote a different story than the truth of what happened, which is that when my boyfriend called that night, I lied to him and said that I was still at home. That I couldn't talk because I was busy with Nicki, though she really did write in highlighter on my arm. It was only the next day, over gchat, that I confessed. *you're going to hate me for this*, I typed.

I only realized I had remembered wrong when I went to check my email for the archives of our conversations. *i was already a little drunk, and i knew you'd be mad*, I'd written to him.

A funny thing happens when you're always writing, when you begin to narrate your life as you live it. The crisp, fat braid of the story begins to overtake the impressions of memory—and it's true that was partly why I kept a diary, to pull a sieve through the disorganized world. Not so different from any other writer, and it's true that, like so many other writers, I wrote first for me.

But in any text the self is performed, a persona crafted. On my blog, I found, I was creating that character, a girl who wasn't quite me. She performed her pain and performed her joy, and I wrote through her, I was of her, but she wasn't entirely of me. I knew the difference, but it didn't seem that anyone else would. I felt guilty for writing only my version of the story, but not guilty enough to stop. I didn't think I was wrong for it: my version was the only version I knew. My boyfriend and I fought about that, too.

In any case, I forgive myself for lying earlier. It was my own sad story, and I wanted a better, more powerful ending from it.

After I realized my misremembering, I started going back through all my old conversations with my high school boyfriend. Maybe I went back too far—I'm surprised at how frequently I see myself pleading, asking to video chat, asking him to talk to me, to look at me. To see me.

Following the thread of one particularly catastrophic conversation, I find a photograph I'd sent him late at night, after an argument.

> *Monday, September 6, 2010.*
> 10:32 p.m.
> me: look, i'm sending you an email.
> that way you can see my face.
> i think you need to see it.
> now i want you to have this conversation with me
> and i want you to look at that photo

In the picture—and it feels hysterical, that I sent a picture, but it makes sense to call it hysterical and that I sent it also makes sense—everything is grained over with the purply green of the 2010-era MacBook photo booth app. Framed in the middle is my seventeen-year-old face, sans glasses, puffy and backlit. The wall of my freshman dorm room is a sickly yellow, my skin an unearthly mix of violet and pinks, the color balance all warped by the photo booth camera. There are two light sources in the room: the sour overhead light and my computer's blue screen, which must have been on my lap, shining its harsh glow onto my face. Unlike the stagey selfies I'd learn to take later, carefully measuring out the reveal of features and tongue, I'm looking at the camera in this image, not away. I am surprised, looking back, to see that there are no visible tears.

The crying wasn't the point. It was my massive sadness and, more than that, my frustration that I wanted to show. Taking the photo

was my proof, but taking the photo did something else to me. It wasn't just proof; it became performance. I chose to do this. I wiped my face. I opened the camera. I made a picture of my pain.

Today at my desk I open that photograph—*Photo on 2010-09-06 at 22.32.jpg*—side by side with an image of Saville's *Stare*. Again, something of the hysteric in this gesture, but the images do compare. The shiny reddened nose, the eye contact, the choppy bangs: I had gotten a bad haircut right before I left for school, and it worried me that I wouldn't feel enough like myself to make friends. Even the three-quarter angle of the portrait is the same, left ear— my right, flipped by the front-facing camera—exposed. The puffy mouth with its sliver of teeth showing, something wounded-looking about it, each the same.

I find myself a little jealous of Saville's *Stare*—that the subject's pain is so visible, rendered in vivid colors on their face. It makes me feel silly, but I still want it. My portrait doesn't have that immediate evidence, those literal, bloody marks. If you're looking, you'll see my pain, but you won't see it if you don't look. Or maybe what I mean to say is that you won't see it if you don't know—or refuse to know—that I'm hurt.

How much of an image lives in the story behind it? In what I know about the circumstance of its creation, which a potential viewer doesn't?

When I sent it to my boyfriend, he wrote, *well honestly, you look pretty bad, but I have seen you worse.*

it was a joke, he added.

some joke, I wrote back.

It wasn't the response I wanted. All I wanted was for him to *see* me. To understand how he had hurt me, and how that hurt had left its movements on my face.

After we broke up, I pierced my nose in the spring, straight through the septum. Its shiny circular barbell made me easy to spot. Because of it, men began to notice me, and I wrote about it—about how prickly-proud and pretty I felt with the heat of their gaze upon me. I went to parties and I wrote about it and I lost my virginity to a near-stranger I no longer speak to and I wrote about it and then once that gate had opened I slept around, a lot, and I wrote about it. The project of my blog exploded, halfway between confessional and hagiography, a constant race to keep up with the ways I was learning to be perceived. It wasn't as though there weren't mistakes. There were mistakes.

The guy I have sex with for the first time ever, he tells me: I was wondering if you'd have a sideways pussy.

No, I'm remembering wrong. That didn't happen to me. That happened to a different girl, and she told me about it. He does tell me, though, that I'm like opium. I'm so, so dangerous. To him, anyway.

In an art history seminar in the spring of my sophomore year, I read about Kristeva's theory of abjection. The space of the abject is a cast-off, rejected space, a space where boundaries break down—between self and object, the self become object. By then it had become fashionable among my cohort online—young, feminist, self-aware sad girls of color—to talk about sex using the language of critical theory. The theory itself wasn't new, but its sudden accessibility enabled by Tumblr's sharing culture meant its popularity was cresting. We read Edward Said's *Orientalism*, Chandra Talpade Mohanty's critique of western feminism, and Gayatri Spivak on the subaltern. We posted block quotes online and reblogged one another with our interpretations of the text and the ways we saw it applied to our own experiences. I was drawn to the potency of the language—by how this kind of theory necessarily looped in on itself, grappling with the limits of speech, describing ways of being and reacting in staggering contours that nevertheless, at times, rang emotively true to the experiences I'd felt. I admit this is how I've always treated theory: panning for the parts that feel true to life, looking less to challenge my perspective than to find new ways of articulating it.

All along I'd had the sense that something was different about the way men treated me, different from the free-spirited adolescent romances I'd grown up watching and reading. No one had told me it was going to be different for me. That it would feel so much harder to be loved. I felt crazy for not understanding.

But it was through reading these texts, which articulated what I hadn't thought to claim as actual, that I arrived at a way of

understanding my position. Sometimes, though no one ever asks, I say that it was moving to the East Coast that led me to understand that I was raced—to understand that the gaze upon my body bore the effects of a system far larger than me. I could no longer think of myself as a neutral subject; no one was, and in that realization there was a kind of relief. Emboldened by my reading, I began to consider my own Asian-Americanness, and within it to draw a distinction between being East and Southeast Asian, finally acknowledging the effects of being a repeatedly colonized subject—the ways women who looked like me had been degraded and degraded. Because I was emphatically a brown girl fucking, I related to the term *abject* so much that I made endless puns about it: *abject permanence, abject story, abject of your affection.* For that was how I felt, melodramatic as it was: cast-off, objectified. Kristeva was the spotlight that illuminated my condition.

That April I showed up at a boy's house with a bouquet of roses, but by then whatever we had was already fading. What I remember: my knees digging into the nubbly orange carpet of an auditorium. A few weeks later, he broke up with me in an email. I am an archivist; I have kept it, but what he says about me is so honest and so cruel, I still can't bear to read it.

"[IT'S NOT ABOUT RACE]," I wrote once, in an essay, trying to parse the patterns in my relationships. "[IT'S NOT ABOUT RACE. I CAN'T TALK ABOUT THIS.]" But it was about race, even if I couldn't quite articulate exactly how, even if I felt crazy for trying. It was incredible to finally have the vocabulary, a way of theorizing around my experiences—it made them

explicable; it made *me* angry. Through Tumblr, I'd been drawn to other Asian women like me, who had come to third-wave white-feminist sex positivity expecting the same sort of liberation and been startled by men's capacity for cruelty, or worse, indifference—cruelty meant they cared enough to hurt. Reading Mohanty ought to have warned us. But we weren't strangers to pain, anyway: we'd read Sylvia Plath together; we'd taken pictures of our bruises. We'd been dumped by men who would go on to date white girls with nearly indistinguishable haircuts. My friend Leila, Southeast Asian like me, described herself in a blog post at the time as a haunted woman, a ghost of a woman who teaches someone how to love without being loved in return. That was where we saw ourselves consistently falling: acting as a stepping-stone on the way to wholeness, clinging to the scraps of affection that we tried to reassure ourselves were signs of more to come. But they never did come; not to us, anyway, not in those grasping years. We saw in the relationships that followed our own how fully the men we'd chosen *could* love; it was that they didn't choose to love us.

And yet I was never repelled enough to stop trying for love. Never repelled enough to turn away from desire, which was pain's arbiter. It was something new, and something to write about. I wanted to be known even in my abjection, to be witnessed by an audience in order to be certain that what I felt was real. Then—how easy is it to fall headlong—it became a way to be. The self I'd been architecting through my writing took the story of pain—now racialized, now gendered—as its scaffold. If I was to be wounded, then let me be a wounded woman. I would wear it.

If you cannot love me, then will you please, please, please just touch me?

Sometimes, when I think about these years of my life, from nineteen to twenty-two, I picture those twinned seed pods from maple trees, the ones that, when thrown up in the air in handfuls, come whirling down like helicopters. That was how it felt—an exhilarating race to the bottom. My pain was pain, but my pain made me interesting. It offered a way to become.

In an interview from 2005, the same year she painted *Stare*, Jenny Saville considered her changing relationship to the formal content of the body, the subject she'd painted her entire career. "I have moved from the anatomy of the body to the anatomy of paint," she declared. She called it a pathology of painting—the strokes themselves became the flesh and the subject. "That is how I see it. Spaces within the body of the paint are what interest me now." From the body itself to what the body can hold. The way it's said. The way it's shown. But I notice that her subject matter from that era—dissections, pig carcasses, images of torture—still retains that violence, even if her interest moved to the workings of the paint itself. Her compositions are more abstract than her earlier portraits, the application of color more loose. But I'm not sure Saville really left the body behind, though maybe it was useful for her to think she had rejected it. Our wounds do follow us, even when we think we've abandoned them.

Writing this down now, I'm reminded of a conversation I had with someone recently, after a dinner party. We were standing in a circle on the subway platform, talking about love. He'd just started dating someone, a bit younger than all of us, and he was

surprised at how little it took to delight her, how outsized her reactions were to the simplest things. "She said no one had ever bought her dinner before," he told us. "No one had ever gotten her a present before. How crazy is that?"

Not that crazy, I thought to myself. It happens all the time that people aren't nice to girls.

Hurt someone enough times, and she begins to feel like a hurt person. Jamison comes to mind again: "The ways a wound can seduce, how it promises what it rarely gives." It was easy to lean into that pain, the sickly sweetness of rotten fruit. To consider myself unlovable because no one was loving me the way that someone should be loved. It never occurred to me that it could be any other way.

While doing research for an early version of this chapter, I found a website dedicated to the Catholic saint Gemma Galgani. Galgani was canonized in 1940, just thirty-seven years after her death at age twenty-five from tuberculosis, making her canonization one of the church's fastest in history. Perhaps they rushed because there was much to idolize her for. Known as the "Daughter of Passion," Gemma was famous for her deep mysticism. She experienced mysteriously appearing stigmata, was said to have levitated, and was frequently struck by states of ecstasy so intense that she was mocked for her mystical ardor. And she was unrelenting in her own practice of self-flagellation—in her imitation of the Passion of Christ.

One of the pages in Saint Gemma's web shrine shows an image of a knotted rope—not a relic but a replica, realistically streaked with blood at the points where the knots would have dug deeply into her skin. The image feels prurient: I wonder at the webmaster who thought to include it. Looking at it, I imagine the knots pressing against my own stomach. I press two knuckles deep into my side to see how it feels. Nan's photographed bruise. Francesca pulling at her flesh with clothespins.

It wasn't only Gemma who flagellated herself so. Saint Catherine of Siena fasted to extremes, eventually living only off the daily Eucharist; Saint Hedwig walked to church in her bare feet, leaving bloody footprints in the snow. Saint Teresa of Ávila performed mortifications—punishments upon the body as a practice of spiritual discipline—so severely that they caused her to become ill. Yet she seemed inexorably drawn to that mystic pain. When she had a vision of an angel piercing her heart with a lance, she described it as such: "He appeared to me to be thrusting it at times into my heart, and to pierce my very entrails . . . The pain was so great, that it made me moan; and yet so surpassing was the sweetness of this excessive pain, that I could not wish to be rid of it."

Pain purifies, the stories say. Pain cleanses. Pain is proof of god in the body—the stigmata written in blood. The bruises become holy; Teresa's ecstatic agony sculpted by Bernini. The artifacts—the testaments, the knotted rope—live forever in a museum, online. Before there was Saint Gemma, or Catherine, or Hedwig, or Teresa, there was Saint Lucy, who died in A.D. 304, often depicted in paintings as holding her eyes on a plate. She tore them out herself, the legend goes, in order to discourage a suitor who

admired them. The wound is its own meaning: the manifestation of unwavering belief.

I don't like that I love reading about Saint Gemma and her mortifications. There's something cloying, even embarrassing about how I'm so drawn to her pain. My cheeks burn. I find myself greedy for descriptions of her punishments, nearly voyeuristic—I scroll to the bad parts, the worst parts, the harshest rituals and tools. What she used: A knotted rope she tied tightly around her waist. An iron scourge with which she struck herself. A belt studded with sixty sharp metal points. I want to know—how *far*? How far did she go?

Years before I ever learn about Saint Gemma, I go home with a friend after a party somewhere. He's a grad student in a department I'm not a part of. He tells me that I'm one of the best people he knows, and also that he will never sleep with me. Both things are true. Then he gives me a cough drop, ties me up in his bed, and spends the rest of the night doing things to me that aren't sex, that hurt, that crack my world right open.

"The practice of mortification is a means of curing bad habits and implanting good ones. Penance is making reparation for one's sins (and even the sins of others), and these practices come in two forms, ordinary and extraordinary." So muses Saint Gemma's webmaster, seeming to have his own penchant for mortification.

The morning after that long night, I felt like someone had taken the top off my head, letting my entire brain show to the world. Skinned. I was beautiful/I was dirty/I was beautiful, and I was

capable of so much. The breeze blew between my legs. I felt lit up from the inside, full of perfect and shameful secrets. I would cure my bad habits. I would implant good ones. It was like losing my virginity again, but better—I knew something no one else around me knew, and that was that being hurt could feel so, so good.

That semester I checked out all the books on BDSM I could find, putting down a list of holds at the university library. Georges Bataille, the Marquis de Sade, Anaïs Nin: all the classics I'd found from looking on the internet. *Techniques of Pleasure*, by Margot Weiss, for the anthropological approach. Like my earlier forays into critical theory, I went about this new development in my sex life like an earnest academic. I read Bataille sitting on Cross Campus, wearing a short skirt, feeling the heat of the sun on my legs. I liked that no one else could tell what I was reading, though I hoped someone would look over and see. Maybe they would know then I had joined a secret club. Something hot and liquid was forming in me.

I liked being called a good girl, a bad girl, someone's girl. (All I wanted to do was totally surrender.) I liked the heavy, underwater place that submission put me in. It was like sinking into a cool, deep pool. Everything moved so slowly, and I could experience every sensation, until I became something small inside the sensation, surrounded completely. The stinging slaps, my arms wrenched behind my back. The pink streak developing on my ass. I liked taking it. I liked the way taking it made me relinquish control.

A flogger is the same thing as a scourge. The shape of the object has not changed for centuries. When I write "an iron scourge,"

as in the object Gemma used to punish herself with, I picture a sturdy handle, with leather thongs emerging like the pistils of a flower, and iron beads at the end of each strand.

I don't believe violence is inherent to us, but I do believe it is inherent to our vocabulary.

There exists another photo of me in pain, one I like much better than the one of me crying, aged seventeen. This one, taken five or six years later, is a black-and-white photograph of me getting flogged on a Saint Andrew's Cross at a dungeon in New York City. Part of the frame obscures my face, but you can see me smiling, hugely. My teeth are showing. I'm ecstatic. My wrists are restrained, but the rest of my body arcs to meet the whip.

When I look at this picture, I think, PURE JOY, like that painting by John Baldessari. It is joy. I think I believed, at the time, that it was pure. But I think since then I've learned other meanings of *pure*. Other meanings of *joy*, too.

Along with her physical mortifications, Saint Gemma was said to have fasted nearly constantly, like Saint Catherine, and slept sometimes just an hour or two each night. Though everyone encouraged her to eat, she frequently refused, burning with "the desire of practicing penance to master herself and her senses." At meals, she took soup with a spoon "that had holes in it, so as to let it appear that she was drinking it, and then when she thought she was unobserved,

she took her plate to the kitchen." Reading over the descriptions and the meticulous ways Gemma attempted to avoid eating at all—which were almost certainly embellished with the passage of time and with her canonization—I think to myself, she sounds like an anorexic. *Passion* was one way to rationalize or encourage it.

"Whenever I read accounts of the anorexic body as a semiotic system," Jamison writes, "or an aesthetic creation, I feel an old wariness . . . They risk performing the same valorization they claim to refute: ascribing eloquence to the starving body, a kind of lyric grace. I feel like I've heard it before: The author is still nostalgic for the belief that starving could render angst articulate."

Starving brought Saint Gemma closer to what she thought was the spirit. When I was younger, starving did something similar for me, too. But for me it was about approaching that flat, calm plane of control, not the spiraling heights of spirit. So much was out of my control, but here, in the closed loop of my body, was one thing I could manage. I never liked having an eating disorder, though at times I certainly liked the restrictions that restricting built around me—the way each day dropped into a tight, focused battle with the self. Either way, it was an impulse that arose in me, and which I found I either had to kill or nurture in order to survive. Its framework could make *me* make sense; it also threatened to undo my entire bodily system. Sometimes, when I killed it, it came back and I had to kill it again.

In an anthropology class in the winter of 2013, I feel I've recovered from my eating disorder sufficiently to do an ethnography

of pro-ana—that is, pro-anorexia—bloggers on Tumblr. I qualify this ethnography with a sizeable body of existing research, which classifies the anorexic's relation to her condition most frequently as ambivalent. Not apathy, but ambivalence in its truest sense: she both loves and hates the condition. This lines up with what I find in the texts of the blogs, some of which reject the label *pro-ana*. The writers express a desire to recover along with a desire to succumb. Succumbing is more seductive—the old, nostalgic wound again. Despite my best efforts, I succumb, too. While writing the final, I have a relapse, don't eat for two days, and only turn the assignment in when the professor, concerned about the deadlines I've missed, asks where my paper is.

When I used to write about my relationship to anorexia, I tended to retreat to metaphor. It was a *worm*. It left me *hollow, scoured, cleaned of mucous contents*. It was a *fire*. It was a book set aflame, and I was both the fire and the paper. Because I believed it didn't have anything to do with how my body looked, I felt, at times, like there was something more regal, more holy about my condition, as though its removal from my body reduced the amount by which I was abased.

I regret this, and I regret writing about it that way—with poetry. It was a way to make sense of a thing I found lived inside me, but I regret trying to accept it by making it beautiful. Though this is something we all do, cope by aestheticizing our pain.

I'm thinking of someone attending to a wounded animal, or a child. So *what hurts, then? What hurts?*

Once, a guy I was dating asked me to help him throw up. Crouched over the toilet, he said, "Punch me in the stomach." I told him, I don't want to, put your fingers in the back of your throat, and he said, "You'd know about that, wouldn't you," and I reeled back with hurt, and I didn't punch him, and he didn't gag himself. But he did throw up and it was all red wine and it was still red.

In my early twenties, I made paintings about my pain. Obliquely, sexily, like a sad little ballet dancer making a moue over her shoulder. Among them: a pink canvas shibari-tied with red rope. An orangey-purple bruise, livid against tan skin. A photo transfer of a selfie with a hickey the morning after a hookup, glazed in sour greens and streaks of chalky white. An abstracted painting of my wrist, a hair elastic striping across the faint trace of two scrapes— there were wounds in the paintings, wounds everywhere. I titled them in all caps. I guess you could say the paintings themselves were bruises of a different kind—another way of taking, or making, evidence.

Some of it was political, wrenching with other people's desire: I was an Asian woman, a yellow body, a brown body, a fuckable fetish fighting against the label. My hypersexual paintings were a way to call it out while playing the game. (Johanna Fateman: "It's no surprise that for a lot of artists, gaming the system is more appealing, or simply more feasible, than changing it.") It was an erotic system within which I felt myself ambivalently entwined—I liked being wanted, but I was always suspicious of why I was desired. Rather than turn the whole thing on its head—I wasn't brave enough to make myself ugly or undesirable—I thought if I

could take control of my pain, if I could own it, I could become a woman with agency. It wouldn't matter if I still hurt. At least I'd be able to describe it.

In my research on the eating disorder blogs, my most salient finding was that the bloggers—no matter their relationship to their disorder—crave agency. They aren't victims; they're subjects.

Around 2014, maybe 2015, the preferred term to refer to a person who has been sexually assaulted becomes *survivor*.

In 2015, too, I encounter this line in Maggie Nelson's book *The Argonauts*: "But somewhere along the line, from my heroes, whose souls were forged in fires infinitely hotter than mine, I gained an outsized faith in articulation itself as its own form of protection." I liked to see someone else say it. It meant that articulation had protected her, too.

Five years after I made the last of those paintings, long after leaving New Haven, I'm laying naked in bed with you. Telling you about the way I came to be the way that I am, or the only way I used to think I could be. "I still can't tell if it was because I was Asian and men didn't take me seriously as a romantic interest, or if I was just dating bad guys," I say.

"What do you think?" you ask me.

I roll over, showing my body to you. Suddenly I don't want to talk about this. "Oh, a little of column A, little of column B," I say insouciantly, like it's funny. But it's not really that funny.

●

That the beginning of my career writing in public coincided with the development of my sexual abjection is not, I think, a coincidence. In the mid-2010s, the dominant mode by which a young, hungry writer could *enter the conversation* was by deciding which of her traumas she wished to monetize. The struggle—be it anorexia, depression, casual racism, or perhaps a sadness like mine, which blended all three—was described lyrically, articulated through the lens of a recent book or film and hung out to dry. For this, I was paid the industry rate of $150. It was 2015, and everyone was a pop-culture critic, writing from the seat of experience. Representation mattered, and we had our grievances, shaken free by a new, easily accessible language of social justice. I write about it cynically now, but all of this was important—to shifting culture, to creating literature, to developing a shared language toward describing a better world.

The problem was that I, along with so many others, was doing it for the first time. The process required us to bare ourselves, with little in the way of material or emotional protection. We were confessionalists again, but instead of one another, our audience was the world at large, eager to hear tales of flagellation.

Pain resonates. Pain is an unlocked room with the door shut: it paid too much to stay away from the source of it, so I kept walking

in. For online outlets I wrote about heartbreak and about systemic racism. About my struggles with mental health, about my eating disorder, about casual sex, glorifying my methods of coping, which became, in itself, a way of coping. At times the disclosure did feel like bravery, and I believe that it was deserved. Other times, I keenly felt the cynicism of it—selling out some minor trauma for a byline and a news peg. And in all of this I found yet another framework to lodge my pain inside, another way to show off my bruises, more lucrative than any online diary or camera roll.

It was, and is, tempting to dwell in this close, sticky space, to crave being hurt, to glorify the wound, to want to stay interesting and close to the flesh, poking at the bruise. As long as I have my pain, I know that I can feel something. As long as I have my bruises, I can show that my hurt exists. To stop being hurt—no, to stop calling yourself a hurt person, I've realized—means accepting a different way of existing in the world, a new one, with different challenges.

I worry that in writing this down, I'm showing you the ways I made myself abject. But it was useful before, and I've never liked the self-help books where the writer comes across as holier than thou, already healed and already recovered. I want to honor the girl I was, whose pain was real. It's her I write for, too.

It's not actually that fun to look up photographs of floggers or bruises, unless shopping for sex toys at Purple Passion. A search

for "photos of bruises" doesn't generate Tumblr-ready Goldin photographs or Saville paintings but lessons on how to take images of evidence of domestic violence. This evidence is important when filing a police report, or for requesting an order of protection—in states other than New York, it's called a restraining order.

(BDSM is the blow with the blow removed. "The playful nip denotes the bite, but it does not denote what would be denoted by the bite," writes Gregory Bateson in *A Theory of Play and Fantasy*. But to appreciate the pleasure of the bite, the violence of its origins must be reckoned with.

Violence is its own shadow side. The dark side of cruelty is more cruelty.)

In January of 2016, I begin a six-week crisis hotline training at an anti-violence agency in New York City. I'm there because I've realized I want to help people—that even though I'm not a social worker, there are ways for me to support survivors. I feel so strongly about doing this work that I almost feel selfish for volunteering.

In one training, we're learning about intimate partner violence, and what it means to have a dynamic of power and control in a relationship. This is to help us better understand the situations in which our callers contact us. One hypothetical scenario sketches out a dire relationship between a woman and her abusive partner, a dynamic that's only reinforced by their financial precarity and constant proximity to each other.

"Why can't she leave?" I ask in class, then quickly correct myself. Every day she stays makes it worse. But we already know why she doesn't go.

(The violence of the bite's origins can be reckoned with through a safer, sanitized violence. For this reason, social workers are encouraged to have an understanding of BDSM dynamics and practice, so that they might be able to tell the difference between consensual kink and abuse.)

Heart-Shaped Bruise isn't the most famous photo of a bruise that Nan Goldin took. That would be *Nan One Month After Being Battered*, from 1984. There is no strawberry-jam pink in this image; it is not the kind of photograph that lends itself well to tiling as a Tumblr background, a form in which I once saw *Bruise*. Instead, in this self-portrait, Goldin looks straight ahead, her curly hair gleaming, crimson lipstick impeccably applied. It looks fresh; you can see its sticky shine on her lower lip. She wears a dark dress, its details lost in the high contrast of the flash. On her face, the focal point of the image, her expression is resolute. Eyebrows thinly plucked, two perfect arcs. Her right eye, its white the unblemished cream of milk, has a deep purple bruise beneath—healing still; the edges are yellowing out. Her right eye, in its wholeness, becomes ever more perfect compared to her left, the white of which is a terrifying shade of scarlet, suffused with blood. A nebula of bruised skin surrounds it, umber and brown ochre.

I cannot look away from this photograph. Her bloodied gaze demands mine. She looks directly at the viewer, her expression

carefully composed, as though presenting evidence. Which the photo truly was: Goldin made it, a month after being beaten by a former lover, Brian, so badly she was nearly blinded, in order to remind herself of what had taken place. Of that particular relationship, Goldin has said: "I craved the dependency, the adoration, the satisfaction, the security, but sometimes I felt claustrophobic. We were addicted to the amount of love the relationship supplied . . . Things between us started to break down, but neither of us could make the break."

The image is from Goldin's epic, *The Ballad of Sexual Dependency*. Originally conceived as a series, the photographs are most frequently shown as a slideshow in which, ordered loosely by theme, the images appear on a screen in a dark room while music plays. The effect of this viewing experience is that the images arrive next to one another, each informed by its neighbors, and by the songs in the background, just like a playlist: Nico, The Velvet Underground, James Brown, Dionne Warwick. The photographs appear in a particular, intentional context—not like the way I removed *Heart-Shaped Bruise* earlier, placing it on my studio wall.

As a whole, *The Ballad of Sexual Dependency* asks the viewer to recognize the entirety of the world Goldin has observed—the sex, the love, the beauty, and, arriving as an emotional climax to the series, the very frank depiction of her pain. In its forthrightness, her self-portrait stands as a counterpoint to everything else I might want to say about her, or, perhaps it's more accurate to say—anything that I might want to say in her stead.

Because I took *Bruise* out of context to write my own story about it. I wanted it above me, as some kind of spiritual mother to my work, but I took it out of the entirety of the experience that Goldin had intended to display. I wanted the aesthetic of the bruise but not what the bruise denotes. I wasn't ready to look at the real, which Goldin insists we confront in her image.

Within the series of photos that make up *Ballad*, Goldin's self-portrait asks of its audience an impossible calculus: to witness her happier memories of her relationship as well as the darker ones, nearly side by side. One seems like it must cancel out the other—as viewers, we must either deny the relationship or deny the abuse. But a photograph isn't an argument. It can simply be, the way a depiction of pain is just that: a depiction. It's up to us, as viewers, to grapple with how we consume the pain of others, how we process our relationship to woundedness.

And I'm doing Goldin a disservice, too, by trapping her in time like this. I'm holding on to what she represents to a culture obsessed with wounds and bruises, unable to witness her healing. These days, Nan Goldin is known more for P.A.I.N., or Prescription Addiction Intervention Now, her ongoing advocacy campaign in response to the opioid crisis and her own experiences with drug addiction. P.A.I.N., which has specifically targeted the Sacklers, the art-world donors and the family responsible for the widespread use of OxyContin, has led actions at the Met, the Guggenheim, the National Portrait Gallery, and the Louvre. In 2018, Goldin led a die-in at the Temple of Dendur, located in a wing of the Met named for the Sacklers. When she gave the sign, protesters threw hundreds

of orange pill bottles into the temple's moat, then collapsed to the floor. The pill bottles floated, empty—little oblong shapes on dark water. As of 2019, the Louvre has removed the Sackler name from its galleries. The Met hasn't made the same change, but in 2019, it pledged to stop accepting gifts from the Sackler family.

I'm guilty of romanticizing her pain because it meets my ends. Every time I go back to that photograph—Nan's bloody red eye staring out—I'm refusing to acknowledge that love could ever look like anything other than this. For Goldin, the portrait was a reminder to never go back. Sometimes, lingering in my own wounds, I'm not there yet. I've kept Goldin a hurt person, the way I've kept myself hurt. But Goldin took her pain and made something useful of it. She opened the room of pain, its unlocked door.

●

Here's one promise of a bruise: it heals. A bruise is a way of witnessing: one has endured a blow and survived. It disappears once flesh has been knit back together. In some ways, a bruise is the inverse of photography, or any kind of art making. Art preserves; bruises fade. Once I could get past saying, *I hurt*, I realized I had so much more to say.

In recent years, Jenny Saville has taken breaks from painting to make drawings—large-scale, heavily layered images of bodies overlapping, limbs and breasts and faces breaking through. The drawings in *Erota*, her 2016 show at the Gagosian in London, are

stenciled, erased, drawn in pastel and charcoal and erased again, the impressions of each gesture leaving a patina on the canvas. "Some sort of human scribbling," Saville described it in an interview. In the pieces there's a sense of motion, of a soft evolution—the movements of two figures in bed; the changing shape of a body over time, layered over in Twombly-esque smudges and scribbles. Saville hasn't abandoned oil paint completely, but in these drawings, as in the drawings of many painters, we are allowed to see her hand more sensitively, without the thick, buttery flesh of paint as its vehicle. It's a kind of vulnerability, and a generosity in that vulnerability, the way she's opened up her hand. "I can't say I'm wiser; I'm probably more foolish," Saville said of this new work. "But I think I've accepted that making things that are beautiful is interesting, whereas before I was not interested in beauty at all."

I first thought about calling this chapter "Swan Dive." It felt apt for that plunging, thrilling sensation—that giddy feeling of cascading down, down, down. I liked the association with swan song, that last, desperate call.

Sometimes in my life I've thought I wanted to free fall, just to see how far I'd go, how deep I could descend before I hit rock bottom. There's something so appealing about coming unhinged, about not stopping the process of falling to pieces. But I never let myself let go that freely—there was a little part of me always holding on to the lip, the edge of what was possible.

A swan dive, in swimmer's parlance, is a dive that begins with the arms outstretched and ends with the hands together, pointed forward. But swans don't dive; swallows do. The way swallows do it, it's like surfing on air—they glide on currents, their bodies made for staying constantly suspended in flight. When they dive, they dive acrobatically, skimming close to the water and pulling away, soaring into the air again.

They never fall. It's not a fall.

Today I have *sensitive* tattooed in script above my right elbow, an impulsive decision I made with you. Sometimes I skim my fingertips across it, feeling where the skin is still raised. All the bruises I've gotten over the years have sunk back into my skin, the capillaries absorbed, the flesh healed. The photos remain, and I do love them, but their beauty isn't solely in the suffering. What I needed most from my bruises, after all, was not to know that I had acquired them but to know that I had endured.

Crush

"what's the point of a crush that doesn't ruin you"
—@clare

1. To apply Claude Lévi-Strauss's linguistic anthropology, a crush is called a crush because it crushes you. A crush is distinct from friendship or love by dint of its intensity and sudden onset. It is marked by passionate feeling, by constant daydreaming: a crush exists in the dreamy space between fantasy and regular life. The objects of our crushes, who themselves may also be referred to as crushes, cannot be figures central to our daily lives. They appear in the periphery of our days, made romantic by their distance.

Crush can act as both a noun and a verb: "You are my crush"; "I am crushing on you."

Crush can be both subject and object: "You are my crush"; "I have a crush on you."

According to my Google searches, the first recorded instance of the use of *crush* in a romantic sense, to mean "a person one is infatuated with," is from 1884, in the diary of Isabella Maud Rittenhouse. As in: "Wintie is weeping because her crush is gone." By 1913, it had entered usage as a verb.

2. Early October. The days are cooling in New York, and I am in my orange skirt, saying to you: I have such a big crush on you. Crush isn't a word that adults are supposed to use. But it feels right, because you make me feel like a teenager. I'm listening to pop songs. I'm reading love poems. I'm a dog with its head out the car window—a drooly cartoon of happiness. My emotions feel outsized, unwarranted, when I slow down to think of how little I know about you. Not much. You're five years older than me; six between our birthdays. You keep your hair short, wear plain T-shirts. Somehow, though you don't even believe in luck, you have chronically bad luck. It's okay, I say. I can be the lucky one.

We hold hands walking over the Manhattan Bridge, stopping in the middle to look at all the rushing water. I say: You make me want to make you a mixtape. I say: I want to spend all my time with you. It's a desire so strong it feels annihilating; this part, I don't say. I'm greedy for this contact, want to be filled up with it, but at the same time it's embarrassing—how obsessive I feel. It's too much; I'm too much. I can't tell you.

So I shut up. My hand in yours: this is all I'll ask for. The sun is setting over the East River, the sky bleeding into

candy-sweet pinks and oranges and shimmering gold. It's cold now, and both of us are underdressed. Wind whistles through the chain-link fence and I take a picture of the sunset through its mesh.

For the next two days, I repeat your full name in my head, over and over, like a mantra. Like I'm preparing to introduce you to someone important to me. I am crushed, utterly; I am crushing myself, compressed into feeling, feelings for you.

3. It's a crush because it's not real. Not yet, not maybe ever. I'd be content to spend forever in this liminal, cresting place, the interval before we know each other.

But then you throw a wrench in my plans. You say to me, I like you. This is your way, I've learned: you are honest in all things, and for the first time, I'm incredulous. It seems a small admission, but it's so surprising to me, so open and genuine, that I cover my face like a shy child. You were supposed to be the object of my affection, and I the one projecting feelings—I didn't know how to respond when you turned out to be a subject and showed you have your own.

I'm not normally like this, I want to explain from behind my fanned hands. But you've threatened to see me.

4. The Greek poets often used melting as a metaphor for eros, Anne Carson writes. As in: *Eros, loosener of limbs*, where Sappho invokes both the goddess and the languid, heavy

feelings of erotic desire itself. "Alongside melting we might cite metaphors of piercing, crushing, bridling, roasting, stinging, biting, grating, cropping, poisoning, singeing and grinding to a powder, all of which are used of eros by the poets, giving a cumulative impression of intense concern for the integrity and control of one's own body," Carson continues, in her work *Eros the Bittersweet*. "The lover learns as he loses it to value the bounded entity of himself."

Carson's lines suggest the idea that we learn our boundaries by losing them—that the breaches of the body that desire imposes remind us that we have a body at all. But that doesn't seem to explain my own willingness to give up. Even now, writing this, I read Carson's list of verbs and accept what they wager, racing toward eros headlong; it seems like a reasonable exchange for something destined to interrupt my body anyway. Go ahead and grind me to powder: it hurts to wait.

I'm curious now, though, about a word Carson uses—*concern*, which implies a fear of loss, and instilling that fear, a care for the self I didn't have when we met. For I was never afraid of dissolution by desire, not the way the Ancient Greeks put it—I wonder if they weren't truly afraid of eros, but if describing it with violence was simply a way of honoring its power, the same way they venerated their other gods. But I don't know what comes after, once I decide to let desire have its way with me. How to unmelt the melted? How to turn the ground powder back into a person? This idea points to a knowledge that I don't have: how to love without losing the

self. It's this I struggled with, when I first met you—the reconciliation of those feelings beyond first blush.

5. The first time I meet you, you're standing on a hill in the blue-gray light, shaking the sand out of the bottom of a tent. In the dusk, I'm lost, and you look like home—handsome in a denim jacket, shaking the sand out of the bottom of a tent. I'm embarrassed when I finally greet everyone, cold water sloshing in my shoes, explaining I slipped into the creek at the bottom of the slope. Later, you'll tell me your first memory of me was of me falling.

Our mutual friend tells me I have two options for where to sleep. I can sleep in the storage tent, next to the handles of tequila and the cooler full of snacks, or I can share a tent with you. Up where we stand on the hill, I can hear the music already starting, a low, intense beat that moves across the water. I ask if I can share with you. Sure, you say. It is what opens the door.

No—not the sight of me falling, but the knowledge that I fell.

6. Carson theorizes that eros as the Greeks understood it arises as a product of literate societies, writing: "It is in the poetry of those who were first exposed to a written alphabet and the demands of literacy that we encounter deliberate meditation upon the self, especially in the context of erotic desire." She suggests the intensity with which these poets insist on conceiving eros as *lack* may reflect, in some degree,

that exposure: "Literate training encourages a heightened awareness of personal physical boundaries and a sense of those boundaries as the vessel of one's self. To control the boundaries is to possess oneself."

This makes sense to me—that becoming literate requires conceiving of a self, blocking out the distractions of the outside world to focus on the life of the interior. Suddenly the mind becomes a realm, too, a landscape with vocabulary and topology, and to give life to one's thoughts means giving them a life outside of one's head.

But I can't imagine telling you how much space you take up in my thoughts. In these early days, I'm crushing like a lunatic: in my most deranged moments, I believe I would erase my whole future for a future with you. Of course—it seems so easy to exchange one unknown for another. But I can't *tell* you.

Is that the lack that Carson writes of—a lack of expression—or is it something different? Does desire always require relinquishing control? It seems that that runs counter to what I, absurdly, want—which is to long for you, silently, until you wake up one morning and know without being told exactly what I need and how to give it to me.

If I'm willing to lose myself in what can be said without words, it must be the voicing of my own feelings I'm frightened of. Or, no, it's the asking, and worse yet, the needing.

That's what paints me as a discrete and vulnerable subject, and opens me to disappointment—and that which is worse than disappointment, the kind of hurt I can't anticipate.

"For individuals to whom self-possession has become important, the influx of a sudden, strong emotion from without cannot be an unalarming event," Carson writes. "When an individual appreciates that he alone is responsible for the content and coherence of his person, an influx like eros becomes a concrete personal threat."

7. On the first night of the festival, close to dawn, after hours wandering the dance floor, I find you on the path to the campground. Now I'm not alone anymore.

Are you coming or going? I ask you. You're not sure, you say.

There's a tiny bit of light in the sky.

Let's go home, I say, and I don't know then how many times I'll say it to you, say it again.

In our tent, we crawl into each of our sleeping bags—yours is a spare of our friend's; mine is one with a broken zipper I've borrowed from an ex. We undress without looking at each other, moving clumsily in the dim, new light. Something about you makes me shy. I even keep my socks on; it seems all the cold of the night has pooled in the foot of my sleeping bag. None of this is normal for me. I should have tried to seduce

you already. Instead: G'night, I mumble, turning away so I can't see your face. Good night, you say.

In the morning—the sun steaming through the nylon of our tent, so bright I think I can see its heat rise off the floor in waves—I wake to see that you've tugged off your shirt in your sleep. You're curled up, still passed out, a deep red flush coloring your neck. It frightens me to see you so vulnerable like this. To see how quickly you seem to have given up your defenses.

8. Oh no, I thought then. Here you are, all of you, and before I even knew what I was doing, I'd already let you into my imagination.

Part of me wanted to put up a wall that day, to protect the self-possession of which Carson writes. What I felt for you was cause for alarm, but an alarm that was new and strange to me. I wrote earlier I wasn't afraid of the dissolution desire promises, and I don't believe I was, so why, then, was I so scared? To be crushed and stung, burned and ground—all those seemed like fair trades for physical intimacy. And if that had been all we'd wanted from each other I would have gone there gladly, but instead, that weekend, we never even kissed.

Already I could imagine myself disappearing; I could imagine myself changing, rearranging my life to make room for you. But I couldn't imagine you seeing me for me, the way I felt I'd accidentally glimpsed you.

9. The first night you come over, three weeks after we've met, I'm scared by how much I want you to want me. I'm drunk, too drunk; so are you. We've had too many whiskeys at the bar I picked because it was a fifteen-minute walk from my apartment—that was my plan tonight, to lure you somewhere close to me. But now that you're here and it's no longer a dream, I'm not certain what to do with you. I feel awkward and shy. My saving grace: you go to the bathroom, and while you're away I undress and lower the lights.

Earlier in the day, in an attempt to feel like an adult, I'd bought a fragrance diffuser from Muji, one of the ones that glows gently and puffs sweet-smelling steam. I'd lingered for almost an hour deliberating which scented oil to choose. To pick the one called Love seemed almost duplicitous, like I was trying to put a spell on you, and I wasn't sure I wanted to Love you like that anyway. I picked Smile. It felt gentle and safe.

That night, I lie with you beneath the diffuser in the dark as the smell of oranges and grapefruit and yuzu floats over us. It's beautiful and lush. It's like we're already dead in heaven.

And you want to kiss me and I want to let you but I'm still scared. I keep turning my head, dizzy with the spins, overcome with want and yet unable to articulate it. I don't understand how the night has ended up here. Why aren't you taking me— why aren't you pinning me down and doing whatever you want? Why are you giving me so much choice in this? You're looking at me, your eyes gleaming in the moonlight, and I can't bear you

being kind. I tell you I don't like kissing, but I'm lying. What I mean is that I find kissing too intimate. What I mean is I am frightened of descending into that soft, close place with you.

When I say I have a crush on you, what I'm saying is that I'm in love with the distance between us. I'm not in love with you: I don't even know you. I'm in love with the escape that fantasizing about you promises. Poisoned, stung, bit and bridled. The promise of being ground down until I disappear.

But that's not what you want. You won't remake me; you want to know me, and I am afraid to be known. I'm not even certain the self exists: how am I to know what you'll find?

10. That night in my room, I say to you, Maybe there are some languages that I speak better than others. I take your hand and put it on my chest to let you know what I mean; I want you to feel how soft I am. I want you to know the temperature of my skin.

Why didn't you say so before? you ask.

I didn't know how, I want to say. I wasn't brave enough. But I don't know how to say that either, because I'm not certain what I want—I keep vacillating, veering between extremes. The path you've put us on seems like too far to fall and I'm not ready to be that kind of vulnerable. I'm hoping then that you'll touch me instead, prove me wrong and take us to the place I do understand. That you'll fuck me, overpower me— anything to keep that distance intact between us.

Instead, you hold me. I want to get to know you, you say. We don't have sex that night.

11. Later, you told me you were surprised by me. By how shy I became. You knew me to be one type of person, one type of girl, and suddenly, in my bed, I was someone else, someone you didn't recognize. For my part, I felt as though something of me had been trapped in ice, inarticulate. I wasn't used to having to confront my desire, to say *I want, I want, I want.* I was used to dissociating, to closing my eyes and letting men enter me from behind, thrusting away while somewhere else my mind was in a place full of static.

But you wouldn't do that, and you wouldn't let me make you. You wanted to know where my mind was; you pulled me back into that small, glowing room with you, smelling of oranges. I wanted you to dominate me, but all you wanted was to understand me. We stayed there, in that place, for a long time.

12. In the summer of 2015, there was a Yayoi Kusama installation at the David Zwirner gallery in Chelsea called *The Obliteration Room.* This was two years before I met you. I saw the Kusama piece all over Instagram, the installation a prefab house full of white furniture, white textiles, white walls, every surface white as though some designer had clicked "fill" and flooded the whole thing white. White at first, I mean. Visitors to the room were given a sheet of stickers, colorful dots in varying sizes, to be applied anywhere in the room. As the exhibition went on, the room turned into an explosion of

scattered color, the surfaces confused by the optical mixing of the stickered dots. You could tell who had crested the wave early by the amount of white wall in their post on the grid, and people posed goofily in the installation, sticking dots to their cheeks, clothes, and eyelids.

People think of Kusama's installations as lighthearted and fun, which they can be. Many of her contemporary pieces lend themselves well to photographs, like her *Infinity Mirror Rooms*, which use mirrors and light to create the illusion of distance and make the viewer's own reflection the focal point, or her large-scale sculptural installations, which play with the scale of objects—chromed polka-dotted pumpkins, colorful tentacles, and giant spotted flowers—as they're set within a gallery or outdoor landscape. Her sculpture in particular feels poppy at times, outsized and exuberant. Yet in interviews Kusama, who has lived in a mental institution since 1975, is frank about how her work stems from her experiences with mental illness. "My art originates from hallucinations only I can see. I translate the hallucinations and obsessional images that plague me into sculptures and paintings," she said in a 1999 interview in *BOMB*. The visual hallucinations, taking the form of dots, are a repeated motif in Kusama's work. In applying stickers to the white walls and furniture, visitors are reenacting Kusama's visions, replicating them in a medium visible to all—each addition, inexorably, an act of accretion.

"Is your work a kind of art therapy?" asked the critic Akira Tatehata in 2000.

"It's a self-therapy," Kusama responded.

Later in the interview, Tatehata asked about the phallus shapes that cover Kusama's soft sculptures. "Is the imagery of phallus-covered furniture related to your hallucinations?"

"It is not my hallucinations but my will," Kusama responded.

"Your will to cover the space of your life with phalluses?"

"Yes, because I am afraid of them," Kusama answered. "It's a 'sex obsession.'"

Thinking about crushes, I'm interested in this contrast, in the difficulty of squaring the person of Kusama with the reception her art has received. How something so seemingly light can have the weight of anxiety behind it. I'm interested, too, in the terror she gestures at, the terror inherent even in the beauty of her pieces. How the fear of sex was folded into her work and made a hallmark of it; how the fear of disappearing into visions—of being *obliterated* by her dots—is embraced and transformed into something vivid and even more encompassing.

The images I've seen of *The Obliteration Room* appear playful at first, especially on social media feeds—the posing figures within the installation giving a sense of scale and humanizing the unlikely space. And it's true that as a project, it was originally conceived for children, a way for even the smallest visitor to become part of an art piece. But photographs of the

installation over time chart its evolution from polka-dotted suburban home to a strange and confusing otherworld, as the colorful dots begin to merge into an amorphous, overwhelming mass. The dots flatten the space, confusing surfaces—a chair blends into the wall behind it, and the wall into the floor; even the difference between near and far objects can't be easily discerned. The boundaries of discrete objects are visually erased: the dots become one shifting, colorful, annihilating field.

Describing this, I think of Carson again—how the lover learns by losing. Does the lack that characterizes eros appear again here, though the boundaries Kusama disrupts seem different? The colorful dots don't represent the intrusion of desire, which is just one way of breaching the self, but instead, perhaps, constitute a breakdown of the interior and exterior entirely—yielding to a total kind of loss.

I've often longed to be in a room like Kusama's, but I've never had the patience for the long gallery lines. The closest I've physically come to her obliterating fields are her *Infinity Nets*, a long-running series of paintings she began in 1958. Of all her work, it's these I'm most drawn to now. Ranging in size from a few feet square to the length of an entire wall, they're meticulous paintings of dense, abstracted nets, the curved, tight strokes seeming to create dots in the negative space between brushstroke and ground. The uniform width of the stroke and the flat composition—the nets fill the canvas, uninterrupted—speak to an obsessive hand. Yet there's no grid as there is in a

Martin, no regularity even in the repetitive stroke: each mark has its own logic and connection, the surface of the painting seeming to shift and writhe. In earlier paintings, the nets are all of one value, like white strokes on gray ground or red vibrating against green. In more recent works, like *Infinity Nets [MAE]* from 2013, Kusama adds gradated shading to the foreground painting, giving the nets a coruscating, organic depth, the surface looking more like lace or coral.

I like seeing how something is made—those moments when the hand of the artist reveals itself. It's why I painted; it's why I'm drawn to the churning surface of Kusama's nets, the tight, repetitive strokes that speak to the effort borne upon the surface. Like Martin's paintings, the *Infinity Nets* appear neutral from afar, but even more so than Martin, Kusama's gestures are coiled with emotion, with passion, and obsession, and fear. For Kusama is afraid of the dots, her visions. She chooses to encounter her fear forthrightly: "I paint them in quantity; in doing so, I try to escape."

Describing how she began the series *Infinity Nets*, Kusama said: "My nets grew beyond myself and beyond the canvases I was covering with them. They began to cover the walls, the ceiling, and finally the whole universe. I was always standing at the center of the obsession, over the passionate accretion and repetition inside of me."

I know Kusama wasn't thinking about the agony of desire when she was making these pieces about obliteration, but I

find myself drawing the metaphor anyway, that testing of the bounds of the self. For Carson, desire begets the creation of a self; for Kusama, the fear of shattering the self leads to the desire to possess that fear. As for me—I see how desire could obliterate me; I stand watchfully at its edge.

The crush exists at a point of distance. The less I know of you, the better, because then I can safely project my affections on you. I can begin to write a story, a catalogue of intimacies, a script that we will inevitably fail.

13. "*I am engulfed, I succumb . . .*" Roland Barthes begins *A Lover's Discourse*. "Another day, in the rain, we're waiting for the boat at the lake; from happiness, this time, the same outburst of annihilation sweeps through me. This is how it happens sometimes, misery or joy engulfs me, without any particular tumult ensuing: nor any pathos: I am dissolved, not dismembered; I fall, I flow, I melt."

When I first read these lines as a sophomore in college, I underlined *engulf, succumb, annihilation*. I was never much one for fighting feelings, and I recognized Barthes's ecstatic absorption. Yes, that was it, I agreed, down to the detail of waiting for the boat at the lake—that slim interval between inaction and action, when one's expectations have yet to be disappointed, is often so much more thrilling than the outing itself. But reading it again, eight years later, I'm surprised by Barthes's second sentence. His use of *melt* makes me think of Carson's interpretation of Greek eros, but there's no tumult

in it, he writes. He is dissolved, not dismembered—eros isn't acting as a threat to his bodily integrity. He won't go to pieces; instead, he peacefully disappears.

Is there a strange gentleness to Barthes's engulfment, which twins pain and pleasure? "The crisis of engulfment can come from a wound, but also from a fusion: we die together from loving each other," he writes. It's as though being a lover is the sole construction that keeps his self discrete. Without an object on which to project, Barthes's self dissolves: it is nowhere, no place. That part frightens me—this idea that desiring you might become my entire identity, my basis for a sense of self.

14. The word *crush* makes me think of an avalanche. How do those start? With a tremor in the ground, some fault in the earth that shifts its weight and sets the side of a mountain tumbling. Or something deep within the snow itself, the load exceeding the strength of the pack. After it's started, an avalanche quickly gains momentum, churning up snow and channels of air. It becomes a cohesive, inevitable force of its own, the dense head of the avalanche moving quickly across a vast distance, churning up a trail of lighter matter in its wake.

I've heard that a loud noise can set off an avalanche, like the bang of a gun or the sound of a horn—isn't that how it happened, once, in a movie?—but it turns out that that's a myth.

Wikipedia tells me an avalanche, like a rockslide or a mudslide, is referred to in geological terms as a mass-wasting

event. Other types of mass-wasting events include creep, slides, flows, topples, and falls.

15. One evening I meet you at your apartment in Crown Heights. You're making margaritas, halving and squeezing an entire bag of peridot-colored limes. I take a video of it on my phone—your hands around the enamel citrus juicer. You've made simple syrup; it's in the freezer. This, I am learning, is the kind of person you are.

And in bed I learn more about you. In my body, yes, I'm learning to let you be kind to me. But what's more important to my memory of that night is that it's when you first tell me about you. Your past and how you came to be, all the way to this moment, here, in this room with me, with the parquet floors and the window that looks out onto the street. I listen to your history, freely given. It's a gift you're giving me, this knowledge of who you are. I've never thought to tell someone about myself like that. But I want to tell you.

In the morning, you make us breakfast. You like your coffee strong, your eggs runny. Moving gracefully through your kitchen with its harlequin tiles. You're going to know me, I think. I want to give that up. I am willing.

Camera Roll
(Notes on Longing)

1. The most intimate photographs are photographs made at night, in the dark.

2. There are two ways to take a photograph at night. You can set the aperture large and the shutter speed slow. Opening the aperture gives the photograph a small depth of field, but it lets as much light in through the lens as possible. When the light hits the lens, it reflects, through a series of mirrors, onto the film, which is sensitive. The slower the shutter speed, the longer the light can pass through. This way, the film has more time to react to its presence, building up value; this is called lengthening the exposure. If you do it right—and you don't always know how it will come out—you will have an image, deep and luminous, with true blacks and gentle highlights. The shine on a wet eye; the glowing fabric of a white T-shirt; a lover's shy smile in the dark.

The other option is to use a flash. Here, you can keep the exposure short, the aperture small. Mount it on your camera

and, as the shutter is open, throw your surroundings into sudden brilliance. Like lightning through a window. This process creates shadows.

These are the two ways. One lets light in slowly. The other is a violation.

3. When you weren't looking, I took a photograph of you. It was quiet, and you were sleeping. That was the first of my many thefts. It was just—the light was so beautiful, and so were you in it. Low, everything: the bed, our scattered clothes, the level of light in the room. I stood in the doorway, carefully balancing my weight on the floorboards so as to not wake you. Looking at the curve of your spine, the hard, pure shape of your shoulders, the way the spotlight outside your window cast a perfect parallelogram on the wall. It was early days, and we were still tenuous and new. I slid my finger on the screen to adjust the white balance, trying to capture the dimness of the light, trying to render you in a way as perfect and real as the way I was seeing you.

 How little it takes now, with a phone camera. No aperture to adjust, no shutter speed. Just the image in an instant, forever if I wanted it. Which I might. I am referring to it now, though I have never shown it to you.

4. When I was twenty, on a friend's recommendation, I took a studio course in black-and-white film. You could identify our class on campus by the boxy 35 mm cameras that dangled

from straps about our shoulders. I carried my camera during the day too, but the outside world didn't hold a pull for me—I already knew I wanted to focus on human closeness, on what happened within the interior.

At night, in different bedrooms, I'd make photographs of my lovers. Our professor had warned us of the difficulty of making pictures in dim lighting, but I wanted to try to see what I could take from that lush, dark place. I'd set the shutter speed to at least half a second or more, holding my breath and steadying my hands to get the exposure. Mornings, when I found them, were different: the light flat, gray, no gold in it whatsoever. Short exposures then, and the aperture small, capturing every detail of the room. Days later, the roll done and packed with mystery, I'd rinse photo paper in chemicals and watch as faces rose out of nothing into the red light of the darkroom.

All year long, I made the same kind of photograph, over and over again. That's a kind of closeness: when you continue to return to the same thing. I'm not sure if it was because my subject was constantly changing, or if I saw it changing—those taut, intimate moments in bedrooms, the people in them moving close to me, and then away—and I never wanted it to change.

5. A photo I still recall: A man I'd been sleeping with for a few weeks, divinely beautiful, dozing in my bed. In the image, he's only half awake, one eye cracked open. His lashes are in focus; you can count each one, delicate as a stroke of the pen.

When I took the photo, he stirred awake, his face obscured by my sheets. It was morning.

Where's this going to end up? he asked. I didn't answer, and he fell asleep again.

Five years later, walking through the Morgan Library at an exhibition of Peter Hujar's photographs, I thought about that image I'd made. I hadn't seen Hujar's work before—no, I must have, but I hadn't known his name. Seeing his body of work at the Morgan I loved it instantly: the slow, searching portraits, his intimate relationship with the subjects laid bare in simple compositions. In each image there was a sense that life passed between them—that it was still in the room. Over thirty years after the images were first taken, looking at Hujar's photographs of the seventies and eighties, I could still feel it in the room.

The ever-serious Susan Sontag reclining in a turtleneck in a moment of repose; artist Greer Lankton gazing with wide, clear eyes into the camera; Candy Darling on her deathbed, glammed up under the hospital lights and surrounded by roses. Even Hujar's portraits of animals—a duck, a cow— were weighted with the serene gravitas of earnestly witnessing another living thing. That was what I'd always longed to do in my own work: to capture that searching, close feeling, to manifest forever that tenderness I felt when taking a photograph. The tenderness I still feel.

6. *Phōtos*, from the Greek, meaning "light," and *graphé*, meaning "representation by means of lines," translates, roughly, to "drawing with light."

And we have learned that light travels in straight lines, and that it retains the details of the surfaces upon which it reflects. This is how a mirror works—it bounces light from the world into your eyes. In a film camera, where the light makes contact is translated into a dark spot, as a result of the film's photosensitive coating reacting to the exposure. Where the light doesn't touch remains transparent. The result is a negative, carrying the details of all the light has seen: a landscape, a portrait, a still life.

When you print a photograph, you're using the information you have captured. You place the negative beneath a light and expose photosensitive paper to it. It's a projection; you see the image radiating through. The parts where the silver has built up don't let the light pass; the page stays white. The areas of shadow in a photograph: those are clear, on a negative. You can see right through.

My night exposures—the film for those was nearly transparent; tiny smears of silver marking a smile, a highlight on skin, white teeth. How little there was that had been exposed, and how tenuous.

How little of you had I captured? How little of you had you let me witness?

7. Photographing portraits, Hujar frequently had his subjects recline—on a sheet, on pillows, a made or unmade bed. To recline in front of a camera lens is an unusual, uncomfortable act, and it provoked different reactions in his subjects: some gaze forthrightly into the camera; others look away, subdued.

 In one of the portraits I saw at the Morgan, Hujar's lover-turned-friend and mentee, the artist David Wojnarowicz, leans on a mound of pillows, nude from the waist up. Wojnarowicz, twenty years Hujar's junior, appears frequently in his photographs, his long, distinctive face channeling a burning, fierce energy. In this reclining portrait, David's face disappears into valleys of shadow. The bright, contrasting light blocks its way across the planes of his face and arms: a searing sensuality. Behind him, the pillow seems almost a mountain, its softness made serious with shadow. Man as landscape. Wojnarowicz doesn't look at us, precisely, in this image—he looks past us, somewhere far away.

8. Was I trying to do something similar and more craven in my images, trying to trick intimacy out of those liminal moments—sunset, sunrise, post-coitus? Before the day changed; before we became strangers to each other.

 Another memory: another lover, an evening. That night, he took his guitar from the wall and played me soft songs. In the dim light of his bedroom, I took a photograph, a second-long exposure. In a quiet, dark room, a second feels interminable.

The shutter clicked—I've always loved that beautiful, dramatic noise—and we breathed again.

In the print, which I feared would be too dark to develop, there are lines of light along his arms, a highlight along a vein. Light along his nose. Tracing the hem of his ribbed undershirt, like a hand. The rest: shadows, sumptuous, dark and deep.

(In taking your picture, was I trying to capture you as you were, or to capture you as I *saw* you?

Perhaps the photograph was my defense. I don't know if I was always brave enough to see you for *you*.)

Sometimes I think about how in the photographic process we are taking old light and reflecting it from surface to surface, trying to preserve the information that it has stored. That's all we're doing in photography, moving light from place to place.

9. Speaking of the dark areas in photographs, of the velvety blacks and grays, which in our student darkroom were so frequently blotted out and overexposed, my professor would ask us, touching the print with his finger: *Is there information there?* If we cared to look, to try to bring it out, we could raise the shadows in printing by dodging, waving our hands beneath the light of the enlarger—allowing the details in darkness to emerge.

I always liked that idea: in darkness, information.

10. Somewhere in North Africa, in 12,000 B.C., a girl is watching an image of the landscape shimmer, vibrantly, upside-down on the inside of her tent. Outside, there are animals running: she knows, because she can see them. The light is coming through a tiny hole in its exterior, and the world streams through. When she opens the flap of the tent to call to her sister, to describe to her what she sees—a world captured!—the image disappears.

In the fifth century B.C., Mo Ti closes the door to his study. Through a crack in the wood, the light passes through, creating an image on the opposite wall: colors, upside-down, moving. He is enchanted by this remarkable coincidence, of the image's fidelity to the outside it has brought in. He studies it and records the phenomenon; he calls what he has discovered a "locked treasure room."

A hundred years later, a young Aristotle is making a camera obscura, though he does not yet know the entirety of what he is making. He is asking why—he is always asking why. He is watching the sun through a mesh of leaves, observing how the shape the light makes is circular on the ground. Again, information.

The astronomer Gemma Frisius is sitting in a darkened room, observing the eclipse of 1544 through a tiny pinhole. The shape of the sun is projected on the wall: the far becomes near, and so within the realm of human experience as to appear nearly mundane. Still, when the moon passes in front of the sun,

reaching totality, plunging the outside world into unreal darkness for sixteen seconds, it sends a thrill of excitement through him. The wire-thin outline of the sun visible on the wall.

Auvillar, France, 2012. I am nineteen, no Aristotle nor Frisius. I am studying at a monthlong painting and drawing workshop in the south of France, in a tiny village too far west for its time zone, so that the nights blend into evening and the sky remains a luminous phthalo blue as late as 11 p.m. When I come back from making lunch, on one of the last days of our program, our studio is darkened, the windows covered in cardboard, and when my eyes adjust, I can see the pale green shape of trees susurrating across the far wall. There is the parking lot, the edge of the garden, shimmering faintly as if in a dream. Two of my fellow students are outside, running in circles in the parking lot, to give us something to see inside our camera obscura. I see their legs, their swift, dappled shapes, and I feel so young, younger even, almost like I've never been born.

August 21, 2017, New York City. You are watching the solar eclipse through a pinhole you have made with a cereal box and tinfoil. You hold it in front of your eyes, like a pair of ski goggles that block out the world. Except, when you move your head, the tiny crescent of the sun moves, too, ping-ponging off the walls of the singular observatory you have made. This delights you, and you do it again, and again.

11. I was always nervous about unloading my camera, transferring the undeveloped film from canister to developing reel. It

seemed too fraught a process—there was so much I might do to disturb what was living on the roll. In the pitch-black of the locked reeling room I'd squeeze my eyes shut, fingers groping over each plastic canister until I managed to pop it open with a flat-head screwdriver, sliding out the film, trying to touch as little of it as possible. Quickly, now, hooking the film to the teeth of the reel, winding it into a neat spiral. I closed my eyes because despite growing up near the woods, without streetlights, I am afraid of the dark, and closing my eyes made my helplessness feel intentional. The task wasn't something I needed sight for, anyway, and if I thought too hard about it, I felt myself tense up. I'd make mistakes and have to start over, hands growing shakier as my anxiety mounted. To get anything done, I had to be mindless about it, like a medium channeling a spirit, moving my hands automatically, my body feeling pulpy and wet and loud in the silence of the room.

It wasn't the kind of dark I was used to, that cold artificial night of the reeling room. It wasn't anything like the soft moonlight grays of the interiors I liked to photograph, where the dim light selectively illuminated what I chose and cherry-picked to preserve. The reeling room presented a different kind of intimacy, one more alien and vulnerable: the closeness of my own thoughts; the inside of the body only I would ever really know.

12. But there was a reward at the end of this effort. After the film had been run through its parade of baths and the photosensitive paper exposed beneath the enlarger, what I loved most

was the drama of developing that first print off an exposure. Taking the paper itself—blank and white like a ghost, still holding its secrets—and placing it into a tray of developing chemicals. Slowly, as if by magic, an image appeared out of the fog, areas darkening and resolving into line, form, and shape.

I've never tired of this, of the way the image rises up. The texture of it sumptuous, the fine grain of silver nitrate, shiny under wet chemicals. Here, an eyelid, its oily sheen. The line of a jaw—the shape of the bones showing through under the skin. And now a face. Here it is, my memory, my old light, fixed in time. And sometimes—how quickly did things change—by that point we weren't even talking anymore.

13. Why did I take those photographs; why have I done it again? In critique, I said it was about combating the male gaze, about claiming desire back from men. But that was a lie. My eye wasn't possessive of people; it was only the closeness between us I craved. I knew I would lose it one day, and I wanted to make it visible, as though I could turn the way you touched me into a substance to hold.

14. I wasn't hard. I wanted to soften you. Bring your image up in a long, slow exposure to conjure how you looked at me in the dark.

15. When you make a picture of something, it's easy to think that you have captured the thing, and in doing so, captured

some kind of truth. "To collect photographs is to collect the world," wrote Susan Sontag. I'm reminded of that colonialist, vacationer's impulse—to take the picture of the seaside landscape and the picture of the impoverished children standing beside the road. The photographs that say: *Here I was.* But I think, too, about the kind of photographic claims that can feel akin to love: photos of weddings, of families, of babies beloved by their mothers.

"A photograph passes for incontrovertible proof that a given thing happened," according to Sontag. "The picture may distort; but there is always a presumption that something exists, or did exist, which is like what's in the picture." A photograph is proof that we were there. That I wasn't making you up inside my head. That's the trick of photography: it's so true to our image of the world that we believe it is *telling* it. Maybe that's why I kept grasping, looking for those moments in the moonlight, even while I knew that the story an image tells is still, in the end, a construction.

There is a utility in the fast fidelity inherent to photography. In journalism, photographs are essential to communicating the truths and horrors of the world. But behind each act of photographing is a series of choices that selectively illuminate a certain kind of truth about the world, too—to present it in a certain way. To turn the camera one way is a decision not to turn it the other. To turn the camera on a subject is to subject it to your interpretation of the truth. There is violence in it, and there has been violence often in it, but the violence arises

from where the subject disagrees with the story the image tells. There can still be love in photography, and tenderness in it, when making a picture allows the subject to really be seen.

16. Beginning in the 1940s, the Harlem-born photographer Roy DeCarava made pictures of the Black community—portraits of famous jazz musicians like John Coltrane as well as intimate, unstaged photographs of the ordinary people around him: a couple tenderly embracing, a young woman in a gown after her graduation. Though he initially began his artistic practice as a painter, DeCarava was taken by the flexibility and portability of photography and carried his 35 mm camera with him wherever he went, down busy streets and into domestic spaces. Within a few years after taking it up, he shifted his practice entirely to photography. DeCarava's photos aren't snapshots, though, as effortless as his mode might seem. He never orchestrated his images, but they still feel deliberately, elegantly played.

Looking at his photographs, it seems to me that there's still something of the painter in his approach, especially in his carefully framed compositions, which often feature a single figure or poetic gesture. The silhouette of the back of a woman in a 1960 photograph reminds me of Édouard Vuillard's women dressed in black; another image, from 1962, of a diner table setting and a coat hooked over the back of a chair, has all the moody seriousness of a Netherlandish still life or an Edward Hopper, one of DeCarava's inspirations, the ghost of a figure suggested by the coat's open collar.

DeCarava aimed, in his photography, to portray his community with art and grace. "One of the things that got to me," he said, in a 1982 interview with *The New York Times*, "was that I felt that black people were not being portrayed in a serious and in an artistic way." Making work in the midst of the civil rights movement, in an America that was still largely segregated, DeCarava was surrounded by photojournalists who documented protests and marches in the service of political progress—making images that were important, but necessarily essentializing; they served to uplift a single narrative. In his photography DeCarava saw the opportunity for something richer, something more tender, and honest, and complex: images of Black life as it was really lived. In 1952, at the age of thirty-three, he received a Guggenheim Fellowship, the first given to an African American photographer, and bolstered by the money he began to take pictures in Harlem full-time.

In 1954, he met the poet Langston Hughes, who served as a mentor to the young DeCarava, as well as many other young Black artists, and the two collaborated on a photo book, with text by Hughes, who had secured the publishing deal. The result, published in 1955, was a small black-and-white book called *The Sweet Flypaper of Life*, combining the fictional monologue of Sister Mary Bradley, a Black woman living in Harlem nearing the end of her life, with 140 of DeCarava's photographs. Sister Mary Bradley's peripatetic thoughts—about her family, her neighbors, Harlem's lack of front porches and the young people's craze for cars—are paired with photographs, a

few lines devoted to each page. The book is both an extended poem and a distillation of a moment, a hybrid of two mediums creating a roving, intimate portrait of Harlem, the neighborhood DeCarava and Hughes both knew so well. The collaboration with the well-known Hughes achieved commercial success, further allowing DeCarava to fully pursue his artistic practice. Through his lens, friends, artists, and strangers were all luminously, sensitively portrayed.

And DeCarava knew how light worked: how to light dark skin, how to adjust the aperture of his camera in a dim interior, developing and printing his images himself to bring up the details in the shadows. Where a darkroom technician unfamiliar with his oeuvre might have overexposed his images, DeCarava's control of the entire process allowed his subjects to subtly shine. As a result of this sensitivity, his photographs have an astonishing tonal range of grays—charcoal, dove, ash, sleet, slate—which gives his images a solemn richness. He wasn't afraid of this palette: he embraced it and its uncertainty, knowing the most important information in an image could often lie in the shadows. "When I want a picture, I don't care how dark it is," he said, in a 1996 interview with the artist Dread Scott. "I believe that if I feel something, and I have my camera, I should try to capture it. Even if I have to hold the camera still for two minutes, I will try."

In *Hand and Coat*, a photograph from 1962, a woman holds a herringbone coat over her arm—a warm day, perhaps too warm for the coat, the sun shining. Closely framed, her hand

is half-cupped, curved into a gesture reminiscent of a medieval Christ or a bodhisattva—a gesture of grace. The photograph is exceptionally balanced in its printing, meting out its grays to preserve the information: the tiny, detailed stitching of the dark dress the woman wears is visible even in the pool of deep shadow that fills the bottom right edge of the image. It's a mere moment in time—"in between that one-fifteenth of a second, there is a thickness"—but in DeCarava's hands the gesture is preserved with a slow, serene seriousness, like a dancer's moves, choreographed.

Or there's his portrait of the bassist Edna Smith, which I find myself continuously returning to. Eyes closed midperformance, lips slightly parted, her face is stilled with concentration, her fingers on the neck of the instrument an elegant blur, giving us a sense of the length of DeCarava's exposure—long, but not so extended we can't make out the shape of her hands, the ring she wears, the strength of her wrist. And despite the image's deep tones in the dim light, there's a sense of warmth, of the embrace of the night.

Edna Smith was known in her time as a musician, playing big band jazz and traveling with the International Sweethearts of Rhythm, an all-women band. Unlike DeCarava's more famous subjects, there's little recorded about Smith, one of many musicians who made up a cultural milieu and, for some time, a rare female jazz musician playing in big bands. Yet in DeCarava's image she's celebrated forever in this moment, as an artist, enraptured in the act of making. In the dark room,

Smith's face is beautifully lit: it is as though she provides her own radiance.

DeCarava rarely used flash. He didn't have to. He knew the image was waiting there, already in the room.

17. Before Hujar, before Goldin, before Mapplethorpe or Mann, it was DeCarava who took his camera into interiors—who understood the intimacy, the romance of making pictures in dark rooms.

18. That night in your bedroom, I was conscious of my theft. When I took your picture, I knew it was a taking—I didn't ask for consent to use your image, because I was afraid of what you might say. I don't think you would have said yes: not then, not yet. I took it for my own evidence, the moment one sentence of the story I was writing in my head.

You didn't know. I tried to claim you. There: the violence I mistook for tenderness. It was always my story, not yours; you were a figure in its landscape, and for that, I am sorry.

I think I knew at the time that there was already a lie that I was telling, or maybe a truth that I could only hold on to for so long. I wasn't brave enough to think that I could let the moment pass without documentation.

19. When I was a child, I used to want to yell *Stay!* whenever I was happy or excited. When I ate something I really loved at a

restaurant, I'd ask my parents if we could order another, just to have it, so I wouldn't have to worry about finishing it all and having none left. I was so scared of the moment leaving, I always wanted to grab its tail and make it last forever.

We never ordered a second order of anything—why would we, when there were just four of us, and money could be saved, and my brother and I were so little. And nothing stayed in place, not time, nor our faces, no moment remained unchanged. I love looking at old pictures of when we were small, but sometimes I look at them too long, and then I can't.

Here's the great problem of my life: I always want it to *always be like this.*

Yes, of course I'm bad at farewells, at goings-away, at thinking about death.

20. In *Ongoingness*, her diary that's not a diary, Sarah Manguso writes: "I started keeping the diary in earnest when I started finding myself in moments that were too full." She describes an evening at an art opening, where she "held a plastic cup of wine and stood in front of a painting next to a friend I loved. It was all too much."

Too much—that's how I feel so often, rendered agog by intense emotion. When I feel joyous, or content, or loved, it's as though I'll never feel so held again by the world—and right away, like the clap of thunder after a lightning strike, I feel

the fear of losing it. Manguso stopped taking photographs, she claims, because they reminded her of all the memory she was losing. But I take photographs for the opposite reason, to make those overfull moments stay.

I saw on Twitter a while ago that sometimes, when babies are really happy, they get overwhelmed and have to look away. It's not that they don't like you, it's that they just can't handle how much they do. The feelings are too strong, and their bodies are so small. It's called gaze aversion, that act of looking away. Why is it that I can hardly bear to be in a moment as it's happening, but I take a picture instead, so I can experience it that way? I'm so bad at being present. I puncture the moment right as it reaches its zenith—capture it, like a butterfly in a killing jar. Then, the photograph becomes a stand-in, pinned on velvet, for the feelings I didn't allow myself to fully feel.

21. A day at the beach. I'm taking pictures, afraid to look at you. I've never been to a beach in New York before, but I like you enough to go out to Rockaway, and I'm snapping photos of everything: the waves breaking, the flat horizon, the footprints a child leaves on wet sand. Hey, you say, gently. Be here with me.

I was glad that you said it, hoisting me into the now. Like how at clubs in Berlin, they make you put stickers over your phone's camera. I'm getting better at it—at not savaging my present. At breathing into the moment and realizing it won't obliterate me.

22. The fall I met you, we bought a disposable camera, a Kodak FunSaver meant for families going on vacation. But I don't think it ever left your apartment. We hardly did either, spending two, three, four days at a time together, surfacing from each other just long enough to inhale. There's one frame of the dunes at the Rockaways, from when you went surfing in October. In my memory, there's a palm tree in the picture, but that can't be. I think I'm just confusing my crush on you with California.

Mostly we photographed each other, studying each other's bodies with the intense scrutiny of new lovers. Our hands intertwined. You, lying down, your arms outstretched above your head. You in the shower, the white balance of the print all off and yellowed, smiling at me. There are so many pictures of me naked: standing in front of a sheet of gold foil, my reflection crumpled behind me; sprawled in your sheets with your come on my belly; on my knees above you, looking expectantly at the camera. You photographed me. I photographed you. Sometimes, one of us held the camera high above our heads, or wedged between us, and we photographed us together.

I loved the creamy gray light your room got in the mornings. The crisp rumple of your sheets. I loved how the photographs came out white and green and dusky orange, the colors muddled and hazy—I loved that we were building an archive of us, a catalog of all the moments we were seeing each other. At times, a lot of the time, I felt overcome by good luck. How

could I have fallen into something so delicious? It was like having ice cream every day. There's a picture of you from that first roll I especially loved. You're smiling, and I'm holding the camera so close to your face that your eye and cheek fill the frame, blurry and indistinct, fading into deep green shadow. It's an image of how it felt to be smiled at by you. Somehow, almost on accident, I caught that light. Now it's there forever.

In the pictures I have from my years in New Haven, there are rarely any where the subject actually looks at the photographer. That is, when I held a camera, no one ever looked at me directly, instead gazing down or away. All those pictures of lovers I like to remember are failed attempts at portraiture—failures at holding a gaze. But I can't tell if that's because my subjects were shy or if I was the shy one. If I didn't want their faces in the pictures because I was afraid of what they might say.

Something that still surprises me about analog photography: there are no pixels in it, not until the film is digitally scanned. It's not like a cell phone camera, where the information preserved depends on the camera's resolution, and anything smaller than a pixel disappears. On a roll of film, each note, each shade, each gradient comes from the homogenous material of the film itself—from the light it saw. I imagine that a strip of film must contain everything, every detail, every last impression of memory, if only I could develop it just right.

In one photograph I took, an image of your back, my finger is in front of part of the lens. In the print, the tones of your

skin and my hand have merged together completely, the grain resolving into one shape. In life, we were separate objects; on the flat surface of the film, we became joined.

Hey, I said to you, the film didn't know the difference between me and you here. Something about that made me happy, though you didn't find it as remarkable as I did.

Looking at the thumbnails again, I'm realizing I remembered right. There was a palm tree on the beach that day. How beautiful—how improbable.

23. In taking these pictures, what were we really trying to accomplish? You saw it as a formal project, with your artist's eye—when we got our prints back, you noted the compositions, the use or absence of flash. To you, these were pictures with constraints. But I was doing something else, perhaps. I was writing a story, one in which I portrayed you as though you already loved me. I wonder, now, if it would have helped to know that you did. Either way, it was that thing I do all over again, because I am a writer: if I could make our photographs fit the conventions of genre, then maybe you'd stay with me, the way I wanted you to stay.

24. At the Morgan, walking through the photographs of Hujar's, I thought about the title of the show—*Speed of Life*—and just how much life had sped by in the time between the instant captured in the photograph and the time where I now stood. So much of what made his work beautiful to me was

its enduring freshness, these portraits from the seventies and eighties as quick and sharp as though they'd been made just yesterday. And yet because of this freshness there was an unmistakable elegiac quality to Hujar's pictures: not in the images themselves, which felt full of life, but in how long they had held those moments, and how much longer they would.

Hujar died in 1987, aged fifty-three, of AIDS-related pneumonia, one of countless artists who died in the eighties during Reagan's purposeful neglect of the AIDS crisis. Of Hujar's subjects, who gaze so lucidly at the viewer in his photographs, few are still with us: Susan Sontag is dead. David Wojnarowicz is dead. Greer Lankton is dead. Candy Darling is dead. And one day I will die, and one day you will too. It frightens me to think of the photographs we made outlasting us. But that's the nature of the printed image.

When Peter Hujar passed away, Wojnarowicz was with him. Perhaps unsurprisingly, his instinct was to document: he filmed a sweep of Hujar's body, then used a camera to take twenty-three photographs of his face, feet, and hands, the number a recurring theme in Wojnarowicz's work. David would die three years later, full of light and rage, at thirty-seven, also of AIDS, but this is before that. This is in that moment. The photographs of Hujar are an act of love for him made manifest, starkly beautiful and still.

Writing this, I remember being struck by a similar passage in *The Argonauts*—when Harry's mother died, he stayed in the

room with her, talking to her, taking pictures of her, remembering her as she was not only in life but as she left it, just then. "I spent another 5 hours with her body, alone, with the light on. she was so incredibly beautiful. she looked 19. i took about a hundred pictures of her. i sat with her for a long long time holding her hand," he writes.

25. A few months after my grandmother passed away, back in 2012, my mother emailed me a picture, asking if I could fix it in time for the hundred-days memorial service. We needed to print a photograph for the altar, the image of her we'd fix forever in the afterlife. Could I remove the brooch on her shirt and fix the glare on her glasses so we could see her eyes? Yes, I could. Hunched over on my dorm room bed, laptop burning my thighs, I copied and pasted and cloned and air-brushed, creating a convincing facsimile—an image of my grandmother as we'd known her, smiling widely, eyes bright. It was her, more her than her. And it struck me then how terrible it was that there would be no new photographs of her ever in the world: that this, my poor retouching, my compositing of memory, was all that was left. With my mouse cursor I caressed her face. Mending, blurring. Only I would know the artificiality of it, and that knowledge was mine to carry, until it softened, and wavered, and I forgot.

26. Ways of staging a photograph, from near to far:

With a still life.
With a prop.

With a costume.
With a colored backdrop.
With lights.
With a mirror.
With a front-facing camera.
With a self-timer.
With an object.
With a subject.
With no subject or object.
Alone.
Together.

27. There was the time when a lover was in me and I asked him to record it from his perspective. I wanted to be inside his head; I wanted to see what it looked like to be inside me, as if in doing so I might finally understand why we constantly failed at being good to each other. But I was disappointed by the video we took. It didn't look like the videos made by the pornographers. I wanted the close-ups, the perfect angles, but the reality didn't match up with my vision of us. We were as stilted and awkward as the video, his cock bobbing in and out.

After he left the city, I'd undress for him on camera and ask if he missed me. Did he want to see my body where. And. Do what and. No he couldn't come. No. I wouldn't let him come. My naked body, tucked in a screen within a screen. He'd text me from the airport; a bathroom; his raw new bedroom, barely furnished. That one made me ache, seeing him in an unfamiliar place, in a city I'd never been.

I made paintings of us that year, based on the photographs I sent him and the text conversations we had. I cut wood panels to size and gessoed over them and sanded them until they shone, made our bodies legible across the surface, rendered in electric oil colors. I covered everything in a sleek, wet glaze, like the gloss of a liquid crystal display. Years later, I found them again in storage, where the glaze had yellowed, turning art that used to be a commentary on modernity into a victim of inherent vice.

28. I truly didn't think I was afraid of being seen by you—no, I wanted it, sometimes desperately—so why did I still flinch when I felt *your* gaze on me? There was something buried deep inside that kept me from showing myself to you fully: I had to consciously allow myself to be seen. I'd been so used to being the director of my own images, to orchestrating and composing the story I wanted to see. Or else I was someone's muse, someone's model, articulating some different story that had nothing to do with who I was: all throughout college, I'd posed for photographs for my friend Ben, covering my face in paint, smushed fruit, dirt, cold milk. I knew how to make something up. That was familiar.

But you, as you always would, wanted to see me for me. You wanted to see all of me, to know all of me, without performance or artifice. You were the first person to ever touch me so tenderly. I think I let you. I think it shows in the photographs, the way my gaze shifts to meet yours—the way you slowly undid me.

When I left for a residency in New Mexico, the second time I'd go to that blue place, I made an Instagram account and gave you the password, asking if you would like to collaborate with me. I wouldn't be gone for long, but I was interested in trying new forms of communication, and more than that, I wanted to make something with you. Once in Taos, I posted pictures of the desert, shadows dancing on the wall, my shoulders covered in droplets after a shower. You posted abstractions from your new job in the city and still lifes from Brooklyn, where we both lived. We called our project a conversation. In every image I looked for hints of you missing me.

Later, when we fought, we'd cut off text communication. Would only speak in photographs. I looked so hard at your images then, trying to read them, trying to understand what you were trying to say to me.

When we fought I'd go back to my pictures of you, too, those images I took that night not long after we met. They seemed to depict what I'd lost, when distance opened up between us. But could it really be a loss, if I feared losing it to an ordinary quarrel? Or was it that what I'd wanted to be there hadn't been there all along?

29. "All photographs are *memento mori*," Sontag writes. "To take a photograph is to participate in another person's (or thing's) mortality, vulnerability, mutability. Precisely by slicing out this moment and freezing it, all photographs testify to time's relentless melt."

30. But that was always why I made—to try and keep time where it is and hold it long enough to carry with me into the next interval of feeling. I knew that I was running against time, against its passage, against the inevitability of change, against the chance that you and I would grow distant and apart from each other. And I suppose it's true that all photographs capture is dead time, the instant between your breaths. Though if you believe that time is all around us all at once then I'm still here, in bed next to you, waiting for the shutter to click, and here I am in the darkroom, watching your image rise up out of the fog, and here I am telling you the story of how we came to be.

Haunted

This part is about trauma. How it affects us, and how it unfolds. Here is where it begins—not where it began in time, but where it began for me.

The summer after I finished college, three years before I'd meet you, I moved to a sleepy village in the south of France to help run a painting and drawing workshop led by a former professor. I'd known Robert since January of my freshman year, when I'd taken his famously difficult 8:25 a.m. drawing class—waking up early to stumble to the studio in the cold, the wind buffeting my paper portfolio around like a sail. I'd struggled that spring, trying to find a subject that resonated with me, turning in reams of bad still lifes until I found my focus: images of tightly interconnected, nest-like forms that I'd constructed with fallen sticks and twigs. But even before that point, Robert had liked my spunk and attitude. He'd seen something in me worth nurturing, and from him, that was nearly as good as any positive critique. Bolstered by his mentorship, I took his painting class the next year.

Robert's pedagogy was rooted in repetition. It had been so for the four decades he'd been a professor. He'd assign absurd amounts

of drawings for homework: twenty, thirty, forty. Twenty was a Robert standard; by the end of a semester, a breeze. With each set of drawings or paintings we were to investigate a single subject. In class, we arranged our work on the walls and floors and looked at them together as a grid, scanning the entirety for patterns. When there occurred something that felt like a habit or a weakness—a recurring shape, a consistent color—Robert asked us to lean into it, tapping the surface with one dry finger. To exaggerate it and consider what it might say.

After that first painting studio, I took his workshop in France. It was a monthlong course near-mythic in its intensity, a program so weird and insular and rigorous that the floors of the studios were covered in white cardboard. For ease of cleanup, Robert insisted, but more than that, it transformed the space, making the ordinary studios feel otherworldly. Like we were in painting heaven, or maybe, painting hell. By the end of our five weeks together, the cardboard floors were stained with acrylics, and ink, and charcoal.

Robert led the class. There were just twelve students each summer. We spent every day in the studios, even the weekends, eating dinner as a group in the evenings and returning to the studios to make more drawings until the small hours of the morning. At night, I slept in a dorm by the river. There wasn't any time for sightseeing. The weeks went by quickly, and I didn't make anything good, but by the end of my time there, I wasn't sure if I needed to. It seemed to be enough to take the work seriously, seriously enough to keep making it even when it failed, and I wanted

that—I fiercely wanted to believe that there was an importance to making things.

Robert believed so. He had the firmest handshake of anyone I'd ever known. He loved junk shops, bargain bins, surprise presents, and labeling individual supplies with everyone's name—it makes it feel like a gift, he later explained to me, when I joined the team in France. He wouldn't let us use erasers. Loved cardboard, blue tape, collage, and taking pictures. Two months before I graduated, he asked if I had any summer plans. No, I said, and that was how I came to return to France.

For six weeks that summer, the summer of 2014, I lived in a gîte, a small furnished vacation apartment where I shared a bathroom and kitchen with my colleague, a painter named Paul. Each morning, we walked down a steep, gravelly hill to the studios, where Paul lectured and I, at my desk, did all the behind-the-scenes, officey things: scheduling transportation and scanning passports. Itemizing expenses, arranging flowers, writing emails in English and haphazardly Google-translating them into French. It was hard to describe exactly what I did; the answer was, essentially, everything about a study-abroad program that wasn't related to teaching. I did get to be a critic: every day our small crew walked through the studios—me, Paul, Sam and Jamie the studio managers, and Robert—with our hands folded behind our backs, peering seriously at the students' work. It meant something to

me that Robert valued my eye. I wasn't making art just then, but I thought myself still an artist, too.

Except for Robert, who had chosen us, we were all very young. Paul, who had just finished his MFA, wasn't yet thirty; he had been the TA for a painting class of Robert's that I had taken. Jamie was a budding architect in his early twenties who loved to draw in parabolic curves, and Sam was a handsome, freckled surfer of about the same age—the three of us had been at the same workshop in France. And I was twenty-one. My hair was long and bleached ombré at the ends. In the mild June heat, I tied it up in a high ponytail and wore Oxford shirts undone to the second button and Oxford shoes and pastel shorts from J.Crew.

In the States, I'd left behind an apartment full of fiction I didn't read anymore, a closet of chiffon dresses in pinks and floral prints, and Eli, a boyfriend, whose presence in my life was still startlingly new. No, he wasn't my boyfriend. He was something else to me, unfixed and surprising. I had met him just as I was finishing my senior year, and we spent a lot of the rest of that semester in bed or drinking or both. We were infatuated with each other, and at first, we rarely fought. When I got sick with a spring cold, right before graduation, he appeared at my house with a container of chicken soup and a box of pink tissues, which made me squeal with delight.

"I stood there for a long time trying to decide," he told me. "But I picked these because I knew pink was your favorite color."

I loved his big strong arms, I loved him for that gesture, and I loved seeing the tissues crumpled in the trash after: they looked just like flowers.

By the time I met Eli, it had been a long time—three years, maybe more—since I had really dated someone. In college, following the breakup with my high school boyfriend, I'd frequently found myself in fraught, casual relationships that started quickly, escalated within the conditions the other person always set, and fizzled out within the span of a month or two. I was tired of it, of being someone's secret sex object. I wanted to be wooed—to go to dinner with candles. I longed for romance. I wanted to be treated the way normal girls were treated.

Eli lived in an apartment in a brick building around the corner from my house. He was a year younger than me, worked out religiously, knew how to poach an egg. We were both children of immigrants chasing the American dream, and though we had little other than that in common, we were fiercely ambitious in the same way. I liked that he recognized my drive, something that escaped most people's notice, so focused they were on other parts of me. He told me once: "I like that you're hungry." And I was. At night, in his room, I straddled him. He liked thinking that he had tamed me, and I liked feeling tamed.

We never really defined our relationship—I think because at least I knew that, if prompted, we would say different things, and once spoken, that kind of disclosure can't be taken back. Better, then, to keep acting without asking questions. At the

time, I thought I could make the label matter less: we did all the sweetly domestic things I wanted, and I hid the part of me that craved commitment close to my chest. And he wasn't, I think, bad to me. Being with him felt close and safe, in a good way, and approaching adulthood, I was curious about domesticity. A safe, routine life was something so foreign, so long denied to me, that it had its own veneer of desirability. It was fun to cook together—avocado-and-egg breakfasts, pasta, steak with wild rice. To fantasize about parties in the city we'd go to as part of our fancy new jobs, to talk about the trips we would take when we were both adult and rich. When it was time for me to leave for France, uncertain as our relationship was, we agreed we'd stay in touch. I told myself it was only six weeks.

Maybe there truly was something uncanny in my time abroad in that tiny town, or maybe it only feels dreamlike to look back upon it—the village was so small, and our program an isolated bubble within it, and beside the courtyard between the studios and my office was a giant linden tree that swarmed with bees. One cool morning, I remember distinctly, I came down the hill to the office to find that the stones in the courtyard were covered in huge, unmoving bumblebees, the largest the size of my thumb. When I picked one up, it stirred, scaring me, and it took all of my might not to fling it away. I had thought they were dead, but maybe they were merely dying, or just resting, the way I wanted to. The town was along the route of the Camino de Santiago, the pilgrimage

route of Saint James, and sometimes, in the gray morning, I would see a pilgrim wearing a floppy hat and hiker's backpack emerge from the fog. Sometimes they asked for a glass of water or were curious about the program we ran; others were just passing through, requiring nothing but their own piety. One morning, running late without time to eat breakfast, I hustled across the courtyard holding a bowl of yogurt with a dollop of jam on top, the leather soles of my Oxfords smacking across the flagstones. A pilgrim walking along the sidewalk nearby waved me down.

"Bonjour!" she said. She had a cheerful, narrow, lightly lined face—her short hair tucked under a wide-brimmed khaki hat to keep out the sun. In each of her hands she held a lightweight metal trekking pole, and on her back she wore a large purple hiking pack.

"Bonjour!" I replied.

"Qu'est-ce que c'est?" she asked, pointing to the bowl.

"Oh, um," I said, sorting through my minuscule vocabulary for the right words. "C'est mon petit déjeuner?" She laughed at that, and, picking up her walking sticks, continued down the sidewalk. Soon she turned a corner and was out of sight.

On their packs they tied a scallop shell, signaling their status as pilgrims, which flapped with each step. From where we were, an hour outside of Toulouse, it was just over six hundred miles to Santiago de Compostela. At my desk, I did the math. Two

hundred and eight hours of walking. Briskly paced, the pilgrimage would take two weeks.

How can I explain the beauty of the place—how everything around me was enormously, heartbreakingly perfect, a pastoral dream of Provence of the kind promised in travel brochures. The village's old houses made of crumbling stone, the narrow roads down which bicycles piloted by handsome people soared, the lush gardens full of poppies and roses, and through it all the river Garonne, which flowed beside the town, glistening like fresh oil paint. Some afternoons, I looked at the reflection of the landscape in the water and wanted to cry. I had the suspicion that our town was set too far west for its time zone—the evenings seemed to stretch on forever blue, and it didn't begin to get dark until ten or eleven p.m. Then, when night finally fell, back at the gîte I'd stand on the balcony of my rented room and slowly smoke a menthol Royale while my shadow from the overhead lamp loomed cartoonishly over the garden. Sometimes I took nudes. Sometimes I cried.

Because despite the beauty of my surroundings, I was struggling. I was struggling with the constant switching of languages, navigating back and forth from English to French. I was struggling with the demands of the job I'd taken on, the scope of which I hadn't fully understood—which might have been impossible for me to fully understand—when I agreed to join. I knew that I was there to run the program smoothly, whether that meant helping a student call home, or ensuring we'd made arrangements for our meals, or tracking the program's finances, or doing the time sheets that meant Paul and Jamie and Sam and I got paid—I knew it was

all that, and more of it, but it was an invisible, feminized labor that everyone around me seemed to take for granted. I was overworked and undervalued. I was struggling with feeling unappreciated.

For I did treasure my colleagues, the small, tight-knit team we'd formed. In one way or another, we'd all known one another for nearly a year, our bonds burnished purely in the fire of having been close to Robert. Paul had been my instructor; Sam and Jamie had been my peers. At our staff meals we talked easily, fluidly; we were happy to be working together, excited to see our students progress. Yet—perhaps as a product of this familiarity—I found it difficult, maybe even selfish, to express how overwhelmed I felt. After all, weren't they working too, working to maintain this delicate, rigorous world we'd built?

And there was something else going on with Robert, something I sensed but couldn't put into words. I'd always known Robert was a demanding taskmaster, with his own peculiar logic and ways of getting things done, but he was practically militant this time around. The distance I'd had as a student had protected me before, but now there was still a strain of sharp, painful bitterness in his affect that none of us could understand. In the studios and the office there was always too much to do, and it seemed that we were doing it poorly.

One night, Robert felt unwell. He went to bed early and the four of us who remained at the office got into an argument about some logistical thing or another and Paul, whom I adored, snapped at me.

"I think it's your attitude that's the problem," he said.

I began to cry.

"You know he loves you," Sam said. And I did know. I loved Paul too, the way I loved all of them. "We're all stressed out." It was no one's fault.

It was hard for me to be there. I was the only woman on our side of operations. The students in the program were, save for one male student, all girls; but as their instructor, I could never be their peer. Just on the other side of graduating, I knew there wasn't much of an age difference between us, in some cases less than a year. But no matter how much I longed for it, I felt I couldn't be close to them. They could tell me their problems, but I couldn't share mine—not the difficulties at work or the changes I felt brewing in my relationship—and I missed having someone to confide in, to tell about the fear I felt. I wasn't so naive as to think it could be soothed, but I craved being understood. In the office I needed to be reliable, the person everyone could depend on, the woman—and was I, now, a woman?—whom the girls came to when their menstrual cramps were bad, or they had migraines, or their endometriosis was acting up. Our program was so small and poorly managed under Robert's capriciousness that I was always scrambling to clean up some mess—pay a late invoice, charter a last-minute bus, calm down a crying student after an encounter with a sexist gynecologist—without any semblance of effort, not wanting to lose face with my team or the students.

I was used to having friendships with men, but they were friendships of a different kind than the ones available to me in France. Throughout college, I'd thrived in those close, magnetic, sexually charged friendships that arose from sharing beds, kissing, maybe not kissing, maybe more—like anyone else, at night I always wanted something to happen, and sometimes things did happen, once the door was shut. It never mattered what we actually did together, only that we had created that space between us and opened it, like a blanket fort or a secret attic, just enough for a few of us to fit through. I craved that kind of intimacy. Found it in dark rooms. We were always theorizing, more head than heart, our ambitions outsized. I understood that, this yearning for connection. The men I dated—the men I wanted something from—could hurt me, but my friends never would.

Alone, abroad, I couldn't use sex to understand these men. Nor would we ever come close to the warm, bodily familiarity I used to communicate with my friends back home, or even with Eli, who hadn't ever been my friend, precisely, but whom I missed. I thought Paul and I were close—we lived together, strategized together, put the pieces of the program together when it seemed like no one else would. I knew he missed a partner back home, the same way I missed Eli, and we would have commiserated about that yearning, perhaps, if I'd had the rock-solid trust in my relationship that Paul had in his. But I only had uncertainty, and Paul's faith only made me less sure. Meanwhile, Sam and Jamie were best friends. They had been the ones who, years before, had turned our white-walled studio into a camera obscura. I liked them, but I also feared them—their self-reliant, introverted

masculinity. I envied their closeness: I knew that their duo couldn't possibly admit me.

Perhaps the best way to describe our relationship is that it was like a family—a lonely, oddball family, in a country where none of us spoke the language. I loved them because they were there and the work was hard and if I didn't reach out to them, I'd surely sink alone. I suspect they loved me in the same way—out of stress and proximity. But no matter how close I felt to them, I knew there were things in all of our hearts that we wouldn't share, and this knowledge made that closeness feel thin. I feared breaching it, for its flimsiness to be revealed. We cooked meals together, stayed up late talking about the progress of our students, and Robert's moods, and our hopes for our own careers and futures, which felt increasingly far from our lives in France, but we never hugged. We never touched.

What truly bound us together: we loved Robert, and we loved making art under him. We passed on his lessons: we were hard-nosed formalists, heartfelt conceptualists. We cared so much about the making of work—more, I think, than we cared about anything.

●

My dreams had been growing increasingly abstract and flustered during my time abroad. Time went on; I was alone and yet not alone. On a trip to the hardware store, squished between two of

my colleagues in the back of our car, I closed my eyes, feeling the pressure of a warm human body on either side of my thighs, and I grew dizzy with longing. I couldn't remember the last time I'd been meaningfully touched. Napping on the couch in the office, I had a sex dream about Sam—unprompted, unwarranted—so vividly sensual that when I woke up, red-cheeked, I worried that I might have said something revealing or moaned aloud in my sleep. I couldn't make eye contact with him for days; I felt stained with it. It made me cautious. I was wary of what jolted around inside me, and what threatened to leak out.

In another dream I was back in the States, sitting on the floor outside Eli's apartment. It wasn't his apartment as I knew it, with the French doors and the bead curtain separating the kitchen from the rest of the rooms and a record player in his bedroom, but a different configuration of rooms that I knew, nonetheless, belonged to him. In the dream, he was taking someone home—a pretty, unfamiliar girl with strawberry blonde hair who looked nothing like me, the way they never do. In the dream, I heard them talking and laughing, through the walls, their voices dulled. In the dream, I sat on the floor and listened to them: it's been long enough that I can't remember exactly what I dreamed I heard, but I remember waking up feeling confused and hurt. It was a dream, I knew, shaking myself out of sleep. It was always a dream, with the weightlessness of a dream, but that didn't change how it felt.

That night, Eli and I had planned to Skype, and after a long day at work, I logged on in the dark of my room, feeling haunted and strange. I've never been able to hide an emotion on my face. I'm

entirely beholden to my feelings, which feel practically alive, even when I sometimes don't. They yelp inside me, standing on two legs.

Camera on, I waved at him, but my heart wasn't in it. He asked me how I was doing, about my day, and I answered, trying to sound normal.

"Is everything okay?" he asked, or maybe that's just what I want to remember—that he noticed something was off.

"It's nothing," I said. I could feel the dream churning below the surface of me, wanting to be spoken aloud. "I just—"

But how could I tell him about the dream I'd had, which could only open the door to a conversation I wasn't ready for? It had served to remind me that I didn't trust him, and moreover, that I'd never been given a reason to trust anyone. I'd been hurt before, had my boundaries crossed. And like so many men who had preceded him, Eli had bristled at commitment, at monogamy, at calling me his girlfriend. I don't think we ever decided to be monogamous with each other, not officially. We just stopped using condoms. About a month before I left for France, I'd told him I loved him for the first time, and he didn't say it back.

For the rest of the year that we would see each other, off and on, he'd never say it. I'd thought I could forget how badly I wanted to hear it—that I could make my emotional precarity matter less. But the dream seemed to me to be a premonition, punching a hole in the fiction I wove to make myself feel safe.

"I had a weird dream last night," I confessed. "And you were in it."

"What was I doing?" he asked softly.

I shook my head. I didn't want to tell him. "You hurt me," I said.

"I'm sorry for hurting you in your dream," he said, his voice small and serious, like a grave child.

The first night I'd slept over at Eli's, he'd taken me on a date. This was months before I graduated, before I told him I loved him, before I moved to France. At dinner, we'd pretended it was his birthday. I sang to him when they brought the cake out, slow and languorous, like Marilyn Monroe did for JFK—and Eli had fancied himself a New England scion, if not in name then in dress. The cake was molten chocolate, a flaming candle in its center. That night, I had just started my period, and I remember there was blood everywhere: on his sheets, on his hands. After that first night, we dove into each other. I can still remember the metallic tang of our first week together—ferrous and bloody and fresh.

Later, though not much later, Eli told me something about that first night. That while we were sleeping, he'd dreamed that I hurt him in violent and terrible ways. I was scared to learn it—that I was alive in someone else's subconscious, prowling around. I couldn't imagine the violence he imagined, couldn't fathom that the figure who'd hurt him had worn my face.

But I never hurt him, not like that, though there were other ways I could hurt him, and ways that I did. What he dreamed was outside of me, the way that what I'd dream in France was outside of him—it was something else that haunted each of us, a soft, shuffling animal, following us into our waking lives.

Robert had cancer. I can still remember it—the trips to the doctors; how we'd thought his difficulty breathing came from allergies or asthma; how we'd finally found the bottles of chemo pills he'd stashed in the office mini-fridge. They looked so innocent in their neat rows with their typed-out labels, purpose clearly stated. I felt betrayed.

He had wanted to keep it from us, stubborn to the end, but as he got weaker, we found ourselves forced to intervene, and during a frenzied sprint of days I called hospitals, our travel insurance, and even his partner, whom I'd only met once, and only briefly, to ask for his medical records. At yet another doctor's office, the severity of the situation finally clear, we were given a strict list of foods he had to avoid. But his appetite was so diminished by the chemo pills that it was difficult to get him to eat, and so I was a bad caregiver and let him have whatever he wanted, if it meant that he would eat anything at all. At a lunch, he ordered vegetarian pasta, which we thought would be safe, some kind of zucchini primavera; it came smothered in tomato sauce, which was forbidden. "Tomatoes! All tomatoes!" Paul said, exasperated. Another dinner, Robert poked

at his food. When the table was cleared, he asked for half a cantaloupe, its center cleaned of seeds and filled with port. The Charentais melons of southwestern France are completely different from the chalky cantaloupes we get in supermarkets in the States—they're small, sweet, heavenly fragrant. Deep orange, almost red. Robert ate the whole thing with a spoon, grinning the whole time. I loved him dearly. That prickly old man.

A week went by. We took Robert to the hospital. He stayed there for some time. The program went on—it had to go on. We took the students to the beach, laughing at the way their mouths fell open at the sight of blue water, how they immediately dove into the ocean, their arms and legs still streaked with charcoal. I braided my hair and buried my feet in the hot sand and chain-smoked Royales. Paul and I talked about the people we were dating, whom we'd left back home, and hearing about his certain, happy love life, I found myself missing Eli, and missing the relationship we didn't have even more than I missed him. At the hospital, we brought Robert snacks and Chinese food, though the one Asian restaurant we found didn't have what he specially requested, egg foo young. We shuttled back from the hospital to the office, Sam at the wheel, vaping the entire time. On campus, as though nothing were wrong, we led lectures, introduced wet mediums—India ink, black tempera. When all else failed, the work sufficed. Later, hauling buckets of acrylic paint up the studio stairs, we would add color.

Several weeks into the program, Jamie asked if someone would cut his hair. We put a square of newspaper in the courtyard and he sat in the center, his shoulders hunched, leaning forward. Parting it in

sections between my fingers, I ran the clippers through his curly hair, leaving him shorn and childlike—a puppy, a lamb. I don't remember what we did with the clippings—if we threw them away or poured them in the grass for the birds to make nests.

When I finally arrived back in the States in July, ten pounds heavier and glad to see American street signs, I went to stay with Eli, at his place in New Haven with the French doors and sloped ceiling. Before I'd left for France, a curator-bookseller in Provincetown had been taken by my thesis work and asked if I'd like to show it at his space on the cape. Now my paintings were already in Massachusetts, waiting to be hung and arranged for the show in nine days. It didn't make sense for me to go home to Oregon before the show, and so although I was uncertain where we stood, I asked Eli if I could stay with him. We could go to Provincetown for the opening together, I said—make a weekend of it. Ride bikes on the beach, eat seafood.

Every morning I woke at dawn to make him breakfast, then passed out again after Eli left the house, a pattern of waking and sleeping I'd find myself repeating with more than one succeeding boyfriend. Unemployed and in the wrong city to look, I spent my days in cafés, working on freelance articles and idly scrolling through job listings on Idealist. In the evenings, I rode my bike back to the brick house on Elm Street, where I'd make dinner in time for Eli's arrival, flushed from his commute home from a job in private equity in Greenwich.

For the first time ever, I felt like a wife, playing house—properly domesticated, cooking dinner in tiny skater-silhouette skirts and dresses that nipped in at the waist. I ran errands, picked up groceries, got fucked in the double bed. All of a sudden my world was getting small enough to see the edges, and I strained at its confines, as much as I loved the novelty of being kept. One morning, I woke up feeling cranky. "I don't want to make you breakfast," I mumbled into the pillow.

"You don't have to," he said softly; his voice was always so soft toward me. I heard him get up. A minute later, the shower turned on, and I felt so much for him that I hauled myself out of bed. English muffins in the toaster. Avocado. Eggs.

Remembering that morning—how he emerged in his towel to me in the kitchen, pleased, wet, and surprised—I think to myself, I wasn't entirely happy then, but that was definitely a sort of happiness.

Maybe, then, it was a sort of preparation, for a greater kind of happiness. And in that happiness, a greater heartache. I didn't know then how it could feel—how it would feel when I met you.

In the fall, I moved to New York. I had written an essay that gained some attention, and a literary agent had called me, asking if I wanted to write a book. I wanted to write a book, and I wanted to be a writer, so I went.

Unmoored in a new city at a day job in copywriting that I despised, I clung to anything familiar, unwilling to adjust to the changed parameters of my life. I visited Eli every other weekend; he came to see me the weekends I didn't. And where before we'd never so much as argued, suddenly we were constantly fighting, or worse, tired of my melodramatics, he'd ice me out. I was prone to crying jags, to inexplicable fits of melancholy on Friday nights. I wept at nice dinners, never took no for an answer, hated saying goodbye even when he really, truly needed to go. One evening, we walked past a bodega that sold flowers, bouquets of roses and lilies and carnations gleaming under fluorescent light.

"I've always wanted someone to buy me flowers," I said. We hadn't fought that night, but we were rocky—my moods then were like a leaf balanced on water.

"I'll buy you some," Eli said. "I'll do it right now."

"No," I said, and it hurt me, the way it tumbled out of my mouth. "It has to be a surprise." I didn't want to ask for it. I wanted my desires to be known without my telling. I wanted to be surprised by love, bathed in it, overwhelmed by it. But once I said it, I couldn't go back to being sealed over. I felt like a seed bursting open, a small, greenish-white sprout poking out.

That wasn't why we eventually broke up, though it wasn't the first of many signs or the first of many difficult nights. Eli had his dark moods too, long hours where I'd stare at his back, willing

him to say something—anything—about how he was feeling. It seemed too late to ask. Too late to say much of anything. Some evenings, we'd hardly speak, finding each other only in the hot, liquid language of the body, our mouths dry from the spliff he'd roll on whatever book I was currently reading. We didn't kiss. I got used to being high together. To sleeping a lot. Visiting him in New Haven after some time away, I found a coil of bondage rope in his room that was different from the rope we had been using.

"This is new," I said. There was new lube, too. I didn't want to look for condoms, because we didn't use them.

"It's for practice," he said, and I knew he was lying, and I knew he wasn't trying to hurt me. And I knew that once again I had to accept that the bounds and responsibilities of our relationship had always been different for him.

I didn't say anything.

Robert died that winter. My grandfather did, too—my favorite poet, my friend who raised me. Both of them artists. Both of them mentors. My world became, for many weeks, overtaken by a wild, keening static. I flew to Oregon for my grandfather's funeral, flew back, developed an ear infection that burst one day while I was at work—it sounded like fireworks had gone off in my

head, and a horrible yellow pus dripped down my neck—quit the copywriting job I hated, started working at a sex store, broke up with Eli, slept with a lot of randos, started writing again, got sick again, got sicker.

How impossible is it to say aloud that you want love? Not just love—I wanted proof of its existence, that I deserved it. I cried thinking about it. After Eli and I broke up, for a while, he sent me notes late at night: fragments of *The Little Prince*, poems that made him think of me. One May evening, we had sex again—I was coming down from acid after a festival at our school campus and he was too. It felt delirious to be in touch like that, like tonguing a loose tooth. Then I told him we shouldn't talk anymore, and the messages stopped.

I dated some other people; I dated some more. A few bad boyfriends here and there—all my bruises coming back. A year went by, then two, then three.

When I started hanging out with you, I noticed something strange. I flinched too much, and at things that shouldn't inspire flinching. My heart was open—I was cracking it open, bodily, with both hands—and I felt bared to the world. I was unbearably sensitive, so much so that the October evening we decided to get tattooed together, I got inscribed with the word. *Sensitive,*

in lowercase cursive on the back of my arm. That evening, giddy with a flood of endorphins, I touched my nose to yours in a dark bar and clung to your hand, so ecstatically rapturous you wondered aloud if we were on drugs. We weren't, but it felt so good. All that fall, we talked incessantly, processing near-constantly, about where we were and how we were feeling. I liked the talking—I clung to it too. Though I knew I was safe, at least in the moment, I found myself constantly on the verge of holding my breath.

By then, I was working at the nonprofit that provided support to survivors of sexual violence, and volunteering on the agency's 24-7 crisis line, where I took overnight shifts. Some calls were straightforward—a person in an abusive relationship wanted to know how to get an order of protection, for example. Other calls had no obvious outcome, but often went in circles, as I cycled with a caller through a panic attack, or quietly listened while they talked about something in their life that was going wrong. One night, I got a call from someone in an abusive relationship. They didn't want to leave, or perhaps, more likely, they couldn't safely leave, but they were floundering, feeling like they were losing themselves. At a loss for what to do, I suggested we do a body scan together over the phone.

"What's that?"

"First, start with the very tips of your toes. Then move up, slowly through your body, checking in—"

The call was interrupted by a sob. "No one's ever asked me to pay attention to myself before," the caller said through tears.

I wanted to cry, too.

I worried about the people I talked to, how my final interaction with them on the phone was often the last time I ever spoke to them. The agency followed up with each caller, offering in-person counseling and other supportive services, but I wasn't a social worker, just a volunteer covering shifts, and client confidentiality meant that I never knew if the people I talked to came in, anyway. I thought often about their daily lives, of which I knew nothing. About whether they were okay, of which I also knew nothing.

When working with victims of trauma, a useful term to keep in mind is *hypervigilance*. It refers to the tendency to be on guard at all times, sleeping lightly, startling at sudden noises, at shadows in the periphery. Hypervigilance, I learned, is a symptom of trauma. After experiencing physical pain, violence, or emotional abuse, survivors tend to move through the world with their hackles up. I even noticed it in myself, as a result of vicarious trauma—drenched in the torrent of violent news I monitored daily, I had trouble sleeping. I jumped at shadows. I whirled on people tapping me on the shoulder from behind, my eyes frenzied and wide.

But I didn't think it was just my job. After an argument, in which we kept talking past each other, saying things without hearing

what was said, you said to me: "Sometimes I feel like you say things to me, but you think I'm someone else."

I felt my vision double—like I was seeing a ghost.

In the spring of 2014, I was raped by a man I considered a friend. Though I wasn't romantically interested in him, we were emotionally close. We texted frequently and talked on the phone, sometimes for hours at a time. He was nearly a decade older than me, and when he saw my paintings, he encouraged me to keep making work. My paintings were naive and sexy then, curious, vulnerable, full of desire and pain. In the halo of his regard, I felt chosen—like I was being seen for my talent, for my exceptional understanding of the body's abject condition. Now, looking back on how everything turned out, I'm only left with a sick, sad feeling. Was I actually talented, or was he only telling me so because he wanted something else from me, and he saw that in my work, I had it? One night, he wanted me to see the studio in the warehouse where he lived. I went out there, and I said yes, then no, then no, then no, then no. I cried—tiny shaky little heaving breaths. In the morning, like nothing at all bad had happened, he drove me home. I felt sick. Half-dead. Went to class.

Remembering it now is like looking a long distance through water. We stopped talking after that incident, which is the

only way I know that he knew what he did was wrong. At the time, I wasn't traumatized, exactly; there was no time for that, and I'd been long familiar with the concept of having sex with men I didn't want to have sex with, for whatever reason made sense. So I started dating Eli—someone else, someone safe. Graduated and moved to France. Buried the memory deep inside myself and stored it away.

It took me a long time to realize that there was a power differential between that man and me, and that he had taken advantage of it. Some months later, settled in New York, I told a friend about the experience.

"Larissa," he said, "you were raped." Because I stared at him blankly, he said it twice.

"I don't want to think about it," I said, and covered my face.

I felt sick. I felt complicit. I had not intended to tell a rape story, but then I began telling it and, in telling it, realized it had been rape.

It was at this point, I think, in realizing this about myself, that I found I wanted to help others who had experienced what I had experienced, or worse. Maybe this isn't so surprising—trauma seeks out trauma; pain seeks out pain. Butterflies on a carcass. In the way that after a nick to the head, you're surprised by how you feel no pain, I touched my temple and saw that I was bleeding. I went out looking for blood.

I understood something. The injustice of it, but the pain, too. That winter, I signed up for the crisis hotline training. I wanted to do it—to be confronted with someone else's pain. To talk them through it. To heal them, in the hopes of healing myself.

Maybe it was my way of confronting my own ghosts.

The psychologist Bessel van der Kolk has written of this feeling, which I think of as hauntedness, but which might more ordinarily just be referred to as the aftereffects of trauma, or in more clinical terms, PTSD. "Being traumatized means continuing to organize your life as if the trauma were still going on—unchanged and immutable—as every new encounter or event is contaminated by the past," Van der Kolk writes. "After trauma the world is experienced with a different nervous system . . . It is critical for trauma treatment to engage the entire organism, body, mind, and brain."

Trauma doesn't just live in our heads. Our trauma is stored inside us, inside our bodies, and, long after the inciting incident has passed, it surprises us when it comes out. It changes us completely, stopping us in time, in that moment of the traumatic incident, even when our circumstances have changed. Hence the haunting. Hence the shadows, looming. As Van der Kolk puts it, "the body continues to defend against a threat that belongs to the past." Van der Kolk identifies this mechanism as being initiated

by our emotional brains—the oldest, most primal parts of ourselves, the parts of us that recognize fight-or-flight situations. In times of stress or when triggered, these primal instincts overpower our conscious minds—the parts of us that intellectually know we're safe—and we're back in the traumatic moment again.

Time passed. You and I hurtled into each other. For some time before I'd met you, I'd been stoically, happily single—my emotional life safe and self-contained as I steered through the world on the little rowboat of myself. Then, suddenly, you arrived. Someone I wanted to share my life with. It was like being pulled into the orbit of a neighboring star. The sprout bursting out of the seed. The thing in me that wanted to be loved—that needed love, that offered love—sat up and looked around.

But every day I moved closer and closer to that place of loving I felt myself growing more and more vulnerable. It was like opening a door, a door to a secret and hidden part of myself that was only visible when I wasn't on my own. And behind the door were very old things, some of them broken or cut-up or raw. They weren't things that I was used to seeing, and because I hated thinking about them, they weren't things that I could easily name. Often I was embarrassed by them—here are some. My abandonment issues. My neediness. My lack of trust in anyone, in anything.

Sometimes you would say or do something innocuous and I would flinch and shut down. It was like the dropping of a curtain. Even when we talked through it—and we tried, and we did,

usually, manage to understand each other—I still felt like a ghost was behind me, or behind you, staring me down. It was the kind of feeling that I can only describe in metaphors—like being in a forest and running into spiderwebs that stretch across the trail. Silk grazing my face. Like walking down a hallway in a hotel when the power goes out.

The language of trauma and PTSD is most familiar to me through the lens of victim services, in close proximity to which I worked for two years in total. And I know when I consider the experiences of other survivors of abuse that the everyday ways I've been hurt pale in comparison. No one's ever hit me, ever thrown a bottle at me or threatened to stand watch outside the house where I live. But why do my shoulders still rise up in the shadow of a threat? It's not that I've been hurt any less, but that I've been hurt at all, the way you have, too. Maybe the answer is simpler than I think. That trust betrayed is still trust betrayed. That pain, once felt, follows us into our waking lives, no matter the source. When I was afraid, and I was afraid, I felt my fear like a bird trapped in a room.

At my job in anti-violence, we often spoke of the "loop of violence" that people often found themselves in. We preferred "loop" to "cycle," because calling it a cycle felt too fixed, too inevitable—it made it seem a fact of life, like water. What we referred to were the conditions that arose as a result of violence, which continued to harm people, even after the immediate trauma had passed. Some of these conditions were material, like economic insecurity or housing instability in the aftermath of an abusive

relationship—these were things we could work to address with programs and plans. But others were more psychological, and harder to unravel. The behaviors that we learn to protect ourselves as a matter of survival aren't always the behaviors that best serve our current needs, but it's hard to unlearn the things we learned when we were fighting to live.

While researching the effects of trauma on war veterans, Van der Kolk noticed something unusual. Many of the veterans he worked with, all men, suffered from nightmares and were triggered by loud noises, which reminded them of explosions. They seemed to be caught in the past. But, Van der Kolk noted, they also seemed to come most alive when describing their traumatic experiences. The nightmares—their dreams—involved frightening places, sites where the trauma reoccurred. But when a veteran was asked if he wanted the nightmares to stop, he resisted—it would have been as though he were abandoning his past, and with it, the relationships that were most important to him. It was as though the past was where these veterans remained, and where they felt most themselves.

In the fall of 2017, three years after it had happened, I started having nightmares about being raped. #MeToo was trending, and my Twitter timeline was full of testaments to trauma—a litany of women, all talking about their pain. I'd never dreamed about the incident before, or any kind of sexual violence, but more than once in those months I did relive it, waking up panicked and sweating, feeling as though my body were not my own. All around me, even outside of my job and shifts on the crisis line,

women—and nonbinary people, and yes, men—were recounting their experiences of sexual violence, of workplace misbehavior, of bad bosses and bad boyfriends and worse. I'm certain it was empowering for some, but I felt saturated with the knowledge of other people's traumas, and while I was grateful that such conversations were being had, in the open, under bright lights, all of it was triggering, and unavoidable. I was newly in a relationship and trying my best to be vulnerable. I knew I was—I knew I *could be*—so happy with you. If I could only allow it. But at the same time I felt inescapably haunted, by the rape, by a history of poor treatment. My body refused to trust. My body refused to stop thinking it was in the presence of a threat.

A loop—think a curl of fishing line, a squeal of sonic feedback that screeches upon hearing itself, a habit one slides into with her eyes closed. *Head down. Eyes in the distance. Dissociate.* A cycle feels ground in—generational—and it's true that trauma works this way too, trickling down a family line. But a loop implies *caught*, implies *stuck*, implies a way out. It was getting out of this loop that my day job, and Van der Kolk, and ultimately I myself were concerned with.

With moving forward, into the present, into the new.

How to write of this—that clotting, bodily anxiety, the fear and doubt that seemed to emit from my pores like steam. There was

so much that was good in my life, but that goodness made me scared. When I thought of that door inside me, the door to all the calcified pain I held, I was convinced that no one would ever love me. That there was too much inside me that made me ugly, and unlovable, and impossible to care for. I have been so many people in my life, and on my worst days, all my selves seemed stacked up inside me, too full to allow anything else in, like trash shoved in a compactor. I thought of myself as haunted. Like a cave, or something dark and underwater, bristling with rocks and dead coral.

I can't tell you now how I got from there to another place, or that it was easy, or that it made sense, or if I really am fully in that other place. I don't think I am, but sometimes it feels like I could be. Now when my shoulders rise up and I feel haunted, I think about that night in France, about my own face pixelated in the Skype window. "I'm sorry for hurting you in your dream," Eli said. But it hadn't been his fault, in the end—it had been my dream, my ghost to confront. After all, hadn't I hurt him in a dream, too? I still don't know who or what Eli was haunted by, but I know that I was haunted myself. At least—now—I have words for the feeling.

And still, even now, when I think about that summer and my time in France, I can narrow those six weeks down to a fine, sharp point, a needle so thin it doesn't hurt at all as it slides through the surface of past to present. It's nighttime, how I remember it, and the sky is deepest blue. We're sitting around the

table in the back office, a rectangular table with a clean white surface, and we're talking, the four of us—the five of us, it would be, but Robert has fallen asleep, sitting in his customary chair by the radiator. We're holding each other, gently, not with our bodies but with our words, taking care. It's this care I remember, this utter, solid peace. At the end of our meeting, I go outside. It's quiet out, so quiet, and in the river, its surface as clear and smooth as glass, the sky is doubled, the stars just beginning to come out.

One night, some time after we first met, I lay with you in your bedroom. Talking. I wanted to tell you everything about me, so that you would understand where I came from. I hoped that if you understood who I was, and what had happened, everything that had happened, you might know how not to hurt me. That you might be able to protect me from the only way I used to know how to be. It was hard to look at you directly when I told you all this.

"I never want to hurt you," you said. But, you said, we were going to hurt each other.

That was how it was, and how it is, in the way of being with any person. All we could hope for, maybe, was to work to love and understand each other, to make peace with each other's ghosts.

And I saw myself then not as a cave but a shore at low tide, and there was everything inside me that I was afraid of, laid out and dressed. And maybe it was enough to look at it, to know it was there, to not let it haunt me the way it had haunted me for so long.

And I took a breath. I opened the door.

What we say without saying

1. There's a recording of James Blake covering Joni Mitchell's "A Case of You" live, on a BBC radio show, from February 2011. Because it's radio, the audio is pure and clear, without the ambient roaring sound of a crowd that often characterizes live recordings, but his performance still has all of the quivering, flickering vividness particular to live performances. It's just one song, three minutes and seven seconds, preserved online forever, playable on loop. In one of the top YouTube comments, a user named garfreeek writes: "He means it, it's like he's singing it half drunk to my voicemail. Very fragile (and beautifull IMO)"

 The song's production is spare, Blake accompanying himself on piano. "A Case of You" is an alcoholic's love song, a song about getting drunk off someone's pure presence, about coming undone, and in his performance, he comes undone, his voice loosened, lurching a little over the notes. The riff at the end of "Oh, Canada," the way he elongates the vowels, voice hitching—there's a palpable vulnerability to Blake's performance. It's not quite like when someone's nervous, but more like when someone's about to cry. It reminds me of how when

talking about something painful in our lives, sometimes even years later, we catch ourselves crying during the telling, the act of speaking reaching to touch the emotion inside of us and breaking us wide open.

That happens to me, often, crying while speaking. It never happens when I expect. It's surprising to hear that same moment, the point of almost breaking, in someone else. I never think it'll have an effect on me in a recording, far removed from the source, but it does, like a key that opens a secret compartment full of water, or a flower that has been tight in a bud so long you forgot what it looked like in bloom.

2. In the recording, Blake's voice stretches at the confines of the melody imposed upon it. It's as if there's simply too much of him in the performance, warping the boundaries of the song, which unexpectedly grants us access into some soft, passionate place that exists both in his performance and within our own hearts. When Blake sings a line about remembering being told that love was touching souls, his voice shifts from singing to nearly speaking, the words hanging in the air, unembellished. It's a moment of such pure feeling that it's almost painful to listen to.

I know it's a typo, but I like how in the comment, garfreeek writes "beautifull," as though the usual spelling is not enough, as though the performance is so packed with emotive sensitivity, so overflowing with sentiment, that it requires a portmanteau of "beauty" and "full."

3. Not long after we met, I left the city for that residency in Taos. It was the second time I'd go to New Mexico that year—first, my blue trip; now, a book trip—which made it feel fated, the way everything that season seemed to feel. I filled my suitcase with books by my heroes and packed for the desert—bright days, cold nights. Before I left, you gave me two things. One was a purple carabiner, for my water bottle and keys. The other was a sweatshirt of yours, an oversized black hoodie with a front pocket and a white drawstring. I wore it on the plane, guiltily, indulgently, wanting to be wrapped in you completely. When I finally landed at the tiny airport in Santa Fe, the sky was a brilliant blue and the ground beneath was dry and cracked. I could already feel the change in altitude, like a note held high in the throat. My nostrils felt tight.

I stayed that first night in Santa Fe, at the house of a friend of a friend, a woman named Diane. We went out for tacos and she took me to a talk by Roxanne Dunbar-Ortiz, held by the Lannan Foundation. Outside the theater, we ran into someone Diane knew. "Larissa, this is my friend Lucy Lippard," she said. I shook the friend's hand, trying to play it cool. She was Lucy Lippard.

The next day I took a harrowing shuttle ride to the residency, located in the mountains at a religious university's secluded seasonal campus in Taos. There was a dining hall, a library, various nooks and conference rooms to write in. A short walk from the main building were the casitas, cozy adobe cottages where the residents lived; in each was a working fireplace,

dorm-style showers with swinging metal doors, and three bedrooms. All around us there were trees: white fir, ponderosa, quaking aspen, and beech. The place had the feel of a summer camp: a firepit, a stream, a stage in the woods. The colors of the campus were adobe red, mud brown, bright blue, the pale green of tall grasses, and, all around, the crackling gold of dry aspen leaves.

We were told to pack headlamps or flashlights before leaving, but I didn't pack one—I didn't think it'd actually be necessary. But on my first night I realized there were hardly any lampposts on campus, and you needed a flashlight to travel even a short distance. Once the sun set, the darkness felt impenetrable, velvety-deep. It was the kind of thick, syrupy darkness that spreads like a pool of water, that reminds you that darkness is the natural condition of the night.

The seclusion of the campus seemed to mask a whole hidden landscape of tiny sounds, too. Coyotes prowling through the woods; leaves rustling in the trees. Tinier, even: I imagined I could hear the sound of a bug crawling across a dry leaf. I was assigned to a casita with a nocturnal poet and a short story writer. The window in my room faced an empty field, through which I could hear the breeze blow. In the mornings, the sky blue-gray and pale, sometimes I heard the crunch of someone walking on the gravel path outside.

I missed the constant noise of the city, the sirens and rumbling truck traffic that eclipsed the minute disturbances of

the night, blanketing me in an ocean of ambient sound. Lying awake on the casita's lofted bed, my ears pricked at the slightest noise. I imagined ghosts. A pair of eyes peering at me through the wrong side of my window.

4. It was at night, too, that I'd call you. I wish I had the record now, of all the hours we spent on the phone during those two weeks I was away. Sometimes we used video, and I pointed my desk lamp at my bed and held my phone above my head, blinking up at your image alluringly, but more often, once we had grown accustomed to the distance between us, we talked on the phone in the conventional way. I liked to put my earbuds in and snuggle up in bed, closing my eyes so I could pretend you were next to me.

I loved the sound of your voice, right in my ear. I felt so close to you then—our voices mingling together on the airwaves. It felt so pure, like the cleanest kind of communication— the sound went straight to my heart. I loved to hear you breathe; I even loved the crackle of static that told me you were still on the line. I learned to sense when you were growing tired. Sometimes, I thought I could tell when you were smiling, or maybe that was just because I was smiling all the time.

We must have talked about something—so often did I hang up from what I thought was a short call and realize it had been over an hour, my lips dry. But I don't think I could tell you now what we said.

5. Sometimes I look at a painting or a drawing and I think I can feel the way the artist must have felt while making it. There are some brush strokes, some lines, some marks that just have *it*. This is one of my favorite games to play, alone or better yet with someone else who also wants to look for *it*, walking through galleries, pointing at drawings and paintings. "This has *it*," we say to each other. "This doesn't. This one, this has *it*."

What I mean by *it* is a kind of emotivity, a strength of gesture or performance that comes through the work so strongly I don't have to know what the piece is about in order to feel what it's trying to say to me. It's hard to describe *it*—a feeling, an instinct, a response provoked by the work. I don't associate the feeling as much with photography, where the message can be more visually explicit, and the process of construction more removed from an object's surface, though there are certain pieces of video art that have *it*, like Bruce Nauman's, which have given me chills. Drawings, to me, are most likely to have *it*—the hand of the artist is more visible, which to me makes the emotion more palpable. Jenny Saville's drawings in *Erota* have it. Cy Twombly's paintings are full of it; same with Basquiat's. But sometimes it surprises me with its vitality—radiating out of a Monet water lily. Trembling in the penciled grid of Agnes Martin's *The Beach*.

Walter Benjamin theorized on a property similar to *it*—he called it the "aura" of a piece of art. Written in response to the technological innovation that allowed people to make prints

and perfect replicas of artwork, he suggested: "Even the most perfect reproduction of a work of art is lacking in one element: Its presence in time and space, its unique existence at the place where it happens to be." When we can reproduce a work of art, Benjamin argued, its aura withers. Take away a work's specific context, and the work changes—imagine the ceiling of the Sistine Chapel as a print, completely separate from the ceiling. But this change isn't necessarily a bad thing, Benjamin wrote: "In permitting the reproduction to meet the beholder or listener in his own particular situation, it reactivates the object reproduced."

What Benjamin was identifying was the separation of art from religion and ritual, which placed an emphasis on the authenticity of a work, like iconographic painting placed inside a church. In reproduction, that specialness is shattered, and what comes forth, as Benjamin suggests, is a reactivation, provided by the viewer's own specific context. The presence of aura hasn't totally gone from us: it still remains, as in works of art that rely heavily on their location in context, like the Rothko Chapel, in which fourteen black-hued paintings by Mark Rothko are displayed beneath an octagonal skylight. I'd extend the logic to say that live concerts carry an aura; so do protests, and durational performances, anything that crackles with an energy one feels just by being there, and which dissipates with even the highest-quality photograph or video recording. In those recordings, the *it* might remain—and I think it often does—but the work's aura wavers when we view past performances through a filter of time.

6. I think they must intersect, Benjamin's aura and my ineffable *it*—these two ways of thinking about the experience of art. But Benjamin's aura degrades with replication, and the *it* I'm thinking of seems to survive it.

 That YouTube video of James Blake singing "A Case of You" live—it has *it*. The stirring emotion I can feel in Blake's voice, in each line. I could make thousands of copies and play it a thousand times, and each would still have *it*, until with the passage of time the files became obsolete, a version no software could play. I can listen to it, encountering it in my own particular life, and I can send it to you, in your own particular life separate from mine, and you will still have it, too. That's what Benjamin must mean when he writes about reactivating a work: that the work takes on a different significance.

 So what is *it*, if it survives replication, if even with degradation it might pick up an extra patina of character? I wonder if distance is the distinction. The aura—I have to be there, with the work. *It*—I can feel it even from far away.

7. Sometimes, I listen to your voice on the phone, and I think to myself, *Yes, you have* it, even from two thousand miles away.

8. It wasn't what we said to each other but the fact that we were on the phone at all, late at night, when everyone else was sleeping. It was the crackle of your voice in my ear, in the sound of your breath, in the way I could tell when you shifted

in bed, even though our eyes were closed and a country of fields and desert between us.

What I remember, and what I treasure in my memory of those nights, isn't the content of our conversation but how it was carried in your voice, its warmth and its timbre. Thinking about our phone calls now, I'm reminded of that Marshall McLuhan coinage, "The medium is the message," which he loved to riff on—the *medium is the message, mess age, massage*.

The message of any medium is simply another medium, McLuhan suggests. Written text carries speech; speech carries thought; thought itself is one of many nonverbal processes, the language for which we are always grappling. Reading McLuhan's text in grad school, I always pictured each medium swaddled in the prior, like a series of Russian nesting dolls; the last and most inarticulable, thought or emotion or touch itself, I imagined as a kind of shining pearl. I wondered at what was lost, in each translation: how did I know that I was really saying what I wanted to say?

To truly understand media's impact on society, McLuhan argued, we ought to examine a medium itself and the way it changed our behavior. He used light as an example: we don't think of it as a medium until it's used to spell something, like words on a neon sign, or—like the way I'm typing this—words on a screen. But light is simply pure information: it reveals the world, the image of which is carried to us by the

light that reflects off the world's surfaces. Light makes pictures. It extends the reach of our waking hours; it makes a whole range of actions possible: night baseball, brain surgery. Considering the way light shapes our world, then, is just as important as what that light reveals.

The headlamp I ordered online and had delivered to the residency—its weak beam illuminating a pale circle on the gravel roads to guide me home. Stacks of Polaroids, instant photos refiguring our relationship to performance, to the immediacy of memory—I think of all the memories I've tried to keep, packed in ice and stored on my camera roll. Video calls, cell phones, a radio in every bedroom, bringing the world indoors and face to image to image of face, eye contact suddenly something that could be sustained internationally. Or a voice—a voice carrying across miles.

You could have read me the dictionary and I would have felt just as close to you. I was moved by it—by how across distance you wanted to close that distance with me.

9. On "Good Guy," a one-minute interlude on his album *Blonde*, Frank Ocean sings of coming to New York and being set up on a date of sorts—how, upon first meeting, he had to reconcile that the actual person, the *you* of the song, was so different from the person he had imagined.

On the track, which, like James Blake's cover of "A Case of You," is spare, just vocals and keyboard, Frank's voice feels

intimate, mic'd close, but with a little crackle to it—a little grain, as if synesthetically experiencing a song like a landscape through a window screen. Paradoxically, it's the scratch and grain of it that makes me feel closer to him—if the quality were too high, it'd feel uncanny, overproduced and clean. Instead, it feels like a phone call—I'm reminded now of garfreeek's voicemail comment—and each line comes across like poetry, separated by simple chords, until the end of the track dissolves into chatter and conversation, as Frank turns away from the microphone.

Every time I listen to *Blonde*, I'm always struck by that line about the person he meets for the first time, after messaging together—how they text nothing like they look. The way Frank sings it—half sings it, really—the end of the sentence hangs in the air, a stray observation made poignant by the pause that follows it. And isn't it true that we type differently than we speak? The staccato blip of the text message; the lapse and pause of the typing-indicator dots. A line of text can seem so bare and honest, yet detached—it makes me brave, as I lie in bed, in the glow of my phone, trying to decide what to write to you.

10. I liked the shape of my days in the mountains. It was like camping. I went to bed early, earlier than I'd ever managed in the city, with its distractions of clubs and dive bars, and every day I woke with the sun. I wore your sweatshirt daily. Filled my thermos with piñon coffee and drifted into the dining hall to find breakfast—oatmeal, blueberries, cold milk.

I was there to write; I was there to start to write this book. (Maybe this is why you are in so much of it: you were in my mind when it began.)

Provisionally, it was to be a catalog of intimacies—the closenesses, the small things, the tiny accretions on the surface of a relationship that not only built a relationship but gave it its texture. It felt tautological, but it was the intimacies that let us know we were intimate—the way we became close to each other. I was intrigued by the phenomena, so separate and articulable, by how the emotional language I found myself developing so often seemed to be shared with others. The universal and the particular.

It was a book of surfaces, in other words, or so it began that way, and so I considered myself a sponge, eagerly absorbing the details of the world, ready to identify, to isolate, to describe. But the mechanics of closeness can be feigned, and defining intimacy itself—of thought, of mind—still seemed elusive to me. I'm only realizing now that my approach was itself a study of a medium: of intimacy's various containers, and not its content.

What, in all of these vessels, was I trying to hold?

11. It's impossible for me to write all day, every day. I have tried. I always find my mind winding down in the afternoon, and after dinner, it's impossible for me to put down anything new. In the evenings, in Taos, we'd gather after dinner in

someone's casita, and build a fire, and talk, drinking bourbon neat out of paper cups. I recall there was something in the hard liquor that dissolved the adhesive in the cups at the seam, turning the paper translucent and cold to the touch— so many cups I'd found myself absentmindedly pulling apart mid-conversation, my mouth a little numb from the whiskey. As a group, we had become close quickly, the kind of quick kinship brought about by circumstance that I remembered from France, though here we were all women, and none of us were white.

We didn't talk about writing; we had all day to do that. We talked about other things, life things, getting straight to the heart of our vulnerabilities with an intimacy only isolation and proximity can foster. And we talked about how the land made us feel. We were convinced that there were ghosts on campus, old ghosts that felt close because of how close we slept to the earth. At night, we avoided running water, where La Llorona was said to walk. One of us said she saw a figure sitting at the foot of her bed. What did you do? we asked her. She was tough, the toughest among us. It stared at me, she said, and I stared right back!

One night, one of the last nights I was in Taos, we heard there was going to be a meteor shower. It was October, so it must have been the Orionids. We went to the athletic center and arranged folding chairs in a semicircle around the firepit; there was a fire in it, and blankets for all of us to lay across our laps.

The meteor shower wasn't visible until after midnight—did you know that, like so many other things in the sky, meteors are falling during the day, but the sun's so bright we just can't see them—and I'd like to think that that night I did see them. Look for meteors long enough, especially on a dark night with a clear sky, and your eyes will start playing tricks on you. Vibrating in the atmospheric twinkle, jumping from star to star, you start to wonder if what you see is actually falling or if you're just noticing the presence of something that was there all along. I'd like to think that there was a shower, that the sky glittered and spat and spun. But I think what happened was that we stayed up all night together, and, for a few seconds, every now and then, a flash of something moved in the sky.

The only meteor I really remember seeing before this was in Portland, with my little brother, maybe six or seven years before I went to Taos. It was summer, so it was the Perseids, the showiest seasonal meteor shower of them all—at its peak, there were supposed to be fifty meteors falling each minute. We were both home on break and feeling restless, and when I found out there was going to be something in the sky, I convinced him to drive us to the middle school in our suburban neighborhood, where a track encircled a field, both open to the public. In the parking lot, we sat on the hood of the car, a kitchen knife between us to scare off any lurking creeps. But there were no creeps, and it was just us, and before ten minutes had passed we saw a meteor—huge, with a sparkling tail that seemed to fall, slowly, stretching an inch across the

sky. It was the kind of meteor that made me understand why they were also called falling stars—that made me understand why anyone could think a star could fall. We looked at each other in disbelief, but it was true: we had seen it. I don't think we saw another meteor that night, but we didn't have to. I can still remember it clearly, its descent so breathtakingly slow. It is on my eyelids, silvered as if etched into a printing plate; I can see it now.

12. Why is it that YouTube seems so much more authentic to me than any other audio copy? It isn't the sound quality, which is just fine. I think some of it has to do with the fact that it's video, which necessitates a kind of visual articulation. Some choice of image must be made, which reveals the hand of the person, who, out of passion or duty or desire to preserve, uploaded a certain clip. Or maybe it's the comments, that accumulation of praise and unabashed poetics. I love to scroll down and read the notes people have left— sometimes, especially the deeper you get, they start to feel like diary entries, or postings on a bulletin board gone faded with time.

From Ranja Ranja, five years ago: "am weeping ..don't even know why." From Buum, eight years ago: "To the awesome girl I met on omegle that I linked this song to: My internet disconnected and I couldn't get your contact info. Email me at [email address] plz :D."

I hope she did find Buum, and write back to them.

Back in the city with my word count and my new manuscript and my fresh memories of the desert, I played the James Blake cover for you—the version I liked, the live one on YouTube. The version on his 2011 album, *Enough Thunder*, doesn't feel the same to me—it lacks that *it*, that alive, charged quality.

They're from the same performance, you said. But I was skeptical. We listened to both, again. Yes, the same riffs, the same intonations. I still felt like one was missing something. It must be something in the way the album version was mastered, you explained.

In mastering, whatever the mastering had done, they had pressed the *it* out of it. That made me sad—it was like how the studio version of a song always feels too squeaky clean, each note perfectly in place. But as long as the YouTube version is up, I'll know where to find *it*—with the accretion of comments and sentiment I love to read. Its context, its history, how I've linked to it over and over, like a thousand other listeners: maybe, inadvertently, that's where its real aura lives.

13. There's another live recording that I love. It's a video of Stevie Nicks, backstage at a 1981 photo shoot for the cover of *Rolling Stone*. My friend Harron showed it to me, on an afternoon I was hanging around at her house. In the video, which is low-quality, full of the artifacts of its provenance and recording, Nicks is seated in front of a window, while a makeup artist attends to last-minute details, powdering her temples,

her cheeks. After Nicks sings a few lines from the song that would become "Love in Store," a capella, without much pre-amble an impromptu performance occurs, as someone puts on a tape of a track's instrumentals. This is the one, Nicks says, smiling and pointing toward the camera, as though a note can be seen, and then she and a friend, a backup singer, begin to sing.

The demo version of "Wild Heart" Nicks performs isn't the same version that would end up on the solo studio album of the same name, which she released two years later. That version is slower, wound-down and pristine. Instead, there's a fluttering sweetness to Nicks's live performance, emphasized by her bare face and white clothes. "Like a white swan," Harron said. The song's chorus has a propulsive energy, the singers joined in a tight harmony, while the ongoing guitar riff beneath their voices carries the song forward—I find myself leaning forward, too, as I listen.

The quality isn't very good, warped as the recording is through time and transliterations across mediums, but the performance still feels special. When Nicks sings I love you, I do, she closes her eyes, her shoulders rolling with the music, half dancing, half swaying. It's a moment that brings me to that point of breaking—that loosening again, as in Blake's performance. As though tears are about to fall, though in Nicks's case, it's an overwhelming, happy kind of slippage, an opening of compassion. One of the top YouTube comments feels telling:

"If it's 3 AM and you're slightly drunk and you need to cry, but you're emotionally constipated and can't, watch this video. It's my go-to," writes Don Sulis.

It's as though listening to Nicks, seeing her lose herself in her performance, grants us permission to lose ourselves—to turn the key in the lock, to open the door, to empty the room full of water. To let ourselves cry. The comments are full of this kind of affective response:

"lost in music with the voice of an angel! Tear in the eye!"
"Yesss, so pure and perfect and innocente... tears in the eyes and lump in the throat"
"I get the chills..."
"This is so comforting to me. My soul can't get enough."

There are a number of factors that lend the video its enchanting presence, like the low quality, which serves to enhance the spur-of-the-moment aliveness of Nicks's performance. The grain and distortion become an obstacle to fully comprehending the song, which paradoxically encourages us to listen closer, ears pricked. Many of the video's comments speak to this desire to hear the song more clearly, wishing someone would restore the audio. But like the mastered version of Blake's live performance, I wonder if we *don't* actually want a cleaned-up version of the Nicks demo. I wonder if some of the magic would be lost then, like how a blurry photograph always looks more in love.

In the video as it is, there's a sense that something has been saved, as though we're allowed a glimpse into a world behind the scenes. It's a backstage, off-the-cuff performance someone thought to record. Aren't we so lucky to have it now, even as a fragment? It feels as if we've kept only the most beautiful, brightest moment of bliss, the way I always want my life to look when I look back upon it. Maybe it's better that we're only granted a part of the whole. Even the song itself feels like a fragment, a chorus the singers launch into again and again, with no real end point, although the song does end, as all songs do.

14. Sometimes it's easier to write to you, or to speak to you without seeing your face. I feel like I can be more honest about who I am and what I need.

I wanted to show you the real me—not the version of myself I thrust in front of me at all times like a cardboard cutout, anticipating the pain of being misunderstood. I was so used to that kind of disclosure—a way of being seen without really being seen.

At night, in Taos, there was no performance, no spotlight. Just my voice and your voice and the things about us that we were beginning to share, slowly, like slipping into a swimming pool.

Later, much later, you'd learn how to read me, how I said things with my body instead of saying them aloud. You'd

glance at me and within a second, two seconds, you'd know what was wrong. How you understood me then—how completely.

15. Writing this chapter, years removed from these events, I find myself humming along to the songs that I'm playing in the background—Now, Now; Caroline Polachek. For the most part, I think of myself as a failed painter, but in the hierarchy of the arts what I wish most of all is that I were a musician. I miss how it felt to sing in a choir, lifting up my voice in service of something big and pure and full. When I was younger, I used to sing around the house when I was happy—I imagined my voice cascading in a ripple down the stairs. Then, for some reason, I stopped.

I sing around you, sometimes.

It's always seemed so unfair to me that I could write paragraphs and paragraphs and yet all that could be felled by a song. Writing to me seems to be a kind of playacting—a gesture that dances around the feeling, which cannot be held in words. I just want to make you *feel*.

Dark Vessel

1. There was the time where an old boyfriend and I fucked as quietly as possible just to see how long we could do it. I was happy and we were drunk off a bottle of Jack Daniel's I had bought with the fake ID that said I was a Gemini from Pittsburgh. Try, he said, putting his hand over my mouth as I put one knee up on the bedframe. Shhh. Don't—don't make a sound. There in my dorm room, with the leaves of the elm tree outside tapping against the windows, I could feel the cries of pleasure bouncing around my body with no exit, as though I were a vessel stoppered, a hot, dark liquid splashing around within.

It seemed that we had discovered the secret of the world, and that secret was silence. How much joy did we get from keeping our joy quiet from each other, each of us exploding into pleasure in our own, separate worlds. No, it was never meant to be; we hardly lasted as long as the magnolias, blooming in the spring like little unclenching hands. But I learned something then, about how it's possible to be together and still feel alone.

2. In 2015 I dropped out of grad school after a professor accidentally left a whole page of porn tabs open in his browser while trying to navigate to a YouTube clip from *The Birds*. It wasn't the moment itself that bothered me; it was that I was paying so much to be lectured at by someone who didn't understand the concept of a private browsing session. But I did retain one concept, one image that has lingered with me ever since I read it—not even a particularly salient idea, just a one-off line in the prologue to an essay by John Durham Peters about Hegel:

> Language is resistant to our intent; nonetheless, it is also the most reliable practical means of persuasion we have. Though language is a dark vessel and does not carry quite what I, as a speaking self, might think it does, it still manages to coordinate action between selves more often than not.

It's that image—*language is a dark vessel*—that I still think about often. Our words are oblique; they are tools, imperfect; we trust them to carry what they carry. You have your vessel, with its shimmering fluid, and I have mine. And I cannot see into yours, and you cannot see into mine. Your heart is so dark to me, and so obscure. But somehow I must trust you, and we must make this work, this whole business of talking to each other, trying to take care of each other, each carrying our amphora of fragrant wine.

3. There was the boyfriend who would show up at my apartment in Crown Heights—fifth-floor walkup, low ceilings,

dark wood floors, flat-pack furniture—after taking the train in. He would arrive tired and immediately roll a joint on one of my books, sitting on my bed in an unbuttoned dress shirt and briefs, his sleeves pushed to the elbow. We'd smoke together in silence, then descend into deep, transfixing bouts of fucking, a language we spoke better and truer than any other, our senses waterlogged.

One evening, approaching winter, he fell asleep in my bed, only waking a little after dinnertime had passed. I couldn't sleep; I stayed awake and watched him and read. We had hardly said a word to each other since he arrived. But he had obligations in the city that night and so did I, and he wasn't sure if he would stay over. I remember that I said it was okay. I remember that it wasn't. I walked him to the door, full of so many things I wanted to express which were now blanketed in our silence, as snow blankets the detail of grass on the ground, and I remember that I kissed him as he left into the blueing evening.

After we broke up, which was not long after that night, we had trouble disentangling from each other. Sometimes he would text me in the early hours of the morning—it was almost always him making contact, I had my pride—and once, in those hours, he sent me a poem. I was enraged at the time, upset with him for crossing a boundary that we had agreed to try to maintain. But I think he was just trying to find words for what he couldn't express, or, perhaps more likely, he had encountered something else in his life that had opened up a chamber of his heart and reminded him of me.

4. Plato compared conversation to erotic love because both require the same kind of absolute communion. The most ideal way to exchange thought itself was, or so he hoped, a kind of telepathy as one experiences in the heavens. We were to have pure transmissions between our souls. But the trouble with that now is that our main tool is language. That dark vessel. That blunt instrument.

5. I am thinking now about the word *vessel*, about how it conjures a secret, a chamber, and a void.

6. I sent a poem back, too. Actually, it was a few lines from *The Little Prince*. It seemed easier, and more oblique, and therefore more prone to misinterpretation, to use the words of others. I wanted that gap in communication, to have him have to rely on the implication of feeling. To stand behind a quotation rather than use my own words, words I'd have to own. "'Don't linger like this. You have decided to go away. Now go!' For she did not want him to see her crying. She was such a haughty flower . . ."

7. That's not to say I don't believe that there are things we can say without words. There is a whole alphabet of silences, a lexicon of silences that say without saying. The way I turn away from you when I think you've hurt me. The way I turn toward you to say I'm sorry. The way I turn toward you when I want.

My first semester of college, I took a class called Tragedy. We were reading a play aloud, another student and I. He was a

jock and an English major; I was an art student masquerading as premed. The play was *Venus*, by Suzan-Lori Parks. Our lines came to a section where there was a long, staged silence—

(*Rest*)
(*Rest*)
(*Rest*)
(*Rest*)
(*Rest*)
(*Rest*)
(*Rest*)
(*Rest*)

—and we sent the silence back and forth to each other, holding the pulsing live moment for as long as was bearable. And then I took a breath, and I read my line.

Nice, the professor whispered, as we moved into the next section.

We agreed, after, that there was something in that silence. I could feel it; he could feel it. We could all feel it.

8. I've always loved the idea of an ekphrasis more than the actual form. I like the idea of a poem or piece of writing that stretches toward visual art, trying to tell the story it sees wrapped within, and in telling it, giving life in the new form the author chooses. There's a balance in ekphrasis—of

translating the language of one form into another without falling back on visual description. I remember the first time I wrote my own ekphrasis, in a writing class in high school, on that landscape that hides the fall of Icarus, by Bruegel. A foot and leg poking out of the sea the only sign of how far he'd descended, and how small a man he had become. The challenge was to write something that said something more—or something different—than what the painting said.

And in practice, nearly all my ekphrases have felt like failures—attempts at reiterating something that was already perfect in the language it used. There are things that poems do that paintings can't, and paintings speak to us in ways unlike the way of poems. Wasn't the point of looking at a painting to feel something wordless? Why not let it remain in that realm?

I guess all writing is a kind of ekphrasis, if you look at the root: To tell out. To describe. Maybe that's why I got into art history—it was an ekphrasis that made sense, that didn't feel fruitless, in terms of telling out and around. Providing a context for the work in order to try to see it with new eyes.

I've told you about how I like to go to galleries and museums looking for *it*, my take on the aura I borrowed from Benjamin. I wish that *it* no ekphrasis. I hope it remains beyond writing.

9. I don't like it when I'm dancing at the club and someone tries to talk to me. The dance floor isn't meant for talking.

10. When I'm happy, I imagine myself dancing.

11. When I'm really happy, I imagine myself dancing under strobe lights.

12. A fight with you. I'm not feeling understood. My friend Santi once said that when I'm hurt I wear my hurt like two little horns. You attack people with it, they said, and force them to listen to you.

 That's the only way to be that makes sense to me—how else will people know they've hurt me unless I tell them? But that's not how you respond to conflict. Your light goes dark; I see you're not there. I can feel it in the way you text—short, clipped, with punctuation.

 When we do see each other—sometimes it takes days to come back together—it's as though being close makes us real to each other again. We sit at a bar and talk, wading deep into our emotions, like children. While we talk, I hold one of your hands with both of mine. Then, much later, in the light of the salt lamp you bought online, you touch me. And I touch you.

 How often have I thought, If I could just touch you, I could make myself legible to you?

13. There was a boyfriend I kept sleeping with for too long, long after our relationship had expired. I'd tried to raise it

from the dead, but he didn't love me anymore. We still met up after afters; at sunrise, coming out of warehouse parties; at 1 a.m. on weeknights finding each other in the back of a dive bar, the toe of his heavy boot hooked under the bottom rung of my bar stool. Never once did he say he'd take me back, but by then it wasn't his love I was looking for. All I knew was that if I could get us in the same room at the end of a night, he'd take me home with him. At the time, that felt like winning, though the sex wasn't much of a prize, nor was it a consolation.

This is my weakness: I rely on the language of the body too often, when I think no other language will serve.

14. Some silences are surprising to me. They evolve. I like when a silence starts out uncomfortable and then opens up into something peaceful, without movement or effort. It's like how you walk past a dry old tree at the beginning of spring, when only the evergreens aren't bare, and it seems that there would be no life in it, but then you find it's full of birds.

15. No, it's not like that. I don't know what I was thinking when I wrote that.

16. One spring, my friend Jaime and I drove up to MASS MoCA. Well, I drove, because Jaime doesn't drive. It was about four hours from New York on a mostly narrow stretch of freeway. The new sap-green leaves cast flickering shadows on the hood of the rental car.

I liked the way one of the shows on view was hung and curated, a selection of contemporary painters. The galleries were painted a grayish mauve, and—surprising for a painting show—the lighting was low, so low it felt spooky to move from room to room. Each painting was lit on its own, albeit dimly, as if vignetted or seen through a pinhole, so that its colors seemed to creep into existence. Every time we changed rooms, our eyes adjusted minutely to the light.

I liked the series by Cynthia Daignault, arranged in a grid, collectively called *40 Nights*. She painted them while living alone in a cabin upstate, in the winter of 2014. The frame is always the same, featuring the same thatch of bare trees, one careening to the right as if caught mid-fall, so the paintings have the feel of time-lapse photography—a sunset, a dusky sky, a nightscape, branches lit by the glare of flash. There's something so photographic to me about Daignault's body of work, which riffs on the passage of time and the urge to commemorate—each painting an instant, or an image of an instant. But I appreciate it, how she understands that photography itself is a language. The rectangular frame, subject centered in the middle. The iconography of a beautiful face, as in her paintings from images of Marilyn Monroe. The flattened perspective, though Daignault paints her landscapes en plein air.

In *Night Walk*, from 2015, which was also on view at MASS MoCA that day, Daignault returned to her hometown, using the 35 mm camera she'd used in her adolescence to retrace a

night walk through her old neighborhood. From the black-and-white photographs, Daignault made a series of twelve paintings on wooden panels. Trees illuminated by street-lights; the distant glow of a house with windows lit. Roads feature, and shadowy backyards, and the edges of suburban homes. The compositions of the paintings feel flattened by their source, but Daignault's touch is painterly, thick squiggles of ivory black mixed into cremnitz white that precisely conjure a photograph from afar and dissolve into incoherence up close. To me, the utter lack of color in the paintings feels unnatural, almost digitally rendered, like seeing an uncovered study, or skeleton. All form, all bones.

It reminded me of the way I used to feel about the potential of each night—the world pulsing and digitized and neon. Everything a vessel or a flower or both. Everything a painting or a pop song or a novel.

Later that day, Jaime and I walked through the James Turrell exhibition, which had opened in a new wing of the museum just the year before. Lines cut out of light. Spaces shifting and opening, changing your perception of the room. Something about Turrell: he knows the importance of the thickness of a barrier, of making a wall so thin it seems permeable enough to disappear. (It reminds me of something Robert used to say in drawing class: Remember, even paper has a thickness.)

Turrell has a series of pieces called *Corner Shallow Spaces*. From a distance, they appear three-dimensional, as though

a cube or pyramid of light has been suspended in the corner of a room. At MASS MoCA, Jaime and I walked toward the light. Put our faces close to see how it was made. Peering inside, we saw that it consisted of a light fixture within a convex, hollowed-out space. To give it the illusion of shape—to contain it—the light was bounded by the white edges of the walls, which were thinned so much so as to appear ethereal. It wasn't an architectural fixture; it was light as construction, light as object.

Richard Siken: "The light is no mystery, / the mystery is that there is something to keep the light / From passing through."

In other rooms, darkened by black curtains and painted walls, Turrell draws with light, creating luminous veils and the illusion of vertical planes. I like Turrell because his work reminds me of going to the club, except it's quiet and introspective inside.

17. There is one other piece that I want to tell you about. It's Turrell's *Hind Sight*, one of his *Dark Spaces* from 1984. The space inside is limited, and the two of us had to wait for a spot to enter. When our time arrived, we shuffled past a curtain through a series of zigzagging dark corridors, the darkness deepening with each step. When the last glimmer of light was gone, I put my hand on the wall, and I was scared. I don't remember what Jaime said; I think she told me not to be scared. We stepped into a small, dark room and, unsure of where to sit down, stumbled our way to the two chairs. We sat in the

pitch darkness, in silence. Minutes passed: five, then ten. I felt the borders of my body dissolve in the absence of light. There was no way to tell who I was or what I was made of. I even thought I could feel the surface of my eyes—really feel them, the film on them, as if I could sense the surface of my own tears.

Then out of the darkness resolved a soft, shifting ball of light, like a will-o'-the-wisp. Small—like the moon seen from a city sidewalk, and far less bright. At first it looked white, then maybe red. I thought I was hallucinating, that I had willed it into existence. Is there a light there? I asked Jaime.

Yes, she said, there's a light.

We sat there longer, watching the light shift and change, our eyes fully opened up to it. I thought I might cry. I thought I heard her crying.

18. After I got back from my residency in Taos, I flew into your arms. It was the end of October. We spent the weekend together; saw the Cecily Brown show that had just opened at Paula Cooper and went to Printed Matter to look at spiral-bound zines. On Halloween I texted you, asking, Do you want to get tattooed together? You said sure. We met up after work at the shop I always go to in Manhattan. I was nervous and happy, but you seemed relaxed. My tattoo artist was done before yours, and I found you in the back, sitting on the vinyl bench, eating a piece of chocolate to raise your blood

sugar. That's another time that I fell in love with you: in the back of a tattoo parlor, the ink only halfway done on your leg.

When we were done, we went to a cocktail bar for a drink. It was dark and luscious inside and smelled like an apothecary. I was giddy from the tattooing, shot through with dopamine—I felt like a broken bubble machine, overflowing with suds. There was a bandage on the back of my arm. I put my face close to yours and told you I wanted you, and that made you smile. Your body, my body, inked together. Now we had done something we couldn't undo, and I treasured that—having this moment made permanent. I feel high right now, I said dreamily, burying my nose in your neck.

19. After that day, I'd look down at our joined bodies during sex and see your tattoo. Most of the time I forgot it existed, the way I forget about all of mine or the way with your touch you made me forget about everything. But when I did see it— the ink standing out dark and sharp against your skin—I felt again that hit of recognition. Here was a commitment you had made to me on your body, no matter what happened or would happen.

When I asked you if you had felt any hesitation, you told me you hadn't. I knew, you said, that I would be okay with thinking about you every time I looked down at my leg.

And I felt something inside me recoil, like hope either being birthed or drawn away. We had known each other five weeks.

I ran my fingers over that patch above your knee, feeling the raised ink.

Something else I often forgot: there also existed a part of me that for you I'd marked.

20. In the museum, Jaime and I sat in the dark space until the piece ran its duration. Then a new light came on, and I saw that the chairs were just chairs, and the room was just a room.

Ways of knowing
when it's time to go

A starting gun
A text message
A plane ticket
A phone call
Last call
An upside-down shot glass in front of you at the bar
An orgasm in an unfamiliar room
A failure to come
A silence
The moon is visible

The moon isn't visible, and you want to find it
You're the happiest you think you'll ever be at this party
Everyone else around you is hailing a cab
The sun is setting
The pool is closing
They've turned off the fog machines
The sun is rising
The sun is rising and a song you love has started to play

Breakup Interludes

Before I left for Mexico City

February, and I'd finally quit my job at the nonprofit downtown. I still cared deeply about the work, but I was burning out on how hopeless working within the structure of nonprofits was starting to feel. Late the night after I gave notice, I bought a round-trip ticket to Mexico City and found a place to stay for two weeks in Condesa, a studio apartment on the roof of a building where bougainvilleas bloomed. I'd go to write, I thought, without interruption. Ever since I'd left the residency in Taos I'd been fantasizing about a place away from the distractions of home where I could do nothing but focus on my work. I missed the sweet desert air, the syrupy darkness of the nights.

And I felt the pull, too, of reinvention. I missed who I felt I had been in Taos: the serious, self-possessed writer I hadn't realized still lived within me. Before this, my trips out of town had always been short, bookending my work schedule—a week, four days, never long enough to gain more than an impression of any new place. Now, free of the job I'd had for two years, I wanted to commit to a change. I wanted to see what it might be like to be an artist again, and I thought that shaking up my surroundings might work, wriggling out of my old life to make something new. So go, I thought. Change. Learn something and try to make art

while I'm there. But the moment I confirmed the apartment in Condesa, I felt more anxious than excited.

When I told my roommate Santi about my impulsive plans, they perked up at the idea. Would I mind if they came along? They worried about intruding on my self-assigned writing retreat, but I felt only a wave of relief, embarrassed at how much I welcomed the change in plans. How could I have thought I could go it alone? Please come, I said.

And so it was settled. Santi would join me for the first week, then leave for Miami. We'd do all the things you needed a friend to do—go sightseeing and climb the pyramids and dance at whatever parties we could find. The second week, I'd be alone in the apartment. I had fanciful visions of myself on the building's terrace, hammering away at a manuscript, an iced coffee melting next to me, forgotten for the burst of inspiration I'd surely feel. I lingered less on the prospect of being alone with my own thoughts. A day out from my flight, I packed the long, flowing orange skirt I loved, a sleeveless black tunic, and a striped shirt-dress that buttoned down the front. Sneakers and sandals and, optimistically, a stack of books, wedged into one side of my duffle bag. I was excited to leave, and nervous, excited about what change in me the trip might bring.

The night before I left, I went to your apartment. We lay on your bed in the room with parquet floors and huge windows that looked out onto the street. Someone once told me that I never made love, that I did many things but that phrase would never apply. But

with you it didn't feel that way. When we fucked it was slow, and beautiful, and fluid. Sometimes I thought I might cry from the overwhelming splendor of you inside me. Sometimes I did.

I wasn't going to be gone long; I'd planned for just two weeks, like the time in October when I'd left the city for Taos. But it felt like so much more this time around, because I knew I wanted to be changed. I didn't know what that change would look like, but there were things that I wanted—to commit myself to my writing, to go somewhere on my own, somewhere new—and, maybe paradoxically, I was afraid of losing you. I was scared that any shift in me would lead to something shifting in you, and I wasn't certain that you'd want to stay. To wait.

Can I tell you something intense? I asked.

Yes, you said.

Looking back on it now it seems obvious what I was doing—that I was trying to draw a boundary around how I felt for you, whether or not I was ready, whether or not you were, trying to inscribe it in words to make it last. I thought it was a protection spell, a promise to return. I put my forehead against your chest, so I didn't have to look at you as I said it.

I think I'm in love with you, I said.

You were quiet for a long time. We'd been together for six months. You wrapped your arms around me and didn't say anything.

Maybe I had said wrong; maybe I had said too much. Whatever I had done, I had told you how I felt, and I couldn't take it back. I lay there, inside your embrace, while a loud, roaring noise filled my ears.

Santi, Penelope, Santi

The next day I was in Mexico City, with Santi, looking for our apartment off Avenida Mazatlán. It was warm. Somewhere, twenty-six hundred miles away, you were at work in Manhattan—I imagined you drinking coffee between drawings, frowning slightly at your computer, thumb fiddling with the paper cup's seam. When we found our building, the Airbnb host came down to let us in, a woman named Penelope. She looked glamorous enough to be an actress or a real estate agent, her hair long and framing her face.

Inside, we saw the building was constructed with an open center, with rooms that surrounded a courtyard, each floor accessible by a set of wrought iron stairs that turned sharply at right angles. The car parked just inside the gate was hers, Penelope said. A veritable jungle of potted plants had been haphazardly placed on the stairs and terra-cotta flooring that made up the narrow paths between the apartments—I wondered if that had been her doing, too. Later, to my delight, we'd find that on the days when the plants were watered with a garden hose, the water streamed straight down through the building, pattering on the tiles, as though it were raining indoors.

The apartment I'd sublet was on the roof, surrounded by open air and the terrace that had attracted me online, the structure backed

up against another apartment that was already occupied. The tenants were mostly expats, Penelope explained to us in English, Europeans and Americans who stayed here for months rather than days. More potted plants decorated the roof: geraniums, a jade plant, tiny citrus trees. Bougainvillea spurted off the trellis in a riot of fuchsia blooms. There were plastic chairs on the main terrace and on the balcony that extended from our apartment, and perched on a table, a cut-glass ashtray. As I took in the place, I felt myself mentally taking notes, storing up details to relate to you. Already I couldn't wait to call you, to be reminded of the spark I knew flew between us. Even, I hoped, across this distance.

The interior of the apartment was cool and dim, the walls a light, tan stucco. The front door was glass, but the windows had wooden shades to keep out the sun, reminding me of the studio office in France. The kitchen had a small stovetop and fridge and led directly into a bedroom and a tiny bathroom, which branched off to the side. Another glass door in the bedroom led to a small balcony, separate from the rest of the roof terrace. I could hardly believe my luck at ending up in such a beautiful, homey place—it reminded me a little of my paternal family's home in Vietnam I'd visited as a child, with its mingling of indoor and outdoor spaces. Squat, five-gallon jugs of water with pump taps were stored by the front door, under the kitchen counter. We shouldn't drink the tap water, Penelope said. It'd make us sick. If we needed more bottled water, we could text her.

It was still early afternoon. In the sudden warmth I felt reborn, embryonic. On the building's Wi-Fi I texted you, told you I'd

arrived safely. Santi and I flopped around on the terrace for a little while, the mild air awakening our skin, then went to a nearby market to procure essentials. Groceries and toiletries that had been too big for the plane and a bag of bright green limes, to cut into wedges for the mezcal we'd drink that night and every night thereafter, the entire time we were in the city.

Chilaquiles. Jugo de naranja y papaya. Huevos rancheros at a restaurant down the block. Black coffee. White wine. Street tacos from a cart in La Roma that gave us watery shits that lasted for two days, so bad and consistent that Santi and I gave up on all semblance of privacy and kept the door of the bathroom open so we could keep each other company while our bodies emptied themselves. More chilaquiles. Avocado toast from Fröims, the café in the Hipódromo that all the white expats loved. Mezcal neat, mezcal with lime, mezcal reposado with a slice of bright, juicy orange. Croquettes.

We thrilled to the city. We weren't obvious tourists like the white Americans we saw roving through Condesa in groups of twos and threes, yet we clearly weren't locals, either, and so we fell into a liminal, uncategorizable place—outsiders to the city, treated with a cheerful hospitality and a bit less hand-holding than a white tourist might have merited. I was used to being an outsider no matter where I went, but I enjoyed how unremarkable I felt: even when I wandered around on my own, locals spoke to me first

in Spanish, maybe mistaking me for one of the Chinese Mexicans from the Viaducto or the Barrio Chino. That my Americanness revealed itself after my first faltered query was fine—I knew what I was. It was nice to feel neither at home—nowhere was home—nor, entirely, out of place.

Santi's Spanish was distinctively Colombian, slower than the fast-paced Mexican Spanish I had trouble keeping up with, but their fluency was a boon, and it allowed us to quickly befriend the bartender at the cantina we came to frequent. Santos, we'd say, leaning over the bar. Let's have another one! What's your favorite? I liked that he and Santi had nearly the same name. He wasn't a tall man; it made us feel close to him, and I wonder if he thought of us, with our banter and constant giggling, as children. A tattoo of his daughter's name wound its way in script across one tanned forearm. In the mornings, hungover from our nights at the can-tina, we made ourselves breakfast in the tiny kitchen or went to a restaurant a short walk away, returning to the apartment to sit on the terrace and read. Bare feet up on the garden furniture, the sun cutting a hazy swath through the city's pinkish smog. It was so warm. I had trouble believing that we were so far inland, that there was ocean far on either side of us but here no beach.

Across the street and visible from the roof where we sat was a beau-tiful, empty building—a white skeleton of lofts, the ceilings held up by white columns, framed in big windows, latticed with light. I'd look over at the empty building, the windows levered up, just like an art studio, and imagine a place for me there. Tall stretched canvases, a glass palette the size of a tabletop, and I'd never need

to write another word again. It must have been all apartments once—balconies faced the street—but it seemed that no one lived there anymore; the rent must have increased. On the ground floor was a newly opened, stylish zero-waste botánica, selling grains and pantry supplies in bulk, the new business replacing a pharmacy. The neighborhood was gentrifying: Penelope's building full of expats, and my presence, was proof of it. I'd hardly thought anything of the price I paid for my two-week sublet, and I had the advantage of the exchange rate. It was too easy to imagine slipping into a new, self-indulgent life in this warm, beautiful place—just another gringa in a city already filled with Americans all seeking, perhaps, some version of the same escape.

Lemony, spicy fried chapulines folded into corn tortillas with guacamole and beans, the tiny legs of the grasshoppers getting stuck in my teeth. The bright sour orange tang of fresh ceviche and the burn of the habanero salsa that accompanied it. A whole fish from Contramar, filleted and grilled, one half smothered in green sauce and one half red. Chicken wings so hot we chewed them open-mouthed while tears ran down our faces. Micheladas, margaritas, plastic quart-sized takeout containers filled to the brim with beer and studded with lime.

Afternoons we spilled through the city, not doing much of anything—just appreciating being present. We walked everywhere, through Parque España and Parque México, earnestly learning the shape of the neighborhood on foot, surprised at how many dogs seemed to be running around. Our friend Nico told us about Under the Volcano, the used bookstore in the former

American Legion, on the second floor above what was now an expat bar. We went, looking for first editions, but left soon after: it seemed silly to go to Mexico City just to hang out with a bunch of Americans. Another day we rented bikes from an EcoBici station, wheeling through the city, then went to a techno club that night, sharing hot dogs from a street cart outside before we walked home, single file on the narrow sidewalk as cars whizzed by.

Later that week, the café next door to Penelope's held an informal concert. We sat on the roof drinking mezcal and smoking Lucky Strikes from the 7-Eleven while the music drifted up to us. Someone downstairs was singing sad, nostalgic pop songs in English. One was a cheesy eighties song I recognized, though the name escapes me now, and the singer sang it perfectly, down to the slangy intonation, the way someone sings something they've heard a hundred times on the radio.

I heard the song on the night air, and I felt it—a small, sharp pang. I missed you. More than I expected. Hadn't I left just as I was in the middle of putting down new roots with you? But, I thought, or maybe only half thought, pouring more mezcal over the lime smashed in the bottom of my glass, maybe that was why I had gone at all. I had gotten scared again, and left.

Cerith Wyn Evans

At the Museo Tamayo we walked through the Cerith Wyn Evans show: tangles of neon light suspended from the ceiling by fishing line. I was used to seeing neon lights in signage—jutting from buildings, or backed with a heavy metal support and hung on a wall, as in a Tracey Emin or a Bruce Nauman. But Evans's neon lights, encased and thrumming in custom glass tubing, were ethereal: they seemed another medium entirely. The sculptures hovered midair, close enough to touch, parts trembling at the slightest change in air current. We circled round each large, fragmentary piece like children visiting an aquarium. I took pictures of Santi through the scribble of lights, liking the intricate manufacture of each tube, the way the neon gas of each bulb flared bright blue at the end. The work was like seeing drawings in air, a complex thicket of lines jutting into three dimensions. Some pieces retained a geometric symmetry, the light shaped in concentric circles or bursting out like the spokes of a wheel; others felt gestural, as if strokes of pure light had been dropped with a pen. There was a language, there, in the light pieces—it wasn't a written language like any I'd known, but a system of intuitive mark-making that conveyed a range of feelings. The neon gestures were energetic and close together in some sculptures, precise and clipped elsewhere, and yet in others stretched and ponderous. We moved through the rooms slowly, not saying much.

In another room, there was a series of stately glass chandeliers, hung low, the lights flashing on and off according to some innate, predetermined pattern I couldn't discern. It didn't seem random. I'd later learn the lights were transmitting poems, transcribed in Morse code. If only I had known, at the time, that they were trying to say something to me. I might have wanted to say something in return.

John Baldessari

There's a Baldessari painting called *Pure Beauty*. It consists of a white canvas with the text PURE BEAUTY written across it, in sign-painter's letters.

There's another Baldessari piece called *Pure Joy*. It consists of two printed panels, side by side as in a cinematic split screen. One side is a flood of bright, sunshine yellow. On the other side is the text PURE JOY, in bold serif letters.

Ana

Ana came to pick us up in her car and drove us to Xochimilco, the floating gardens where visitors could drift down the canals in flat-bottomed boats. We had met in college; Ana was from Mexico City and had moved back here after graduation. Seeing her again after four years was less surprising than I had expected, in the way it sometimes is with old friends—she looked just the same, a warm smile on her face, wearing red lipstick. We'd been in touch on social media since we'd both left New Haven; to finally see each other in person felt less like a reunion than a continuation. There were no missed connections to apologize for, and all that had happened in the years between we would cover, later, as the conversation naturally carried us. The time that had passed felt almost irrelevant.

During the drive, in the back seat of Ana's car, I fell asleep. When we parked, I woke up with a start, my mouth dry. Inside the open-air mercado, we bought a six-pack and a batch of quesadillas—mushroom, veggie, chorizo, still steaming on the paper plate. After some discussion with the boat's captain, we climbed onto a long, colorful trajinera, pushing out onto the water. What do you do on the boats? I asked Ana, as we settled into our seats on either side of a long table. The top of the boat was covered, but the sides were open, through which we could see the

landscape, and the prow of the boat was open, too, rising above the water. We drink, she said. The three of us clinked our glass bottles together.

The water was glassy and still, reflecting the trees and reeds and mountains and the islands around us, which had been built on the water, Ana explained. Further down the canal, there were more boats, with teenagers or groups of tourists like us, everyone sitting at a long table full of beers. Every trajinera had a name, colorfully decorated in lacquer atop a structure of straw and papier-mâché: *Veronica, Margarita, Mi Amor, Feliz Cumpleaños, Dueña de Mi Corazón.* I liked the last one: "Owner of My Heart." I liked knowing that someone had named their boat with such sentimentality. Our trajinera was called *Manolo's Team,* though I don't think it was Manolo himself who steered it, as we moved across the water like a blade gliding through paper.

We took turns talking on the boat that day. Buoyed by the beer and the tequila, I found myself settling into a comfortable, drowsy silence, listening to Santi and Ana chatter. We talked about our love lives—I told Ana about my new relationship with you with a feeling of hesitant pride, knowing that I had declared my emotions and then promptly left—and she was happy for me, knowing without being told the significance of this new, caring relationship. We talked about parties, and men, and Ana's life in the city. I felt held between my two friends, safe and understood. We floated downstream. I never wanted the ride on the trajinera to end—if only I could stay on this canal forever.

Willows hung their branches over the water. From downstream, mariachi music wafted through the air, from a boat filled with musicians who, Ana explained, you could pay to float alongside you and play songs. Another boat was selling flower crowns—I saw them perched on the heads of women in other boats. They were colorful, still bright in the fading light. I'd been surprised and happy to see Ana again, but I wasn't surprised to see that her heart had remained just as big and open. After Santi left for Miami, Ana would take me out for dinner in Condesa, whisking me away from my solitude. She knew that I would be lonely, and I was. But that came later; this is then, on the boat at Xochimilco, with the waning light of the sky mirrored perfectly in the water. In the rushes I spied a heron, then a goose, its feathers snow white as it placidly swam past.

Forty-minute FaceTime with bad Wi-Fi

Were you talking to him? Santi asked me.

Yeah, I said, I was. I could still feel the heat in my cheeks.

I thought so, Santi said. You sounded really in love.

Photographs

Away from you, I posted on the account we shared. I wanted you to know that part of me was still with you. In the evenings, back at the apartment, Santi and I both glued to our phones, I pored over the day's photos, trying to figure out what I wanted to say. I wanted to show you how beautiful it was here, to show you the complexity of the place that I was beginning to see, but I didn't want you to think that I was happy to be without you. The images weren't—I didn't think of them as images of longing, unlike other images I'd made with you in mind. But I wanted you to know that there remained a place in my heart that was open for you.

The sidewalk showered with the papery fuchsia bracts of the bougainvilleas

Shadows of leaves coruscating on the limestone wall in the backyard at Frëims

The glass of jugo de naranja that came with my breakfast, the liquid thick and a brilliant orange, the shadow of the glass spangled on the tablecloth

The white goose I'd seen swimming through the canals at Xochimilco

Graffiti on the street, the outline of a flower

A hexagonal paving stone, placed on its side on the edge of the road. It was there to prevent parking along that stretch of curb, but I was taken by how artful it looked, like a readymade. On the pavement, scattered all around, the wet purple petals of jacarandas—

The hem of my orange skirt, moving in the breeze that came across the roof—

You texted me one afternoon, asking how I was. I had told you, playing it lightly, that Santi was leaving soon. Are you expecting any other visitors? you asked.

No, I'm all by myself after they leave, I wrote back. Hoping. I hadn't wanted to ask.

You sent me a screenshot then, of the plane ticket you'd bought.

See you soon, you wrote, and even as I knew it was a cliché, my heart tied itself in knots.

A day at the pool

Your flight was delayed because of a snowstorm in New York. I waited anxiously for updates, checking the weather over and over to see if the storm would stop. The airline put you on a flight the next morning. It was just your luck.

When you arrived at noon, we went first to my apartment. There you were in your dark city clothes, here on the balcony with me—I couldn't believe that you were real. Sun on our skin. You'd buzzed off all your hair. I booked us a hotel in Polanco for the night, wanting to make something special of your arrival, and we took a cab there. Came to a room with wide glass windows, an open balcony, a bathroom with a waterfall showerhead and a bed with crisp white sheets that came untucked in my fists. I closed my eyes, touched my forehead to yours, inhaled you, your familiar smell—how I'd longed for this.

The next day, in the afternoon, we went to the pool on the hotel's roof deck. It wasn't as I had hoped, meant less for swimming than reflection—it wasn't even deep enough to submerge our bodies completely, and there were too many people around anyway. You could tell I was disappointed. We sat in its shallows, like lizards in the sun, drinking mezcal margaritas. Gray salt on the rim of each glass.

I kept looking at you like I thought something would happen. Shifting, sighing. I was frustrated by my own restlessness: wasn't it enough that I was in this place and you had come to see me? You were quiet beside me, your feet in the water. I had hoped everything would change. I wanted you to tell me that you loved me, that you'd stay with me, that I'd never have to worry about being sad ever again. It seemed I needed something to continue the narrative of us, the one I'd been writing in my head all along. But you weren't saying the things I wanted you to say. You weren't saying anything.

Each year, monarch butterflies migrate from the cold territories up north—from parts of Canada, and the regions east of the Rockies in the United States—to Mexico for the cold season. They arrive in waves, gathering in the oyamel fir forests of Michoacán, west of Mexico City. It takes two months for a flock of monarchs to make the trip south to Mexico, and once there, overwintering, they wait, shrouded in the damp fog and clustered together for warmth until spring.

The calendar had changed while I was in the city; now it was March. Soon, the monarchs would be leaving the oyamel forests, flying back north in clouds of orange and black. It takes multiple generations for the monarchs to make the long trip back north each spring—I imagine each insect with its own, private knowledge of their path of flight. I've always wondered about this, about

the persistence of genetic memory, about whether the caterpillar knows what will happen when its body begins to harden into a chrysalis. It seems to me that it must know.

Meanwhile, we walked to the Museo Soumaya. I wanted to show you the dazzling metal shell of it, like the scales of a butterfly wing against the bright blue sky. I was next to you, pulsing with need. Head full of thoughts I couldn't figure out how to articulate. The jacarandas showered purple petals on the sidewalks, which turned to mush beneath our shoes.

Wasn't this all I had ever wanted—a life of freedom, and someone beside me to share it with? It was a warm day and I was with you, anointed in bergamot and geranium leaf and freshly fucked. Yet here I was with the killing jar again, savaging my present to pin it on the wall. I couldn't stop seeing the moment for what it could be, rather than simply what it was.

I took one of your hands in both of mine, interlacing my fingers on either side of your palm.

Once, on a walk with you, I confessed that I had so many questions about the world. Not about the mechanics of material things, but their motives. I knew that caterpillars hardened into chrysalides and emerged as monarchs. I knew that the form of our very bodies—lungs, heart, liver—had begun with the movement of cilia in water. There were so many things in the world that could be explained this way: one instinct, one desire, leads to another. A molecule wants to be close to salt, or to ions, or to

the source of water. But what I didn't understand was how all things knew what they knew. How did the cilia know which way to move? How did the monarchs know to fly south? And if it was a mere mechanical compulsion, did they know that they were so compelled?

What if, you said, you could be at peace with the idea that it all makes sense?

Your answer didn't satisfy me. I wasn't at peace. I wanted to know. There were so many things even about myself that I still didn't know without being told.

We stood under the jacaranda trees. You took a picture of an art installation in the plaza. I wanted it to be enough—to believe that your presence here was proof of your care. And wasn't I happy? And couldn't I be happy? So why—I wanted to know, and I wanted to ask, though I knew it would be unfair to demand an answer that you couldn't give—why couldn't I be still?

Baldessari, again

I still didn't feel like I understood how you felt about me. We were back at the Museo Jumex, where Santi and I had seen the Baldessari show. I thought you might like it, and I think you did, but you seemed restless, once we were on the third floor. I could feel the energy spiking off you in waves.

We paced through the galleries, hardly seeing anything, and it wasn't the kind of show a visitor could read at a glance. I took a photo of us standing in front of *Pure Joy*, our reflections silhouetted in the yellow panel—I was trying, I already knew, to steal a moment I could point to later, an image of us where we looked like the people in love I wanted us so desperately to appear. Downstairs, in the gift shop, I bought a box of matches printed with the same image—the text on one half, a yellow panel on the other.

What's wrong? I asked you.

I'd rather be outside, you said reluctantly.

I hadn't been paying attention, caught up in the moment I wanted to have with you. Nor, I think, had you told me in so many words. I had forgotten how recently you'd left winter in New York City, and how much you loved the sun, always turning your face toward

it like a plant. I used to catch you like that when I was walking to meet you at the intersection of two streets, late as I always was— standing on the sunny side of the sidewalk, your eyes closed, a small, beatific smile playing about your lips.

Bougainvilleas

Dinner at the bar at Lardo. Bright, dressed greens and crackling meat, roasted in front of us on a stove showering sparks. The cooks all handsome young men twirling cuts of beef and pork around with tongs. We ate slowly. I liked that you closed your eyes when you wanted to savor something delicious. I'd seen you do it with oysters and white wine, back home, at the bar we liked on Delancey.

After it grew dark, we walked through the city. The air was still warm, blanketed with the fragrance of flowers and trees. We bought churros at a churrería by Parque México and sat in the Foro Lindbergh, at the end of the park, in the arcing covered walkway that framed the open-air theater. Bougainvilleas climbed around the columns that lined the path, blooming in a profusion of bright purple flowers. I was fascinated by them—it seemed incredible to me that such a brilliant color could exist in nature, and so casually, without profundity. They were like weather. The vines grew all over the city, cascading off rooftops and twining along trellises. In the open center of the Foro, three kids were zooming around on skateboards, the whites of their eyes and teeth glinting in the dim light.

Before I knew it, or knew why, we were fighting. You never called our arguments fights, because neither of us ever raised our voices,

but that was what I called it when we argued, when my heart jumped up high in my chest and I found myself trying to explain myself and my feelings to you.

Under the bougainvilleas we had talked about futures, about the possibility of leaving New York City. It was an easy conversation to drift toward, here, on a warm night. I knew you wanted a change in your life, the same way I craved a change in mine—we spoke of visiting cities with unfamiliar street signs, of taking up different jobs in different places. Just a few weeks after I'd left mine, you left yours. To me, this moment seemed a dazzling precipice—a chance to build a life together, something new.

You told me you wanted to live by the sea. Your eyes were wistful then. And blue, I knew, even in the dark.

Can I come? I asked you, softly, playfully.

And from the look on your face I realized then that the futures we'd started charting weren't shared after all: you had never built yours to include me.

I was hurt, and it surprised me—that you didn't even want to include me in some hypothetical fantasy. All along it had been me who had wanted a promise, a protection spell, to lose myself in you entirely. I'd given you my future; I was willing. But it was clear to me then, the boundary you had drawn, the parts of you that you kept separate. You weren't ready for what I had asked. You hadn't wanted to play along, even if it was just playing.

Writing this, I can't remember exactly what I said in response. Oh, I must have said. But I don't know what came after. I remember how it felt—my insides gone cold and my mouth fallen open, as though there were some kind of frozen channel that ran straight through me. For I'd wanted to know if I could make a home in you that night, and you wouldn't let me.

Then what, I wanted to know, were we doing at all?

I still care about you, you said.

But I didn't want to hear it like that—not in that form, not when my own feelings beat so wildly around my chest. Not when I felt I needed a promise; not when I longed for commitment and stability. I couldn't accept this other kind of care you were willing to give, the kind that demanded generosity and trust from me. Because I wasn't generous. I could only hear the cry of my own needs. The only kind of love I knew was the kind that clutched out of a fear of loss, and every time you threatened to shift its meaning, it only made me hold on more tightly.

I don't know if the entire fault of our rupture was mine. I don't know if you believed then that I could love you, or if you even believed that you were deserving of love in the first place. I don't know if you knew that I was willing to try, with what I knew of love. Which, I guess, wasn't much of anything.

We patched things up under the bougainvilleas. I still wanted you; you still wanted me. We were like children, forgiving each

other for things we had said when we were playacting. But it had been a rupture, a true one—we had revealed a dissonance between us that couldn't be forgotten, like a splinter of wood beneath the skin. The white paper bag of churros had gone cold; I could feel the sugar still gritty between my teeth. We went back to the apartment on the roof, with its trellis of flowers. You held me in front of the mirror and all my cries got caught in my throat. The next day, your flight already booked, you left for the city.

I was supposed to stay two more days, but I couldn't bear to be alone. I never did find a way to be alone in Mexico City. I changed my flight and went home to New York.

Spring dripped into summer. Jaime and I went to Massachusetts. I started renting a studio in Sunset Park, where I made oil paintings for the first time in years. The days grew long and all my clothes smelled of turpentine and the milky iced coffees I bought at the Dunkin' on Thirty-Fifth and Third. I was trying to put some distance between us, to divest myself of the dependence on you I felt growing. I made paintings from photos on my camera roll, of meals and my friends and flowers and, once, a painting of the splatter of your come on me.

Sometimes it felt like everything was okay between us. We'd meet up at Prospect Park and read together. Your hand on my stomach, our bare feet in the clover. And sometimes, an hour or a day or

two days later, it was clear that things were not okay. I'd text you, double-text you, to no reply. You'd wordlessly resurface without an apology. It was the same problem we'd first articulated in Mexico City, the same problem we'd encounter all summer—I wanted you to make a promise you couldn't make, and you wanted me to give you the space that I was too afraid to give.

In the studio, at least, I could lose myself for an hour at a time. Each hour spent painting an hour I wasn't thinking about how much of you might be hidden from me. And there were small joys in it: polishing the layers of gesso on a canvas with a wet sanding sponge. The perfect bounce and splay of the bristles of a size 12 synthetic round brush, swirled through a mix of alizarin crimson and warm white, a dab of lemon yellow and a dab of phthalo blue. How with just my wrist I could control how each line wavered and broke, the strokes moving from thick to thin. I'd forgotten what it was like to make just for myself, to have a space that was mine alone. I'd forgotten what it felt like to draw—to make something from nothing.

That summer in the insensate Brooklyn heat we kept coming together and apart. The industrial building where I worked was downwind from a twenty-four-hour adult video store called CANDY LOVE, which sold lingerie and flavored hookah that perfumed the streets with the sickly sweet scent of tobacco and cherries. I pointed it out to you when you came to help me hang my show during open studios, marking a straight line across the white walls with a piece of string. Nine paintings in a row around the room. You were good; you made the work shine. This was how you showed me you cared, and I wanted it to be enough. One

painting was of you sleeping. The back of your head. The pink shell of your ear.

One night you said to me, Even if we didn't talk for a week, it wouldn't change how I feel about you. I'll still care about you, you said. An echo of what you had told me that night in the Foro. Sometimes I need that time for myself, you told me. To figure out what's going on in my own life.

I knew you were trying to help me understand—your own need to leave; your own compulsions to go. But what you called *care* kept lodging in my throat—I couldn't accept it; it didn't seem real to me. I didn't trust you to come back when you left, and you couldn't know that I would stay.

It was September, then October. As the nights grew long I could feel the warmth seeping out of you the way heat leaves a cooling ember—I noticed the turning away, the silences, the small ways you had of distancing yourself from me.

I felt betrayed, then, by our photographs. The ones I'd taken of you those first nights; the optimistic pictures I'd taken with our film camera, stealing from my present to write that story of us.

●

We went back to the place where we had first met, sharing a tent again, and it hurt to realize how much was different.

●

You moved out of the apartment with the parquet floors and the spotlight that shone into your window.

Breakup

Only when you're ready, I said. You were sitting in my kitchen with your shoes on. It had been a year since we first met. You wrapped your arms around my waist, and I held you, one hand on the nape of your neck. The hair short there, buzzed down all the way. My mouth felt dry. I'd cried too much.

Please come back to me, I wanted to say.

On Being Alone

After we broke up, I spent two days laying on the couch in my living room. My roommates flitted in and out like they were trying not to disturb a corpse. That fall I'd started temping at a different nonprofit in Manhattan, writing ineffectual blog posts arguing against Kavanaugh's confirmation and glad-handing press releases about LGBTQ-friendly celebrities. The gig got me out of the house, but my heart wasn't in it, and I was sleepwalking through my days, dressed in the corporate drag I'd tried so hard to avoid. Your absence bounced around me—sometimes painfully; sometimes, startlingly, with an air of reproach. How had I let myself get so used to having you in my life? I couldn't bear trudging through the city where we both still lived—I imagined it would have been better if you had moved, or if I had moved, or, melodramatically, if you had died or *I* had died, some physical act that made the new distance between us explicable. I kind of felt like dying. I still loved you, a lot. I could feel it running through my entire body like a current—in my sternum, in my wrists.

No matter how I turned it over in my head, the answer was always the same: we'd had to break up. Not for want of care but

because the things we needed from each other didn't line up. I clung, and you spun out.

In our early days, I'd been so scared. Waiting for the moment that you'd hurt me, every argument we had limned by the knowledge of my old ghosts. Had your distance, in your own way, been your version of a protection spell? Were you the one who had been tensed, waiting for the moment when I'd leave you because you'd always thought *I* would go?

Maybe now it was my turn to be the one to stay—if not in place, then, to wait.

Then I got an email asking if I wanted to go to China for a week. A luxury brand I'd done some copywriting for was inviting me to attend a show the creative director had curated at the Yuz Museum in Shanghai. There was no catch. There was no work. I'm not a magical thinker, but I found it magic: an escape beckoned at the precise time I couldn't stand to be with the information of my ordinary life.

A few days later, itinerary in hand, I was picking up my rush-approved visa at the Chinese consulate, the wind blowing strong across the Hudson, tears stinging in my eyes. Then I was tucked into a business-class pod on a fourteen-hour flight, knocked out on free champagne. And then I was nowhere. And then I was in Shanghai.

After I got through security, my phone beeped with a WhatsApp notification from my handler at the brand. I hadn't thought to

pay for roaming service, so I made the most of the Shanghai Pudong Airport Wi-Fi. But all my various feeds reminded me of home, which in turn reminded me of you, which only opened the door to a yowling animal sadness that felt palpable in my body, an ache so loud I pressed my hand over my heart, trying to quiet myself. Outside the baggage claim, I was met by a laconic driver holding an iPad displaying my name and the brand's logo. I got into the black car and leaned my head against the window. Faux wood paneling covered the floor. There was a sort of pink light in the sky, but my body had no idea what time it was. I looked outside. I recognized nothing. I realized, as the driver silently steered us onto the freeway, a string of prayer beads clicking through his left hand, that I had no idea where I was, nor where I was going. I gave myself up to not knowing. I embraced the total surrender.

The president was in town, I was told, which was why the freeways were lined with flowers. The president's presence was also why, I'd later learn, the nightclubs were closed for the entirety of my visit. I was sad to hear it—I was hoping to visit a club my friends back home had told me about. The black car wove through overpasses and sped along an expanse of elevated road, which shot past wide, empty swaths of land and, as we grew closer to the city center, residential neighborhoods. Approaching the financial center of the city in Pudong, the buildings gleamed, rising in front of the Huangpu River.

Shanghai is a strange, sprawling city, its colonial history evident in its architecture. In 1842, after the First Opium War, a treaty imposed by the British designated Shanghai as a strategic port and opened up the city to Western settlement. A number of sovereign international territories within the city were carved out: the British concession in 1845, the American concession in 1848, and in 1849, the French concession, which still exists in name as a historic, trendy neighborhood. Colonial, Western-style architecture sprang up along the Bund, the riverfront walkway that now looks onto the Oriental Pearl TV Tower. The changing landscape passed by me in snatches—I caught sight of the Pearl Tower, magenta pink and crystalline, as if covered in gemstone pavé, and then we crossed into the west side of Shanghai, passing the colonial buildings of the Bund and moving deeper into the city, toward Jing'an. Before long, everything started to look like a mall, twinkling with neon lights.

I was deposited, bleary-eyed, at a luxury hotel in the Jing'an district, a huge glass and steel building whose illuminated tower was shrouded in pinkish fog. High above my head, the name of the hotel—Shangri-La—glowed in yellow, calligraphed letters. Inside, the lobby was replete with shimmering crystal and flower arrangements, and on the walls were large, brushy, carefully inoffensive abstract paintings. Because of the last-minute way our flights had been arranged, I was the first to arrive in Shanghai, before the fashion bloggers and Italian brand reps who'd also been invited on the trip. The front-desk staff greeted me warmly, scanned my passport, and shepherded me into an elevator to the thirty-first floor, where I was met with the biggest hotel room I'd

seen in my life. Floor-to-ceiling windows looked out onto the city, where I could make out the tiny figures of people on the sidewalks far below, and above them a thicket of high-rises, and in the space between two buildings, on a low rooftop, an empty tennis court.

The hotel bed was wider than it was long, an expanse of white linen; it seemed criminal to allot it to just one person. Not that it mattered, I thought glumly, because I was alone. The last time I'd been in a nice hotel room had been with you, in Mexico. Pondering this fact left me profoundly depressed, and then irked—had I really come all this way just to mope? I threw myself on the bed, considering. To my right was the bathroom, which had a huge mirror that stretched the full length of the wall. Far to the left, windows. Mustering up my resolve, I dumped out all my fancy clothes and hung them in the closet, then upended my backpack, connecting my laptop to the hotel Wi-Fi. A swag bag from the luxury brand held a giant branded beach towel, as well as my week's art fair schedule and a copy of my return-flight itinerary.

My friend Sally, a poet, happened to be in the middle of a six-month residency sponsored by a different, sporty accessory brand, and was staying at a hotel close to the Bund. Over WeChat, we made plans to get dinner, and within the hour, she was downstairs, waiting to take me to hot pot. I threw on an outfit and scrambled down to the lobby.

It cheered me up instantly to see Sally, and I was comforted by her gregariousness, as she slipped effortlessly into the role of host, leading us to a hot pot place that was tucked away in a mall that

seemed identical to all the other malls surrounding my hotel. As we wound through the bright lights I felt my glum mood lift: this was what I knew, where I felt most free, letting myself float along in an unfamiliar city. When I saw a sign that said, in English, simply, "Time is passing," next to what looked like an exit arrow, I laughed aloud—surprising myself—and took a picture.

Sally asked why I was in Shanghai, and I told her about the show that the brand had sent me to see. I wasn't entirely sure what they were expecting me to do here, I admitted. I wasn't covering the show as a critic, but I couldn't imagine how the brand benefited from having me in the city. We talked about Sally's residency, about the poems she was writing and the friends of mine who had visited not too long ago—they'd also met up for hot pot and karaoke. In the sudden flush of happiness I felt, basking in familiar, human connection, I didn't want to talk about the breakup, as much as I felt it acutely. I felt that if I did, in this new place, I'd come to let it define me.

We ordered an astonishing amount of food that night: two kinds of broth, spicy mala and savory pork; sumptuous red curls of sliced lamb and marbled beef; a pile of different kinds of mushrooms and another pile of pea shoots; thin-veined, pale-green Chinese cabbage; and translucent, snow-white slices of winter melon, which went rich and soft in the piping hot pork bone broth. Because there was a special on them at the restaurant, Sally and I had ordered frogs, too, and they arrived whole on a bed of lettuce, their legs politely crossed. We dunked them in the mala hot pepper broth, which made my mouth go shockingly numb, and took a picture of them—froggies in a hot tub, Sally said merrily, taking a video for Instagram.

Later that night, alone in my room, my emotions fell again. I looked out at the city, the yellow light of my surroundings reflected in the window, so that my own ghostly reflection appeared superimposed over the city skyline. I felt deflated, even more so after the buoyancy of the evening. It seemed incredible to me that I could have come so far—from Portland to New Haven, to Provence and to New York, to Taos, to Condesa and Crown Heights and my painting studio in Sunset Park—and yet, at the end of all this, remained doing all the same ordinary things. I still felt like me; I wanted to be anyone but. This was the problem, I thought, of having a body: I couldn't leave mine. I stripped, and in the enormous bathroom I tried to take just one good nude. Lips, nipples, sliver of teeth, arranging myself to that slow song of the body I knew everyone knew. But none of my usual angles seemed to work, and my sadness peeked through every photo. Abandoning the effort, I crawled into bed, turned on my VPN, and fell asleep scrolling through Instagram, hoping each photo carried a secret message just for me. But none of them did, and none of them would: they were all just pictures of New York. By the time my eyes had closed and stayed closed, the sun had already risen, hanging in the pink sky like a halved cling peach.

Breakfast: room service congee with black egg, pork floss, mushrooms, and soy sauce. Coffee with soy milk and youtiao. After a charming, stilted lunch with the communications director and a rep from the luxury brand, I was released from the press junket until a multicourse group dinner late that evening.

As befit such an impulsive trip, I'd come to China unprepared. I had no cell service, so I was dependent on free Wi-Fi, and when I did find a connection, the national firewall axed all of Google, including the maps function, as well as basically every social media platform I used; to check any feed required turning on the VPN I'd downloaded, which always felt like a bit of a gamble. To even make use of WeChat, I'd had to pray that my roommate, Clare, was awake in New York, asking her to verify my identity. On top of everything, none of my credit cards worked overseas, and I hadn't thought to bring any cash. All this should have been fine, swaddled as I was in the hospitality of the luxury brand, but it only served to make me feel leashed when all I wanted was to be free.

This was how I found myself at the train station at Jing'an Temple that afternoon, frantically trying to buy a subway pass. I jammed the credit card into the machine—error message after error message popped up. A wave of bland, stupid panic rose in my throat. I paced up and down the hallway of the station, then spotted an ATM. I shoved my debit card in, sighing with relief when it worked against all odds—no one, it seemed, could argue with the merits of a local injection of cash—and bought a three-day metro pass from the information stand.

Twenty minutes later, Sally was explaining to me that Huangpu Park used to be called Public Garden. We were walking on the Bund, the touristy strip of waterfront that extended south from the park; from one angle it resembled a quaint European city with its colonial architecture, and from another, facing the skyscrapers of Pudong, it squarely placed us in contemporary Asia.

The Public Garden had been a place for all people to gather; built in 1886, it was the first European-style park in China open to the public. But during the British occupation, Sally continued, the park was reserved for foreigners only—from 1890 to 1928, Chinese people hadn't been allowed in. There was something perverse about all this, how Westerners had so gleefully invited themselves into Shanghai, reaping the benefits of the city's trade, industry, and international culture, while poorly compensated Chinese labor kept the city running. Western colonialism left its mark architecturally on the skyline of the Bund; now, over a hundred years later, it had become a place where buildings were lit up at night and photos for the bureau of tourism were taken.

It was strange—I didn't feel any way about my being in Shanghai. Being an Asian tourist in Asia had its own difficulties, and I knew that even Vietnam—a country I'd always longed to live in—would never be the home for me that it had been for my parents, but it was an odd sort of relief to be in a place where my face blended in nearly seamlessly with the faces around me. I felt porous, half-ignored. And for the first time, I didn't want to be changed. Instead, I felt dissolved. I wanted to see—to see everything.

From the Bund, we walked through Old City Shanghai, which used to be the walled city, home to Chinese citizens during the decades of foreign occupation, then stopped for tea at Yu Garden, a series of gardens and pavilions that had been built and rebuilt within the city since 1559. The shape of the buildings was traditional in their current iteration, with ornate, lacquered wooden balconies and pagoda-style, tiered roofs, but they'd been updated

for the twenty-first century, outlined in blazing golden lights. A teahouse sat serenely on an island in the center of a pond, ropes of light stretched along the eaves, making the building appear filigreed, like a glow effect indiscriminately applied in Photoshop. I thought, helplessly, of the phrase *gilding the lily*. I loved it. Sally laughed when she saw me looking around in awe. This is the most Chinese shit ever, she said.

The city seemed to me to be a kind of map of past, present, and future, where all its histories were laid out and visible to the eye, like a series of backlit transparencies. It felt optimistic to me, like it didn't matter the means by which anything—building, park, landmark—had come about, because everything could be repurposed infinitely, in constant flux. Public Garden had become Huangpu Park; the French Concession had become a shopping district. The old and the ancient butted up against the very new, and in fact the ancient buildings often wore a sheen of newness, like a glaze of gold leaf or lacquer, brushed right on top of an old, dusty finish. The neighborhood where I was staying, Jing'an, was named for the Buddhist temple at its heart, a huge, multi-building complex with golden roofs that swooped dramatically into the sky. Last rebuilt in 1880, it stood out incongruously within the rest of the urban landscape. All around it were malls—shiny buildings of glass and chrome, decorated with huge billboards of fashionably dressed people embracing. But it wasn't at all incongruous. That was the heterogeneous nature of the landscape itself, the contrast of textures and the hypervisibility of its various pieces. Where in Taos and Santa Fe the low-lying landscape seemed to want to preserve a static, nostalgic image of itself, untouched by

time or history, I saw Shanghai as a city that embraced both deep past and sleek futurity, even if the two seemed at odds with each other.

Even the name of the hotel I was staying in carried its own mixed history, its own legacy of colonialism. The name Shangri-La, it turns out, comes from a 1933 novel by the English writer James Hilton, where the setting was a mystical, isolated utopian place inspired by Tibetan culture and the mountains of the Himalayas. The name itself, a bastardization of Tibetan language that doesn't mean anything, still retains that vaguely exotic, Orientalist connotation. How disconcerting, then, to see an Asian hotel chain embrace its Orientalism, selling the same fantastical paradise to foreign tourists and rich businessmen—a dream that a white man once had about Asia. I felt weird just staying there, and weirder knowing that the brand had chosen it.

Later that night, I got too drunk at the press junket dinner, surrounded by Italians eating lobster and wearing couture. At my spot at the corner of the long table, I felt lonely. I spoke mostly to the brand rep I'd had lunch with earlier, who sat across the table, and I made small talk with the woman seated next to me. The food kept coming out in waves: a whole fish, three different soups, barbecued skewers, the aforementioned lobster, a platter of cut fruit. My wineglass was constantly refilled by a rotation of elegant servers, who appeared without a word and disappeared just as silently. By the end of the meal I felt so tipsy and jetlagged I was falling asleep at the table. Outside the restaurant, some of the brand representatives talked to the fashion bloggers about going

to a bar, but I tapped out, telling them I'd see them at the art fair tomorrow.

⬤

When I got back to the hotel, my room was gently illuminated. Someone had come in and drawn the blackout curtains for me, placed a chocolate on the nightstand, and turned down a corner of the duvet. Even my phone charger had been tidied—it was plugged into the wall socket, the cord wound neatly into a coil. I swept open the curtains—I wanted to see the city at night, all lit up and hazy with fog. Suddenly I was no longer tired, just tired of socializing, of biting down on the hard, hollow aphorisms of professional small talk. My brain felt weirdly wired, and restless. I kicked off my heels and sat on the edge of the bed, still wearing the tight, fancy dress I had worn at dinner. And then, though I knew I shouldn't, I took out my phone, connected to Wi-Fi, and switched on the VPN.

When I'd made the Instagram account you and I shared, in October, just over a year before this trip, I'd thought of it as a conversation between us. And it had started as an artistic collaboration, but more practically it functioned as a way of staying in touch when we weren't in the same place. For my two weeks in Taos, that was how it had worked—I thought of my pictures as romantic postcards mailed from afar. Six months later, in Mexico City, I'd used it that way too, with emotions that had grown more complex. Each image became a stand-in for my feelings of longing, of

mixed fondness and anxiety, each new photograph an attempt at a different kind of speech.

But that summer in New York, when our relationship grew rocky and threatened to dissolve, we stopped talking when we fought. Instead, we'd speak only in photographs, uploaded in silence, a new image appearing on my feed at odd hours of the night or day, never failing to stop my heart. In this new, wordless conversation, the image had so much more weight to it. Your posts were like a code, or a cipher, something I forced to draw meaning out of. Writing this, thinking of my own images—my own dark vessels—I wonder if you felt the same way.

And now it was November. We weren't talking. We'd agreed not to, after our attempts to stay friends failed and kept failing. Everything in the world was something I wanted to tell you about, but I couldn't bear to speak to you with this new, emotional distance between us—knowing that our relationship had in fact gone to pieces. I'd told you to find me when you were ready. But in the meantime—if that time ever came—there was still the account we shared. I knew you would be looking at it, because I was looking at it, too. Maybe that was the fate I'd set us up for when I first made it: as something we'd only use when we were apart, it stood to reason that we'd have to be apart to use it.

In Shanghai I'd already started seeing everything around me through this glaze of fraught language. It colored the world, made me want to preserve each wistful detail, as though they were film stills or paintings. Phone in hand, I scrolled through the pictures

I'd taken that day. Raindrops on a rose petal. A crumpled red cigarette carton on the sidewalk, emblazoned with the Chinese characters for Double Happiness. The light and splash of an ornamental fountain Sally and I had happened upon earlier that day— there had been a light show, a spectrum of colors shining through the frothing water while sentimental, sweetly toned music played.

And I knew that I was doing that thing I always do, mining my surroundings for significance. I was looking for something in the world that spoke for me. Something that reached out to me with a hand and said, *Here. You are not alone.*

It wasn't just in this moment, limited to the images we shared, that I did this kind of scraping, this desperate searching for an image that communicated the way I felt. This was *all* I did, all I knew how to do. It was how I mined the world and its substrates; why I went looking for paintings and poems and photographs, which were all ways that things had already been said. It seemed to me that what I was looking for was art, whether it was called art or called something else. I wanted so badly to connect to something, to recognize myself where I didn't have the words to express—but. I knew I'd throw every painting in the world away to have you here with me.

Late, now. My heart hurt. In the bathroom, I leaned over the sink. Something had broken in the drain, and its stopper rested flush with the basin, so that water collected when I washed my hands. But I was looking in the mirror, inspecting my own face. I took a picture—the rosy wine-drunk flush of my cheeks, reflected in the

mirror. I was thinking of you when I took it; I wondered if we'd ever feel close enough again for you to see the photo. I slipped a bobby pin under the stopper, to hold it in place, and brushed my teeth and washed my face. Then I put on a T-shirt, the soft, faded one I always slept in, and crawled into bed, still scrolling on my phone, the other side of the sheet still tucked in flat.

None of my photos seemed right for the moment—I only knew I wanted to make a gesture you would see. The last image I'd posted was a shot of the sky on my first day in China—yellow-green leaves against a strange, mauve sky. Sometimes I felt tempted to post pictures of my body, to remind you of that other language we shared, but tonight I didn't want to make that kind of easy, indiscreet exposure. Finally, I settled on a video I'd taken that afternoon on the Bund: a clip of the flashing orange-red light of a boat breaking into scattered reflections in the gray waters of the Huangpu. There was something surprising about it to me, how it looked like an altered sunset, the source of the light undetermin- able. I posted it, and after a few minutes of waiting and refreshing, there was no response. By now it was afternoon in New York, and in Shanghai my phone felt like a dead object in my hand. I didn't know if there would be a response at all. I hoped there would.

Sometimes I like to stay up until sunrise, especially when I'm anxious. I've always been afraid of the dark, ever since I was a little kid, so the last thing I want to do is close my eyes to it, leav- ing myself open to all the things that lurk in my imagination. It's comforting to me to stay awake through the night, alert to my thoughts and feelings. And when the sun does crest—even the

tiniest bit—and light begins to fill the sky, it's then that I feel safe enough to sleep, turning over the fraught responsibility of the night hours.

That night in Shanghai, I lay curled up on my side, doing things on my phone. I don't remember what exactly I did, only that for every minute of it loneliness rang through my body like a bell. And then, after hours of this, there was a bit of light in the sky. And I fell asleep.

Crisp Asian pear for breakfast, part of the gift basket the hotel had welcomed me with. Café au lait from the Nespresso machine in my room. I put together a little still life of pale yellow fruit and porcelain cup on the coffee table. My mopey Morandi. My Shanghai Cézanne. Fog lay heavy over the city—the highest floors of the buildings around me were invisible. At ten, a WhatsApp notification burbled on my phone. The day to come was busy: soup dumplings at Din Tai Fung with two of the reps, then a visit to the brand's much-anticipated show at the Yuz Museum, followed by a trip to the West Bund Art Fair. Tomorrow, another slew of art fairs, and the next day, I'd be on a plane back home. But I didn't want to think about that so soon.

After lunch—I ordered for the table, resigned to my role as the only person familiar with Chinese food on this trip—we drove back to the hotel for a pit stop and an outfit change before heading to the West Bund, the arts neighborhood in Shanghai. I had

to pee, desperately, and in the lobby bathroom I yanked down my jeans and underwear to reveal the last thing I'd expected: a streak of bright, fresh blood. It was the first time I'd bled like this in four years, thanks to the tiny T-shaped piece of plastic and hormones shoved deep inside of me. The blood came as a relief, an exhalation: now here was some evidence of the break in me. I shoved a wad of toilet paper in my underwear, flushed, washed my hands. In the mirror above the sink my skin was preternaturally clear, another sign of the change in me I'd missed.

I've never liked art fairs. It's always too bright inside the tents, and the work feels bloodless on the short white walls—it's like nothing beautiful can live under fluorescent lights. The art is always the same, too: a huge, gaudy Anish Kapoor; a bland revival of Alex Katz; a small Frankenthaler; a big Motherwell; a shiny polka-dotted installation by Kusama that feels as though the aura's been zapped right out of it. Because the pieces must sell in order to appreciate, everything feels like it's for sale, which makes you feel like you're for sale, too. The art is selected to be photogenic and selfie-friendly: embellished mirrors ripe for self-portraits, glowing neon, Ed Ruscha rip-offs with cryptic, provocative text that transmit affect while saying nothing of true substance or point of view. Every arrangement is designed to be photographed from just one angle, and the image that results from these pieces has one impression, one note—I always see it, later that afternoon, all over my social media timeline, taken by a hundred different hands.

When my group arrived at the fair in the West Bund, a guide informed us in English that there were two installations not to miss—a new Takashi Murakami mural commissioned for the occasion, and a Dan Flavin, which, she said, was great for a photo op. We were all dressed up, everyone wearing something with the luxury brand's distinctive logo and striped webbing, except for me, still miffed that my swag bag hadn't included any useful merch. Though at that point I was more concerned about bleeding through my skirt. With the help of Google translate and the hotel's very kind concierge, I'd managed to track down some pantiliners in one of the ubiquitous basement malls, but I was still anxious about the weird, sudden change in my body.

Unsurprisingly, when we got inside the fair, models and rich people with a lot of Instagram followers were posing in front of the Flavin, hands on hips, shoulders hunched, their skin glowing green in the neon lights. They posed in front of the Anish Kapoor. They posed in front of the Murakami mural. They posed in front of the Laura Owens, with its abstract, pastry-chef whorls and frosting smears of thick paint. Looking at Owens's work, which deals with perception and playing with digital imagery in traditional mediums, always reminds me of the paintings I made in college, at the peak of my eating disorder—surfaces attempting to mimic other surfaces. The sensory pleasure of mixing pigments into heavy acrylic medium with a palette knife; the whipped peaks of stiff gesso and molding paste that I applied to my canvases with a bench scraper, sanding them down until they were smooth and hard as marble.

But in the airy space of the exhibition hall, even my response to artists I knew and liked felt muted. At a fair there's no context for the work, no way to learn about it—just a clamor of pieces all jumbled together. I could hardly spend time with one work—an installation by Do Ho Suh, transparent layers of green polyester replicating a room down to the details of the locks on the door—before the sight of something else through the fabric dragged me away. At the far end of one hall, above a seating area studded with people on their phones, elbows resting on knees, there hung three Cerith Wyn Evans pieces: a complex mess of thin, winding tubes of neon light suspended in space by invisible fishing line.

When Santi and I had walked through the Evans show in Mexico City, we had been able to move slowly, mesmerized by the intricacy of the light. I'd had the isolation and proximity the work demanded. Here in Shanghai, the part of me that liked naming things—the part of me that had tried to become an art historian—was happy to recognize a familiar artist, but it was strange to see the works in a different, alienating context. When something's so obviously for sale, it removes all opportunities for transcendence. In the big shiny hall full of big shiny pieces, the works felt less spectral, less mysterious, and more like fancy chandeliers. I felt like something had been taken from them, or from me.

Exhausted from the cognitive dissonance the space demanded, I ended up at the Starbucks installed in a garden-esque pavilion between two of the halls. Across the way, a Turrell LED piece glowed through frosted glass in a cycle of soft colors. I hated how much it looked like something in a hotel.

I woke to cool gray light beating in through the windows. The night before, I'd begged off the group dinner: the return of my period had been accompanied by a tremendous migraine. After downing an extra-strong ibuprofen, I'd passed out early, awakening sometime after midnight to keep my usual vigil until dawn, though I must have fallen asleep before sunrise.

At this point in the trip I'd become well acquainted with late nights alone in my room. I'd ground myself down into it, forcing myself to be present with my own feelings. There were no comfortable distractions here for me to lose myself in—even the clubs were closed, the one place I would've wanted to anonymously slip away to, and I hadn't packed a pair of running shoes. So I let myself be with it, unanesthetized. Maybe even a little curious, wondering how it would feel.

For someone as emotionally attuned as I professed to be, I'd never been good with loss. I'd always tried to avoid contemplating any kind of grief, trying to insulate myself against negative feelings—I was more afraid of the grieving itself than the situation that had prompted it. To sink into heartache then, really sink into it, to allow the hole to remain empty instead of stuffing it with drugs or stimulation, was something new. For the first time since we'd broken up, I let myself think to the very end of every thought, every catastrophic possibility. It felt like a weight, but a weight that

lifted as soon as it was felt. I wondered if this was what it felt like to let go—to let go of all that I had wanted, and expected, all that I had borrowed from my present against my own future.

Now, upon waking, I felt as though I'd tunneled through to somewhere, or that I'd reached the end of a hallway, touching it with the palm of my hand. It was a slippery kind of knowledge, changing shape when I tried to describe it overlong, so without much conscious effort, I let it slip away.

Outside, it had begun to rain. Over the steam of my milky coffee, I looked out the window to see umbrellas popping open on the sidewalk, some red or colorfully patterned, but mostly black. They looked like mushrooms sprouting on a log. Soon I would be down there, with all of those people—I felt, bathetically, a spike of warmth for every person in the world. My body ached, but I felt strong. Maybe it was finally getting over the jetlag, or maybe it was feeling as if I had finally gone to the end of my loneliness, gone to its furthest expanse. I finished my coffee. I dressed for the day.

The Long Museum, a new, private museum in the West Bund, was exhibiting a huge show of Louise Bourgeois's work while I was in town. I'd missed the Bourgeois retrospective that had happened in New York just over a year before, and it seemed to be a sign that her work had arrived here, in this new place where I was so wildly seeking an affirmation of my own feelings. Today was

my last day in China, another thoroughly scheduled day of meals and art fairs, but I was already plotting my escape.

I was familiar with Bourgeois, not from studying her work with any great intensity but from encountering it so many places. I'd seen her biomorphic pieces during trips to Dia:Beacon—the soft, sometimes grotesque, undulating forms that alternated with craggy bronze surfaces, one occasionally tucked within the other. There was one of her spiders there, too—she was famous for them, I knew, and had taken the arachnids on as a motif, late in her career. But I was less familiar with the details of her life than the impact of her work, which could be felt, like a tint of color, in contemporary feminist art and sculpture even today. Bourgeois was an artist of the body, of trauma and personal history. For an artist so prolific and so ubiquitously included in museum collections, her work seemed to me to be the opposite of safe: it teemed with an uncanny psychological energy, vibrating with the pain of the interior—the experience of being alive, of being born into a body.

My experience with her work had always been here and there, like a passing acquaintance—encounters in a permanent collection or in a gallery, separate from the larger context of her biography. I wondered what it would be like to see it all in one place.

Yes, my sneakers were the Comme des Garçons x Converse collab. No, I had no opinions on the new Celine. Yes, I did like Cindy Sherman. Small talk waiting for the cars—I still enjoyed the incongruity of the faux wood-paneled floors. Lunch, more small talk. Brands, brands, brands. After a few hours at yet another

art fair, which, for whatever reason, felt even more demoralizing than the first, I'd had enough of walking slowly through rows of booths, looking at drippy neon abstract paintings and sentimental, suspiciously nationalist landscapes, and so I found my handler in the café to let her know I was leaving. I'm going to try to make it to the Bourgeois show at a museum in the West Bund, I said.

She nodded, appraising me. There's a final dinner tonight, she said. And a closing party after. We'll meet in the lobby fifteen minutes before. Do you know your way back to the hotel? she asked then, not unkindly. Would you like a driver to take you to the West Bund?

I shook my head. No, I'm fine, I said. I'll take the train, I like the subway.

The art fair had been close to the hotel, and I found my way back easily. The morning rain had stopped, the sky a watercolor wash of peach and gray. In my room, I ditched the umbrella, then slipped back outside. From the Jing'an Temple station, I found the line I needed, and within a few minutes was on a quietly whirring train, grateful for the rail pass I'd obtained.

When I move through the city—any city—alone, my thoughts are so loud. They cycle through my head without an outlet. Maybe the problem is that without some kind of speech, I fear incoherence. I'm scared that the self stops existing without a story to tell about it. So I have my own anxious response: weaving, weaving, weaving my own narrative. From the train station I walked through an unfamiliar section of the city, then found myself along a stretch of

busy, fast-moving traffic, then turned down a long road, at the end of which was the museum, looking industrial and otherworldly. A tall metal fence, the wiring not chain-link but an open, elegant grid, reminded me of an Agnes Martin painting, and I took a picture. Later, I'd put it on the account I shared with you, but for now, I saw it as a reassurance that I hadn't forgotten how to see. After days under the fluorescent lights of the art fairs, my senses dulled and cynical, I longed to see something beautiful—to encounter something that would feel true to me.

The Long Museum was a cavernous place, the ceilings so high and sweeping it could have only been designed to hold art. I'd arrived just an hour before close, and I paid admission quickly, explaining to the attendant that I was leaving the country tomorrow morning. And then with the same, reverent desperation I'd felt when I went to the Agnes Martin retrospective, now almost two years prior, I went into the show.

In the exhibition's first hall, a towering spider, over thirty feet high, stood guard over a handful of other late-coming visitors. The scale of the piece, indoors, was unimaginable: I looked up, and kept looking. It felt massive and delicate at the same time— the contorted bulk of its body suspended high in the air, balanced on arcing, wiry legs that tapered to points so tiny I couldn't understand how they supported all that weight. I walked slowly under the sculpture, to see that beneath the spider's body of bronze coils ballooned a sac of metal mesh. Inside the sac, eggs were visible, carved from white and gray marble. They gave the sculpture a startling vulnerability, one I hadn't expected to encounter—there was the implication of life there.

Maman, the enormous spider under which I stood, was completed in 1999, as part of a commission for the Tate Modern's Turbine Hall. It is the largest of Bourgeois's spider sculptures, a subject she focused on in the nineties, and which were inspired by her mother, Joséphine, who had brought the young Louise into the family tapestry trade and introduced her to the visual arts, and who, throughout Louise's childhood, had been the artist's best friend. But even learning of the sculptures' origins, I've never found anything soft or sentimental about Bourgeois's spiders. They are simultaneously elegant, frightening, and beloved by young children when placed outdoors. To me, they seem like guardians of a sort—agile, humble, and yet in their very primal form they invoke an instinctive, mixed response of desire and fear.

I felt protected beneath *Maman*, in thrall to its tremendous scale. A few paces in front of me, in the same large hall, was another large sculpture: a standing vanity mirror, its reflective surface angled down at the viewer. On an electronic screen glowed the words, in capital letters, HAS THE DAY INVADED THE NIGHT / OR HAS THE NIGHT INVADED THE DAY, making reference, I would learn, to Bourgeois's habitual insomnia. Of course the night invades the day, I thought, then changed my mind, thinking of the Shanghai sunrises I'd stayed up to see. As is my habit, I did a slow first lap of the exhibition, getting a sense of the entire show. The space of the museum was vast, but the show felt tightly curated. A range of Bourgeois's work was on view, though it was largely pieces from her mature work of the 1990s and 2000s. Inside each large room were just a few pieces, arranged more by theme and medium than chronologically. I appreciated the sparseness of the curation—it seemed to allow the work to breathe.

In one hall was an arrangement of Bourgeois's *Cells*, a series of mesh enclosures that held in their confines symbolic collections of domestic objects: a raggedy armchair, clothing that dangled on hangers or swaddled dress forms. The materials used in the cells, which sometimes gave the impression of a still life or memento mori, frequently came from Bourgeois's own home and archives. I was struck by a closed mesh cell, shaped like a cage, which held two fabric heads. Stuffed and made of a patchwork of white fabric, they felt abject and crude, the hand-stitching coarse and inelegant, adding an emotional texture to the material.

Born in Paris on Christmas Day of 1911, Bourgeois had been raised in the family business of restoring antique tapestries, which gave her a familiarity with the fabric arts, as demonstrated in these soft sculptures. There was something about the way she'd constructed the heads that tugged at me—she could have made them beautiful, used seamless pieces of cloth instead of rough patchwork, but instead she'd chosen to make the image of something whole after it had gone to pieces. No, two things, two heads: one head was larger, one smaller; they faced each other, each on a short, blocky pedestal, locked in eye contact. They wrenched at me.

Another room featured Bourgeois's work in hard materials. On a tall plinth two pairs of hands were clasped, sturdily cast in bronze—I was touched to see such a simple gesture represented. Suspended from the ceiling was a larger-than-life sculpture of a couple embracing, their bodies caught up in a slithering knot of shiny chrome so only their legs and feet were visible. I'd seen a version of it, much smaller, at MASS MoCA. Here, the size

of it made the piece feel monumental—like love was something to be taken seriously, like it could fill a room. The family tapestry business had taught her this scale, and even the spiraling actions of washing and wringing out the fabric found a way into her work—I saw the impact of both in the sculpture of the couple, swathed in coils of metal. Walking through the show, I felt I was beginning to grasp the themes of Bourgeois's work—it seemed to me to be an inquiry not only of the body and its harms, but also of the relationships between people, the fraught, tangled interactions between family members within domestic spaces and the intimacy between lovers.

In Bourgeois's childhood, she had been her father Louis's favorite. It was for him she was named, but she came to hate him after she learned, at age eleven, that he was having an affair with the family governess, whom Louise adored. The infidelity, which spanned ten years, caused a lasting rift between father and daughter, only repaired after Bourgeois left France for New York. That early trauma was embedded into Bourgeois's work, like a boulder that had grown impacted within a tree's roots. As a result of the affair, Bourgeois's mother, Joséphine, became not only the young artist's best friend, but her protector. Joséphine died in 1932, spurring Louise to cease her study in mathematics and commit herself to studying art. Though her father refused to support her study of modern art, she still managed to take classes, volunteering as a French-to-English translator in exchange for free tuition.

She met her husband, the art historian Robert Goldwater, at the print shop she opened beside her family's studio, and in 1938, they

married and moved to New York. There, Bourgeois continued to make art, enrolling at the Art Students League and making prints. A solo painting show followed, in 1945, and she was included in group shows at the Whitney Museum and Peggy Guggenheim's gallery, an incubator for abstract expressionists, though Bourgeois's depiction of organic forms, arising from the primitive and the figural, was never part of that heavily masculine, gestural movement. Instead she worked independently of it; later, in the decades of her career that followed, she would eclipse it entirely, demonstrating the longevity and consistency of her focus. Bourgeois didn't fall in line with major artistic movements—she was never a minimalist, nor a conceptualist. Even her overlap with the feminist art movement of the early 1970s—as a woman artist, and as an artist concerned with ideas of womanhood, family, and domestic spaces—was largely thematic rather than chronological. The throughline, the eternal thread of the work, was Bourgeois herself. In a 2003 interview with the critic Paulo Herkenhoff, she said: "The soul is a continuous entity. I am consistent . . . If Louise tells you that she loves you she is not likely to change her mind."

I'd felt that consistency even in my brief encounters with Bourgeois previously—there was something about her work that identified itself. Sometimes it was a bit of humor—a row of gently sloping marble protrusions that resembled wilted phalluses; a rocky-looking sculpture with carved, cartoonish bug-eyes—and sometimes it was a particular anxiety and angst, as in her layered prints of bodies, bleeding and swirling with red ink. And sometimes it was in the treatment of the materials, in how I could sense the shape was coaxed out. Bourgeois's mixed-media approach was

initially unusual among her contemporaries, but she saw the material itself as a responsive part of the art. "The medium is always a matter of makeshift solutions," she wrote. "That is, you try everything, you use every material around, and usually they repulse you. Finally, you get one that will work for you. And it is usually the softer ones—lead, plaster, malleable things. That is to say that you start with the harder thing and life teaches you that you had better buckle down, be contented with softer things, softer ways." Bourgeois was never one to pull a trick and sculpt something that appeared to be made of something else. Not only consistent, she was honest: honest in her making, honest about how she felt.

Gazing at one of her spiders, nearly alone in the museum, I thought I could understand what Bourgeois meant by materials—the idea that the sculptor might be shaped by the medium, that making art was just as much about change on the part of the artist as it was about any kind of creation. I had gone on that journey, too, as a student in France: I had tried monoprints, black tempera, smudgy willow charcoal, trying and failing to make something good. I had tried it even in different ways, trying to chase a feeling through late night runs and pop songs and looking for *it* in museums. But what had finally led to any shift in me was the pure fact that I had tried anything.

I found myself constantly returning to a series of drawings, installed high on a wall near the crouching bronze spider I'd been considering. They depicted, in two shades of red and pink, two sets of hands coming together and apart across an expanse—a hand touching a wrist, then fingers interlaced, the pairs separating, reaching,

clasping, holding. The series began with a line drawing of a clock, its arrows at the ten and twelve, over which was written in Bourgeois's distinctive, looping script: "10AM is when you come to me!!"

To my eye, the hands evoked an evolving relationship. The ever-shifting closeness and distance that was a product of two people coming into proximity. The clasp, the retreat: there was a story in that dance, especially when I considered the solid, material security of her bronze sculpture of clasped hands. In contrast, the moments of distance in the drawings felt especially poignant. I wanted to imagine that Bourgeois was the reaching party—who came to her at 10 a.m., I wondered? One hand wore a wedding ring. I imagined a homecoming of sorts, a return that set everything at rights, a reunion that warranted the double exclamation points. Looking at the drawings, it was impossible not to think of my relationship with you, the ways we'd come together and moved apart over this last, long year. I thought of the way, even now, I was still grasping, reaching out for you in the dark. My fingers extended, hoping to make contact. And where were your hands?

Drawn on lined pages of musical score paper, a formal choice Bourgeois was fond of, *10 AM Is When You Come to Me* was completed in 2006, near the end of Louise's life. The hands depicted were Louise's own and that of her longtime assistant Jerry Gorovoy, whom Bourgeois frequently used as a model for sculpture casts and who indeed arrived at ten each morning to drive her to her studio in Brooklyn. "When you are at the bottom of the well, you look around and say, who is going to get me out?"

said Bourgeois of their relationship. "In this case it is Jerry who comes and he presents a rope, and I hook myself on the rope and he pulls me out." The dance depicted was that of artist and assistant, of woman and confidant, of the relation between close friends—of falling into the well and being pulled out of it again. The drawings had meant something different to Bourgeois than they did to me when I first saw them, but the dance was the same. I don't think she would have minded my interpretation. I wanted my own reunion—my own 10 a.m. The message of seeking, yearning, collapse, and retrieval remained.

I was moved by the unfiltered, visceral emotions that Bourgeois shared with her viewers. It seemed to be more than just presenting or sharing, bordering even upon reflex. "The subject of pain is the business I am in. To give meaning and shape to frustration and suffering," Bourgeois said, famously. "The existence of pain cannot be denied. I propose no remedies or excuses." Bourgeois took that pain and pressed it into her art. Unlike me, she wasn't afraid to say exactly how she felt. In fact, it was this speech that kept her alive.

In 1949, in New York, Bourgeois debuted as a sculptor, with a solo show featuring tall, narrow sculptures reminiscent of Giacometti, carved in wood, as the forgiving material allowed her to continue to work while raising her three sons. I'd seen similar pieces before, first at Yale, where one was in the permanent collection of the university art gallery, and later, up at Beacon. Long and thin, with soft rounded edges and carved-out hollows that evoked faces, they had a personified warmth to them, like

figures standing apart from a crowd, or a sheltering family. One sculpture from this period, *Woman with Packages*, was on display at the Long Museum. Though made of bronze, it was formally similar to the wooden sculptures, tall and narrow with a small, blank face that still managed to feel evocative. The figure seemed to sway slightly, one arm up, holding an oblong black package—I could picture the woman who had inspired it, a mother or wife running errands for the day.

Yet as a woman artist, working not in abstract expressionism or in strictly conceptual art, Bourgeois's work failed to draw the kind of attention her contemporaries received. This changed in 1966, when Lucy Lippard—the very woman I had briefly met in Santa Fe—saw Bourgeois's work and included her biomorphic sculpture in the show *Eccentric Abstraction*, alongside artists including Eva Hesse and Bruce Nauman, bringing Bourgeois a newfound, late-coming recognition. Sixteen years later, in 1982, Bourgeois was the subject of a retrospective at the Museum of Modern Art in New York—the feminist movement and an embrace of mixed media forms making her work finally legible to a wider audience. The show encompassed her career to date, including the long wooden sculptures, the bronze and marble organic forms, and Bourgeois's early paintings. Yet, perhaps as a testament to the incredible length of her career, nearly none of that work was on view in Shanghai.

As I made my way to the furthest rooms of the exhibition, I noticed a number of Bourgeois's flat fabric pieces, hanging on the walls. Some were single, stretched panels, upon which lines of

text were machine-embroidered; others were digitally printed and set within frames. I hadn't encountered these textiles before, in any context—I was curious about their surfaces, about how clean and simple they appeared in contrast to all I'd known of her work. The overt abjection and anguish of the fabric heads had disappeared, and instead there was a gentleness to these fabric pieces: they looked touchable, as though you could wrap yourself in the textiles, as though they were made for human encounter. On one tall wall, there was a grid of framed pieces, twenty-four in all. In each frame, the clock motif and the musical score lines from *10 AM Is When You Come to Me* were repeated. After a moment, I realized that each page represented an hour of the day, marked on a twenty-four-hour clock, and next to each clock were a few lines of Bourgeois's own poetry, which I'd never seen before. The piece was called *Hours of the Day*. I stood there for a long time, reading each frame.

Digitally printed on fabric, typeset in Times New Roman, and the figure of the clock precisely drawn on a computer, *Hours of the Day* doesn't have the messy, human touch that *10 AM* has, with its bleeding strokes and yearning hands and smears of color. Yet the lines of text—inconclusive, emotive, frequently claustrophobic— reveal Bourgeois's mind just as much as any mark. Panel to panel, hour to hour, her mood shifts, representing that acutely frantic, anxious feeling of being caught in one's own head.

The day begins at six in the morning, with a plea: "I will wait for you / Do not abandon me." At eleven, Bourgeois writes: "I need to hear your voice / every day at 11AM / to know if you are here,"

referring, I think, once more to her assistant, Gorovoy. At two, "I want to be loved for myself / incognito," and by seven, "Turning round like sick pig / It was urgent yesterday / It is not urgent to-day." At nine, Bourgeois writes: "I am on the other side of despair / and this happens to me 4 times a day / I am fed up."

Hadn't I been on the other side of despair, four times a day? Surely I had gone through it just in the time I'd been on this trip. Somehow Bourgeois had put words to that tumult I felt, that acute sensitivity to my own emotional weather. In every moment careening from listless to ecstatic and back again. It felt incredible to see that deep interiority I thought I'd been alone and frightened in, reflected in the words of someone else.

Through the long night, Bourgeois's words undergo a transformation, and at 4 a.m., the text picks itself back up in preparation for a hopeful new day: "Renewal / Reconciliation / Sunrise / Buds on tree branches / Birds return."

I thought, then, of the sunrise vigils I'd been keeping, of the waiting though I never knew what I was waiting for. There was a promise, Bourgeois knew, in morning, in even the tiniest sliver of morning, the sky only just beginning to lighten. Four a.m. was the time I'd leave the dance floor to find a drink of water. Four a.m. was the time I'd wake from a dream to see you in bed beside me. Four a.m. was the time I'd call a car home. Four a.m. was the time it was the first time I'd found you on the path back to our campsite. A little bit of light in the sky. The music ebbing. Let's go home, I'd said.

I saw, in Bourgeois's text, another kind of home. I felt witnessed by her poetics—by how, in her words, I could clearly feel her voice coming through. She hadn't been afraid to say how she felt, even if the way she felt was afraid. I saw that she was anxious, restless, disturbed, and neurotic, and I felt a kinship with that wholehearted embrace of her own volatility. She knew what it was like to go to the end, the very end of the hallway of the self. I had stood there, too, even just hours ago, and I would stand there again. The work wasn't about serenity. Bourgeois didn't ask us to be calm. She just asked us to feel, to feel violently, and her work gave form to the feeling.

I had come to see something beautiful; I had come hoping to be seen. I walked around the museum, hand over my heart, returning again to Bourgeois's drawings of hands and the pages of the fabric book on the wall. I mouthed the lines, half-aloud to myself. I felt so much it threatened to spill out of me, though I had no one to tell about it, and of course the person I wanted most to tell was you. The familiar hot rush of tears started in my throat. I wanted nothing more than to hold one of your hands in both of mine.

"Your sudden perception of beauty / is what keeps you going / step by step along the way."

Last dinner in Shanghai: gleaming roast duck, century egg, fish stew and steamed greens and a parade of other dishes too numerous

to count. White tablecloths. We piled into the wood-paneled black cars and were given custom poker chips, which we presented for entry to an art magazine's closing party. A disco ball sparkled over the pink-lit bar while I drank four vodka sodas, one right after the other. I liked this part of press trips best—when the work of maintaining a professional persona was relaxed and we could finally talk to the people with whom we'd spent nearly a week traveling.

I was back at the hotel by midnight, somehow practically sober. At least it felt that way. I packed up all of my nice clothes, and for the first time that week, my bed and the loneliness it harbored didn't feel like an enemy. I knew what lay there, and I knew that it wasn't going to annihilate me. That despite what I'd thought, nothing could.

I had come here, after all. I'd seen and talked and found my way without anyone to witness me or love me or hold my hand, and emerged triumphant in my loneliness, a pink flower against pink clouds. Nothing had come out of the sky to strike me down. I was still standing, and I could still feel.

I felt bared. All I had was all I had become, everywhere I'd gone and everyone I'd been. There was no way to turn back time— that's something I've always so ferally craved at every breaking point, to turn it back, to rewind until the moment where I made a mistake or you did—and no way to guarantee that we would ever find our way back to each other, even if I wanted it desperately. I was alone, and I was me, and that had to be enough.

For the last time, I pulled open the curtains so I could see the city. The electric glow of the skyline and the pale yellow ribbon of headlights that marked Yan'an Elevated Road, traffic snaking along densely even at this hour. The tennis court on the rooftop below was empty, a rectangle of green inside a rectangle of brick red, and even farther below it I could make out the shadowy, fragmented silhouettes of trees.

This whole time, I'd always been grabbing, grabbing, grabbing. Trying to take time and make it fit the story I was trying to tell. I'd tried so hard to write our narrative before it could ever be fixed, trying to force it to live up to my impossible expectations. I'd done it all in the name of protecting myself—maybe protecting you too—but in doing so, I hadn't listened to what either of us were really trying to say.

Morning came quickly. Bright, soft. I rode back to the airport, and then I was through security, and then I was on the plane, looking out the window at the crisp white clouds.

I landed in New York in the late afternoon. The brand had sent a driver, and he and I laughed about how we'd walked right past each other at the baggage claim. We took the way back I liked, on the Belt Parkway, close to the water. And then I was in Brooklyn. And then I was—

Home again. I was home in the seat of myself, at the end of a year in which I'd kept running, trying to hang on to all of time itself, like I didn't trust anything but the future I'd planned. At the end of a year in which I'd found myself in love, deeply and undeniably, a love that I only just learned meant letting my love be an outward thing.

It was okay that I still loved you, I thought, one hand searching through my bag for the keys to my apartment. My fingers brushed against the Shanghai rail pass, the hotel keycard, landed on the carabiner you'd given me. That I would. Maybe if I just stopped holding on to that love so tightly in my fists, then I could finally use both hands. And if I could trust in anything, then maybe I could come back knowing that if I was going to lose myself in something I could lose myself in the uncertainty itself, in the hope if not the expectation that everything would be okay.

There was a song playing in my head, then. It's a song I've tried to describe to you this whole time, but I think you know it by now.

We say falling and we mean getting closer. We say falling and we mean the music's getting louder. And once again, I opened the door.

Acknowledgments

This book would not exist without the generous support and space provided by the Jack Jones Literary Arts retreat, where the list-style chapters first came into being under the stars of the desert sky. Thank you to Kima Jones and LaToya Watkins, and to the cohort of incredible women writers of color I met in Taos—your joyful encouragement over the years has unimaginably enriched my life. And a heartfelt thank-you to Alexander Chee, one of the best supporters of literary community I am honored to know.

Thank you to my agent, Monika Woods, who has believed in me for so long and who continues to move me with her absolutely boundless vision of creative possibility. Thank you to my brilliant editor, Jonathan Lee, who not only trusted my initial, inchoate instincts but also saw the book living inside the drafts and, with eloquence, patience, and acuity, coaxed it out of me. Thank you to Alicia Kroell for the editorial insight, Nicole Caputo for the perfect cover, Wah-Ming Chang for pulling the book's interior into order, and the rest of the team at Catapult for working on this project with such thoughtfulness and empathy. It's an honor to work with all of you.

There are many editors to whom I am so grateful for the opportunity to roam, speculate, and generally do my thing. Thank you to my editors at *The Nation*, Kevin Lozano and Matthew McKnight, for pushing me to write better criticism. To Nadja Spiegelman, for giving my art history writing a home at *The Paris Review* and encouraging me to write—anything! To Caitlin Love, who first published the essay on Agnes Martin that would evolve into "Blue," also at *The Paris Review*. To Paul Chan, Micaela Durand, Sarah Nicole Prickett, and Ana Cecilia Alvarez. To Roxane Gay, who published an unknown young writer's very first literary essay, "The Prophecy," at *The Rumpus*, back in 2014. And to the good people at *Full Stop* who took a chance on a collegiate blogger even earlier, in 2012.

Thank you to Robert Reed, who taught me the importance of work and still managed, each year, to take us to the beach. Everything I make, I make as a product of your pedagogy.

I owe so much to the people who have shared art and experiences and meals with me. Thank you to Harron, who first played the Stevie Nicks performance of "Wild Heart" for me. And to Sally, for taking me to hot pot on my first night in Shanghai. To Clare, for always somehow being on text message, no matter what time of day, and just, in general, for everything. To Jaime, for sitting in a dark room with me at MASS MoCA and all the other times we've wandered around in the dark. To Santi, my chouchou, my travel buddy! Another time I'll write about the rave in the abandoned building. To sweet Ana. To Diane in New Mexico. To Rachel, Sophie, Dzana, Kat, Anna, Jeesoo, Simon, Lito, Maxy,

Writing Group, and all the friends who have championed and nourished and poured shots for me along the way. To the cheese fries at Up Stairs. To my cohort in Auvillar. To my therapist. To my colleagues in antiviolence for holding space, teaching me, and trusting me. To everyone I wrote with, read, and reblogged on Tumblr from 2009 to 2014: This is for you. I hope you see all of us in it. And thank you to everyone who's read a piece of mine and written to me, DM'd me, tweeted at me, stopped me on the subway to tell me—I am so very grateful for you. Your care and attention honors this work beyond words.

To my family: Thank you for your support and your love. Not only have you always known that I would lead a creative life, you have always trusted that it would find me. Thank you for believing in me.

And to Chris: Thank you. I love you. I love looking at art with you.

Works Cited

"On Running"

1. The accounts of running and runners I describe were referenced from interviews with Haruki Murakami in *Runner's World* and *The New Yorker*, Leslie Jamison on the Barkley Marathons for *The Believer*, and Anna Katherine Clemmons on Pete Ripmaster's ultrarunning ordeal in *Longreads*.

"Blue"

2. This chapter, parts of which were previously published at *The Paris Review*, owes much to Rebecca Solnit's *A Field Guide to Getting Lost* (Penguin Books, 2006).

3. Much of the biographical information on Agnes Martin in this chapter is referenced from Olivia Laing's 2015 longform piece on Agnes Martin in *The Guardian*, "Agnes Martin: The Artist Mystic Who Disappeared into the Desert."

4. Other aspects of biography are referenced from *Agnes Martin: Her Life and Art* by Nancy Princenthal (Thames & Hudson, 2015) and *Agnes Martin: Pioneer, Painter, Icon* by Henry Martin (no relation) (Schaffner, 2018), the latter of which is an in-depth resource on Martin's various relationships with her contemporaries.

5. I used the website native-land.ca to determine the Indigenous nation affiliations for the land and territory we now call New Mexico. Much of the text of this book was written on the traditional land of the Lenape and Canarsie. I encourage readers to learn about the traditional territory you may be occupying, as well as any organizing around land return that might be happening near you, or that you might be able to contribute to, financially or otherwise.

"Body of Work"

6. This chapter, parts of which were originally published in my Devil in the Details column at *The Paris Review*, owes a great debt to Leslie Jamison's "Grand Unified Theory of Female Pain," from *The Empathy Exams* (Graywolf Press, 2014).

7. In this chapter, I briefly quote Kate Zambreno, from *Appendix Project* (Semiotext(e)/Native Agents, 2019).

8. St. Gemma Galgani's shrine, which has a wealth of information about this passionate saint, can be found at stgemmagalgani.com.

9. For the definition of a *scourge*, I quote Wikipedia directly, which itself cites the 11th edition of *Encyclopædia Britannica*.

10. The Johanna Fateman line is from her 2015 essay "Women on the Verge: Art, Feminism, and Social Media," published in *Artforum*.

11. The idea of the nip denoting the bite within BDSM is from Gregory Bateson's "A Theory of Play and Fantasy," which I encountered quoted within *Techniques of Pleasure* by Margot Weiss (Duke University Press, 2011).

12. Much of the biographical information about Jenny Saville is referenced from a 1993 interview with *The Independent*, "This Is Jenny and This Is Her Plan," and her 2016 interview with Emine Saner in *The Guardian*.

"Crush"

13. Thank you to Clare Mao for letting me use your tweet as this chapter's epigraph.

14. Much of my framework for thinking about eros and erotic desire in this chapter comes from Anne Carson's *Eros the Bittersweet* (Princeton University Press, 1986).

15. I also draw from Roland Barthes's *A Lover's Discourse* (Hill and Wang, 1978).

16. The Yayoi Kusama interview with the critic Akira Tatehata was published in Phaidon's monograph *Yayoi Kusama* (2000). An excerpt can be read online at Artspace.

17. I quote directly from the Wikipedia entry "Mass Wasting."

"Camera Roll (Notes on Longing)"

18. I reference Peter Hujar's portrait *David Wojnarowicz Reclining (II)*, which can be seen, along with many other Hujar photographs, at the Peter Hujar Archive at peterhujararchive.com.

19. Details of the eclipse of 1544 were referenced at moonblink .info, a very cool website that collects details of historical solar and lunar eclipses as well as general information about eclipses.

20. Susan Sontag, "In Plato's Cave," *On Photography* (Farrar, Straus and Giroux, 1977).

21. The interview between Roy DeCarava and Dread Scott took place in 1996, originally for *A Gathering of the Tribes*. It was republished in 2001 and can be read online at tribes.org.

22. Other details of DeCarava's biography were drawn from a 1982 interview with *The New York Times* and his obituary, also in the *Times*, in 2009.

23. Little is available online about the life of Edna Smith, but I got a brief glimpse of her biography from Mikael Elsila's remembrance of Carline Ray, Smith's friend and bandmate, published in 2013 at the Local 820 FM website.

24. Sarah Manguso, *Ongoingness* (Graywolf Press, 2015).

"Haunted"

25. Bessel van der Kolk's *The Body Keeps the Score* (Penguin Books, 2015) was integral to the writing of this chapter.

26. Another resource that I've found useful for navigating trauma is *Trauma Stewardship* by Connie Burk and Laura van Dernoot Lipsky (Berrett-Koehler Publishers, 2009).

"What we say without saying"

27. The YouTube video of James Blake performing "A Case of You" for BBC Radio is available at www.youtube.com/watch?v=Ri6bd4G-Aig.

28. Walter Benjamin, "The Work of Art in the Age of Mechanical Reproduction," *Art in Theory 1900–2000, An Anthology of Changing Ideas* (Blackwell Publishing, 2002).

29. Marshall McLuhan, "The Medium Is the Message," *Understanding Media: The Extensions of Man* (McGraw-Hill, 1964).

30. The Stevie Nicks "Wild Heart" live demo can be viewed at www.youtube.com/watch?v=S2rOh6dCwao.

"Dark Vessel"

31. John Durham Peters, "'The Root of Humanity': Hegel on Communication and Language," in *Figuring the Self: Subject, Absolute, and Others in Classical German Philosophy* (SUNY Press, 1997).

32. The line of Richard Siken's is from his poem "Visible World," published in *Crush* (Yale University Press, 2005). It's one of my favorite poems.

"Breakup Interludes"

33. For further reading on Cerith Wyn Evans, I recommend Adrian Searle's review of Wyn Evans's 2017 show "Forms in Space . . . By Light (in Time)" at the Tate Gallery, published in *The Guardian*.

34. I also recommend Martin Herbert's essay on Wyn Evans in his book *The Uncertainty Principle* (Sternberg Press, 2014).

"On Being Alone"

35. I drew upon many sources for the biographical and conceptual information in this chapter, including the 2003 interview between Louise Bourgeois and the critic Paulo Herkenhoff published in Phaidon's monograph *Louise Bourgeois*. An excerpt can be accessed online at Artspace.

36. Louise Bourgeois in her own words and practice can be read in her book *Destruction of the Father / Reconstruction of the Father: Writings and Interviews 1923–1997* (MIT Press, 1998).

37. Michael McNay's 2010 obituary of Bourgeois in *The Guardian* was also a helpful reference for Bourgeois's biography. I also referenced Holland Cotter's 2010 obituary of Bourgeois in *The New York Times*.

38. The 2014 interview between Jerry Gorovoy and Katy Diamond Hamer, published in *Vulture*, provided immensely helpful context and insight into the working relationship between Gorovoy and Bourgeois.

39. The full text and images of Louise Bourgeois's *Hours of the Day* book, which moved me so much in Shanghai, are available online at MoMA's Louise Bourgeois: The Complete Prints & Books site, which is an incredible resource for those wishing to learn more about Bourgeois's works on paper and fabric works.

© Adalena Kavanagh

LARISSA PHAM is an artist and writer in Brooklyn. She has written essays and criticism for *The Paris Review Daily, The Nation, Art in America, Guernica,* and elsewhere. She was an inaugural Yi Dae Up Fellowship recipient from Jack Jones Literary Arts.